Writing the Image

REFERENCE
ONLY

Writing the Image

An Adventure with Art and Theory

Yve Lomax

I.B.Tauris *Publishers*
LONDON • NEW YORK

Published in 2000 by I.B.Tauris & Co Ltd
Victoria House, Bloomsbury Square, London WC1B 4DZ
175 Fifth Avenue, New York NY10010
website: http://www.ibtauris.com

In the United States of America and in Canada distributed by
St Martins Press, 175 Fifth Avenue, New York NY10010

ISBN 1 86064 4740

A full CIP record for this book is available from the British Library
A full CIP record for this book is available from the Library of Congress

Library of Congress catalog card: available

Typeset by Wyvern 21, Bristol
Printed and bound in Great Britain by MPG Books Ltd,
Bodmin, Cornwall

Contents

Chapter Four

Acknowledgements

This publication gratefully acknowledges the generous support of Central Saint Martins College of Art and Design of the London Institute.

Many thanks to Monica Ross, Anne Tallentire and *May Publication Arts* for the support given in the instigation of this project. Thanks also to Irit Rogoff. Special thanks to Vit Hopley, whose criticism and encouragement I value most.

Thanks also to Routledge for permission to use dialogue from 'The World is Indeed a Fabulous Tale: Yve Lomax – a Practice around Photography' from *The Postmodern Arts: An Introductory Reader* edited by Nigel Kneale

Preface
Writing the Image
&
Words in Advance ...
Irit Rogoff

Writing the Image

What is gathered under this title is a collection of writings spanning a fifteen year period. As a title, *Writing the Image* forwards the idea of 'writing images', yet it also implies writing 'on' the image. Yes, the writings gathered under this title do persist with and insist upon a thinking through of the image within contemporary culture; however, there is equally the unashamed turn of writing the image into the 'classic theoretical text'.

Some would insist that the rose which unfurls its red, red passion belongs to the realm of poetry – the written image is strictly for the poem and not the theoretical text. Yet, as Michel Serres reminds us, it is not so fancy to say: *No theorem without poem.*

In respect of this, I would say that *Writing the Image* is an adventure with both writing and theory; moreover, it is an adventure which is moved by two longstanding concerns:

– Finding ways in which a non-oppositional difference may be thought, indeed, may be lived. Here I join forces with those who attempt to effect an ethics of difference which ceases to found difference upon negation and the logic of binary opposition.

– Addressing the 'image' that is held of the image, be it literary or visual, actual or virtual, within Western culture and the production of thought.

Although the question is never directly posed, *Writing the Image* implicitly wants to ask its reader: What image do you hold of thinking?

Love and laughter. Here are two little words that, perhaps, some would shy away from uttering. However, I am not ashamed to say to you that *Writing the Image* moves between these two folds.

Firstly, there is a love of writing and the desire, as a visual artist, to find out what writing can do, what it can develop and envelop.

Secondly, and equally first, there is the folding of a cheek, or perhaps a belly, as a chuckle emerges when the 'author' of this book does not hesitate to say that the writing comes from and indeed constitutes a visual art practice. Although it does question the hegemony of the visual within definitions of art, the chuckle here also affirms the validity of including writing within the repertoire of visual art practices.

For *Writing the Image*, the two little words love and laughter have huge implications, which is another way of saying that between two folds we can always find a thousand folds.

At the end of this collection of writings comes 'Serious Words', a text which takes in a lot of air, a lot of wind – a lot of *pneuma* and *ruah* – in its attempt to put into motion a serious thinking of relations.

For a serious venture the production of 'good' laughter is apposite, if not requisite. To consider something seriously don't we have to equally consider that it can propose to us something we were not expecting to say? And when this unexpected turn provokes laughter, isn't the laughter affirming, as it were, the surprise event? And affirming this surprise, isn't our laughter affirming what is being proposed to us; what is more, isn't it affirming the important lesson of learning to listen?

Seriousness can make us look to impose upon the world a pre-given model which claims to be able to judge what is essential (to the model) and what is only anecdotal. To consider something seriously, however, do we not have to look with a listening eye? Listening, in my experience, does indeed involve learning to laugh – to laugh affirmatively when something does not conform to an existing representation of it or a theoretical aim. Listening offers the possibility of propositions coming about which are made *with,* and so continually are modified by, that which is sought to be spoken of and considered seriously. Listening is somewhat risky; it can make serious words suddenly break into a smile.

How can I not ask this: isn't good laughter born from the 'wonder of the event'? That is to say, the event where something is *becoming* and which offers us the experience of, as Michel Serres would say, 'the immense, sparkling, holy joy of having to think'.

Why should I deny that there are many works of philosophy, many works of literature, art and, indeed, science, which have inspired me and enabled me to take in a breath of air, think, and produce some ideas?

I ask the question because there are many who stride with the conviction that no idea is born except in opposition to another idea. For this conviction, the approach is to obtain a position by way of claiming an oppo-

sition which can be negated. Don't we find this approach in many walks of life? One idea approaches another not in order to construct a relation or affirm a collective process or foster curiosity but, rather, to accuse and denounce.

So, of what will I be accused? That I am uncritical? That I have deprived myself of the power of negation? None of these accusations would make me wonder, make me curious or help me think. How can we speak of the world without having that which is said pass through a tribunal or, worst still, endure the hell of war?

I am tired of and saddened by those who are quick to accuse and denounce so as to win for themselves the august position, or power, of being right and beyond criticism. I may be saddened yet I cannot ignore the perils of denouncing those who are quick to denounce. Opposing those who seek the glorious power of an identity by way of opposition to and negation of another can have, as the philosopher Isabelle Stengers would say, the consequence of making oneself into a 'superpower'.[1] It is not so easy to stop the merry-go-round.

In 'Serious Words' I speak of running with an idea rather than rushing to conclusions. In the latter part of this text I run with Gilles Deleuze's experience of Spinoza's 'ethics of joy'. Here I meet with the idea of an 'encounter' between two bodies which are, in themselves, nothing but a composition of dynamic relations. Will the bodies discover a commonality that enables them, if only temporarily, to 'enter into composition' with each other? Earlier I spoke of *Writing the Image* as an adventure with both writing and theory, and part of the adventure has been to extend these questions (of commonality and encounters) by inviting Irit Rogoff to participate within this book. This participation, or indeed encounter, is marked by two texts: *Words in Advance* ' ... And Words in the Middle'. These texts, and where they appear, add something extra to this book; but, I would stress that this isn't the addition of that extra space which much commentary seeks to occupy, specialize and protect. Although the appearance of these texts most certainly add to the pages of this book there is another sort of addition which these texts make for that has nothing whatsoever to do with increasing numbers. Yes, what this addition makes for is an augmentation of collective processes that do not gather you and me around the 'logic of identity' and make 'us' dance to its tune.

There are many ideas and many processes that I want to understand, to come close to, to unfold. I realise, however, that any serious act of unfolding requires enfolding. Are not the best explanations those which implicate in the explication that which is sought to be understood?

Words in Advance ...

The paths by which one works with, rather than explicates or comments upon, a text a work, an object are unclear and circuitous – they require the effort of charting. An effort that cannot be made within the process of the work itself without denying it all of its exertions at troubling the relation of 'Outside in, Inside out'.[1]

Having been invited to take part in Yve Lomax's book and having recognized certain shared elements between the overall preoccupations of her writing and of my own concerns, it became impossible to stand outside of the writing and comment on it. Even an effort at framing the writing in relation to various other, well known and lesser known, bodies of thought would have continued the dualistic relation of subject and object through the modes of categorized knowledge. Perhaps even more importantly, the shared arenas of engagement within this book all revolve around the unobvious ways in which we momentarily come together as communities of mutualities and of common motives that are not grounded in identity, but in doubts, in questions, in wonder and in the very suspension of identity. This momentary mutuality, these mergings of subjects and objects through performative 'speech-acts', these 'spaces of appearance' as Arendt calls them, is to some extent what we hope to have happened in this book, in the conjunctions of writing and in all the other ghostly presences they bring in with them.

Of late I have become interested in trying to understand participation; in what it means to take part in culture beyond the audience func-

tions of viewer or spectator allotted to us by most cultural arenas. Obviously the active/passive division of that old model of taking part in culture cannot be sustained in the wake of the immense rethinking of positionality that the last twenty five years of theoretical analysis have launched on the world. We all come from somewhere, we all represent something, we all make and re-make ourselves daily through the acts of speech and appearance, but none of these are the stable identities which we can rely on to be constant through the barrage of encounters of difference we face. Being so active and volatile an entity we can no longer be positioned as the observers of work from the outside, and having understood how we remake work in relation to the subjectivity we project upon it, we cannot unlearn this when confronted with the work of 'art'. The question that is raised therefore is what forms of response replace that old model of lost identification and do these emergent modes of response afford some mutuality that links viewers and participants beyond their named location of identity? Consequently I have been reading various philosophers and social theorists who themselves have been thinking possibilities of the common and its articulation without resorting to the stability of 'identity' whether essential or constructed.

At some level it has been possible to locate in those readings possibilities for the disruption of that rapt gaze of culture which has kept us for so long in the position of edified viewers. To find alternative models of both looking away and coming together in Agamben's unhingeing of 'singularity' into the 'whatever', in Nancy's insistence of the disruption of myth – of myth designating the absence of what it names – as the grounds for political possibility, in Arendt's constant flow of made and remade 'spaces of appearance'. At another level it has been possible to locate corollaries between these ideas and some of the main concepts Yve Lomax engages within the work of writing the image; thus the fluidity of non-structured 'power' that Arendt introduced me to made momentarily apparent links to Yve Lomax's 'power constituting itself by way of an act of making ... as the power to act, exist and produce' (in the 'practising' section of 'Serious Words'). And it is not just structurally that echoes emerged between what I was reading and writing but also in the very modes of the telling as in Nancy's understanding of myth as that which comes not in response to the inquisitive mind but ' ... in response to a waiting rather than to a question, and to a waiting on the part of the world itself. In myth the world makes itself known, and it makes itself known through declaration or through a complete and decisive declaration'. Here Nancy's contention links with Yve Lomax's narrative structuring of the argument that the world does not come before the sign in 'The World is a Fabulous Tale', that the meaning is in the sign and the reality only comes about in the telling. And all these in turn link with my desire to find a theoretical mode for looking away from whatever culture has dictated I should be greedily staring at; a theoretical

mode of understanding a participation of averting the gaze from the centre and towards the momentary comings together taking place at the edges of the main event. In our shared preoccupations we, the writers and the writers we quote, mutually inform and embolden one another, we produce our 'state of appearance' through the declared and revealed mutual imbrication of the texts and of what they are all trying to do. But that is not all and it goes far beyond the adherence to certain theoretical modes of analysis or the allegiance to certain schools of thought. It goes towards some possibility of the writings not being the 'source' or the 'authority' or the 'legitimation' of what they have subsequently inspired but of somehow, momentarily singing together in some odd choir formation.

For some time now I have been getting into trouble with my use of 'we' and 'us' in my texts – frequently after the publication of some piece I would be asked, often with great hostility, *'who is "we", who are "us" in your writing?'* – 'we', they would say, *'who don't share your identity, be it national, sexual, political, theoretical, class or language based, refuse our inclusion into your argument.'* Well, the 'we' I have in mind is not identity based; it cannot be found in the named categories by which an identity is currently recognised in the world. Rather, it comes into being fleetingly as we negotiate a problem, a mood, a textual or cultural encounter, a moment of recognition – these shared mutualities do not form a collective heritage but they do provide the short lived access to power described by Arendt, not the power of the state but the power of speech. In the context of this particular writing the 'we' I have in mind is designated through a recognition of shifts taking place in the project of 'theory'. A shared transition, albeit expressed in different ways, that the project of theory has moved on from being a mode of analysis by which you understand what lies behind and beneath the workings of knowing and representing. Instead 'theory' can become the space of making, or re-making of culture, of envisaging further possibilities rather than of explicating existing circumstances. Those who agree to a suspension of the purely critical, to momentarily shared imaginaries, to a bit of groundlessness, lost and regained – that's us, that's who I mean.

Notes Preface

Writing the Image

1. See Isabelle Strengers, 'The Thousand Sexes of Science' in *Power and Invention: Situating Science,* Theory out of Bounds, vol 10, University of Minnesota Press, Minneapolis and London, 1997, pp 134–5.

Words in Advance ...

1. Trin T. Min-Ha, 'Outside in, Inside out', in *When the Moon Waxes Red,* Routledge, London and New York, 1992.

Double-Edged Scenes
A Metaphorical Journey & More and No More Difference
&
Re-visions

1981–1985

Double-Edged Scenes
A Metaphorical Journey

The sun shines. It gives direction. Even in the darkest of hours the sun is a source of inspiration. Books, it is morning, breathe that breath of life and open your pages to the light and presence of the sun! Books, open your pages as naturally as a flower turns towards the sun and opens up its petals. Books, open your covers, do not keep things hidden.

At first it appears perfectly natural to turn towards the sun rising in the upper left–hand corner of the page. Arising in the book, the sun will reach its zenith in the position of the title. Then everything becomes exact and in its proper place. Then everything refers back to the sun's presence according to rays and lines of similar length and intensity.

In the sun-splashed tableau of the page everything has direction. Words know what line to follow; they know where they are going. Metaphor knows what route to take; it remembers from where it has come.

Each page, each day, the sun moves around the house of the book. And it appears perfectly natural to follow it. As natural as a flower turning towards the sun. Little by little, line by line and word and by word, we journey towards the sunset of the lower right corner of the page. It is the evening of the recto, facing west. The sun declines, day turns to night. Darkness reigns. An absence. A gap –

Although it appears that we are plunged into an abyss or lost in a dark valley, this gap keeps safe the memory of the sun's presence. As it turns out, the gap comes to act as a reminder of the sun's presence in its absence.

As a reminder, the gap keeps the sun's presence in store and promises its return.

A reminder: think of a handkerchief tied into a knot. Think of that knot as an outer-covering which frames, keeps safe and stands in for, a presence in its absence. A visible outside and a hidden inside.

Four corners of a handkerchief tied up in a knot. Off on a journey and some stores can be kept inside. Think of a presence being saved so that it can return again the same as before. The knot: a form of conveyance, the means whereby a presence may be carried over for its next time.

Tied as a reminder, the knot not only replaces and stands in for a presence in its absence but also acts to re-place it, to return it present again.

Home again, home again, do not not delay. Do not go off on a detour on the way. When the knot is unravelled, when what is absent returns present, What a proper home coming! What a second coming! What a perfect day! Absence returns to presence. The abyss returns to the golden orb. The gap: the sun.

Four corners circle bound. That which serves as a reminder of the sun's presence in its absence is used up by the coming of the next day – the re-presentation of the capital Sun. The journey comes full circle. And that is the end of the road for the reminder. Exhausted.

Making an appearance

She had acted out for long enough inside those four corners: frame, home, tableau or scene. Exhausted.

She no longer wanted to be found where she was expected to be found, as if each time she was found it was always the same. As if it were a matter of one pattern from which, on and on, the same was cut-out, pressed out and, indeed, could be put back.

Framed into being the same. Hemmed in. Top. Bottom. Left. Right. But now, no more – and anyway, it never was. It never is exactly the same, how it was. It never fits so perfectly. Bits stick out and the seams show. The end of the sleeve never quite reaches the glove.

No more history following the same pattern. As if you can just go back and find it *still* the same. As if you can dress up the past as if it were still the same, present. As if you can cut out bits and put them back, stitch them together again and expect them to go flowing on, appearing to be the same. No loose ends.

No longer inside – top, bottom, left, right – outside she wanted to be. Outside those four corners where each corner circles around to the next.

She arose. She straightened herself out. She made ready to go. But as she turned to look at what she was leaving behind, she knocked some metaphors off the table. She stood still and viewed the tableau in which she

had made her appearance. Yes, she wanted to leave it behind – it had encircled her, framed her for long enough – but as she re-turned she wondered who would come behind and pick up those pieces. Who indeed would clean up and attempt to fit it all together again as if once again it would all fit perfectly. The same as before. She wondered, then, who would attempt to dress up all those bits, addressing her absence as a mystery to be solved, a knot to be unravelled. There is much pleasure to be gained when what is missing is missed, tracked down and put back.

She had had enough, but leaving it all behind, making an exit from that scene so that somewhere else a true entry could be made, wasn't that straightforward. The journey has a twist; it has a double-edge. As it turns out, the outside returns to the inside. One circles back to the other. The tables turn around; strangely, but not so strange at all, the outside comes to support and affirm the inside. She wanted to leave that frame where in all events she felt that she had never really made a true appearance – that frame had determined it such that for her it was only ever a show. But the question remained: was she going to reframe it all again, reaffirm all that which she was attempting to leave behind?

She asked herself: when something is rejected is it also accepted and taken for granted? Taken for granted, do we not grant and give credence to that which is desired to be left behind?

She had acted it out for long enough. She had figured from a green-eyed cat to a bleating lamb, from a black raven to a white dove. For long enough she had been told that when she comes to figure upon the scene the true light goes off. For long enough she had been told that when she makes her appearance darkness reigns. For long enough she had been figured as the *figure* which makes all the difference between the literal and the metaphorical.

Yes, we have heard it all before: with the figurative, with metaphor, something is missing, hidden, kept in the dark. Yes, we all know what that is. What else but that which is most proper to proper literal meaning. What else but the clean and clear straightforward Truth!

For long enough she had been told that with her appearance the Truth was masked. For long enough she had heard it said that with metaphor the Truth deviates from its proper path, is seduced into leaving its proper home and tempted into borrowing someone else's home. But no matter how much she had had enough, she was not going to reject this, and so in a sense accept this, just like that.

Maybe, just maybe, it is Truth's brilliant idea to plan it all out so that something *is* missing from the figurative. Maybe it sets all in (circular) motion so that the figurative is said to be a deviation from the literal Truth. Maybe Truth plans it that way so that it may better itself, save itself and so continue to re-present itself the same. Maybe Truth cuts itself out so that it can return the same.

So, maybe Truth goes out from its proper home, seeks another in which it can hide and disguise itself, so that it can rest, make more of itself and be carried over for the next time. Whilst undercover, whilst borrowing someone else's home, the Truth appears to be absent. The proper is not at home in its proper home; it is absent, but conspicuously so.

The Truth makes its presence felt by its absence, it gets itself missed – if it didn't go missing how would its true value be known! The literal proper Truth goes missing such that its borrowed home, its lodging place, comes to figure as not-a-proper-home, indeed, a metaphorical home, a home-on-wheels, a sort of holiday home. Yet, just as the Truth is missed it is already found; it returns to its proper home and reveals itself, brilliantly, the same as before.

What an economy! The proper Truth can literally save and better itself with the *means* of the figurative. All comes full circle.

She was exhausted with being framed figuratively yet she wasn't just going to accept it just like that. She asked herself: where would the true and proper literal be without the figurative? Where would it be indeed.

How would the literal remain so literal, how would it remain the same, if it didn't contrive a disappearance with the appearance of metaphor? Indeed, where would the literal be if that disappearance, that absence, that visible gap or lack, ceased to make all the difference between the literal and the metaphorical, the difference between the two.

Most proper and literal one, the absence of your presence is a ruse. A turn-trope-trick whereby all is set in motion for a return of the same. Go on presenting yourself as the same, but, most true and literal one: *we saw you go to hide yourself as the so-called metaphorical made its appearance upon the scene.*

Leaving by the stage door

Behind the scene: this is where that most proper and literal one can hold its presence in store.

The absence which marks the appearance of the metaphorical is but the literal hiding behind, hiding inside, metaphor's costume. The literal, that most true and proper one, is two–faced.

Two-faced indeed. The metaphorical has already been *styled* by the literal; it has already been cut-out and framed. As the proper cuts-out metaphor, and inscribes the 'metaphorical', the proper also cuts itself out. A double-edged cut, a double-edged stylus which works in two ways. A cutting in: an imposition, an inscription. Yet also a cutting out: a withdrawal, a flight, a removal from sight. The difference between the metaphorical and the literal is double-edged.

Two–faced indeed. The literal will frame and style the metaphorical

as a flower so that it can turn as if it were a sun one. A one with a sovereign presence. No questions asked.

How the literal will hide itself and appear missing so that it can return the same. And the lightest of petals, the most transparent of veils, will provide enough outer-covering to hide behind. That most true and literal one hides itself and then by way of its absence sets everything in motion to turn heliotropically, like a flower, toward the sun. When the sun shines and the flower opens up to its presence, when the outer-covering bursts open, the literal returns and reveals itself. Once again, it is re-presented.

The literal has the brilliant idea to follow the sun! Where would the literal be if the sun ceased to shine with such presence? The excessive bright-ness, the awe, the power of the presence sensed, that is exactly what the literal loves. A power too clear and bright to be called into question.

And who else but the fabulous feminine is tied into playing that heliotropical game, that game of absence and presence which is full of turns, tropes and tricks. Who else but the fabulous feminine comes to make all the difference between the figurative and the literal. Who else but the fab-ulous feminine is said to make all the difference between telling stories and telling the literal Truth. But I say that the Truth frames the fabulous fem-inine fictionally. I say that the Truth frames the fabulous feminine accord-ingly so that she turns and returns all that which is (in fact) clear and bright to the proper literal Truth.

The true and proper literal says that the fabulous feminine can only be spoken of figuratively. Her name is always someone else's, never a proper one.

The Truth says that the fabulous feminine makes an alluring gift of herself to be given names that do not 'properly' belong to her. And because she is always making such a gift of herself, the Truth says that the fabulous feminine can never come to possess the fixed sense of a so-called Proper Name. Hence, so says the Truth, the fabulous feminine can only be spoken of figuratively. The Truth says that the fabulous feminine's name is always another's: a lamb, a cat, a raven, a dove, a knot, a flower ... Then the Truth dares to say that the fabulous feminine's name – her home – can only ever be but a provisional home, a lodging place, a secondary sort of home, indeed, a metaphorical home. Not a proper home; for, properly speak-ing, the Truth of a proper name is not inside its proper home. Absent, so it goes.

The Truth says that a name is only a proper name when it houses and refers to one thing. Then, so says the Truth, there is no doubt as to the proper owner of a proper name: univocally, one meaning, one owner, one name, one presence. And then the Truth dares to say that to name the fabulous feminine properly is to say that she has no Proper Name. She can only be spoken of figuratively, metaphorically. The Truth dares to fix the

fabulous feminine in a place which is not a so-called proper place. And then the Truth dares to say that this 'paradox' is but the fabulous feminine's own doing. The Truth dares to say all this, framing the fabulous feminine accordingly, so that all is set in motion for a return to an unquestionable proper place.

The fabulous feminine is deemed as all to do with making an appearance. Appearance, so says the Truth, is secondary, merely an outer-covering to that which lies essentially beyond, behind and before. Appearance, so says the Truth, is all to do with exterior figuration. Yes, like a knot or budding flower where only the outside is visible. Appearance so says the Truth, is not intrinsic. It does't come first. It isn't primary. It is secondary. And that makes it inferior. Yes, if the Truth makes out that the fabulous feminine is all to do with secondary outer-layers, with outward dress, then it can return with its primary and essential kernel. The Truth is two-faced indeed.

The fabulous feminine is styled as all to do with outward appearance. As the visible outside of a hidden inside, the fabulous feminine provides a frame in which, metaphorically speaking, the proper literal truth can take a break, recollect itself and so keep its presence in store.

Returning to proper homes

The frame which the fabulous feminine comes to metaphorically provide is double-edged: the outside doubles back to the inside and in so doing transports, carries over for its next time, all that which is most precious to a Proper Name. No irreparable damage done. On the contrary, a gain. When the flower's petals open it is the proper's presence which shines forth. Lo and behold, the sun rises again. And then the Truth has the audacity to return and say that the fabulous feminine has not, as yet, recovered and recollected her true and proper presence. When the petals open and the outer-covering falls away, it is not fabulous feminine's golden presence which shines forth; it is but another's gold.

The Truth ties up the fabulous feminine in knots yet she is put to shame and made to feel guilty when she will not yield, when she will not open as a flower. The Truth says that this means trouble. Double trouble. Abysmal trouble. Yet I say that such trouble is Truth's delight.

Cut, snap, jack, ass: the absence of Truth's presence is a ruse, a trick where all is set in motion for a return of the same. Turn, hide, return, reveal. Yes, we know the moves of the game, that game of absence and presence, that heliotropical game of both movement turning toward the sun and the turning movement of the sun. No wonder that most true and proper one metaphorically styles the fabulous feminine as a flower which turns oh so naturally towards the presence of the sun. No wonder a heliotrope; for,

then the fabulous feminine will but turn and return to the presence of one as golden as the sun.

Helio-trope: sun turning trope. Trope: a figure of speech which is used other than in its literal sense. Where would the literal be if the fabulous feminine ceased to turn so heliotropically? Indeed, where would the literal Truth be if metaphor ceased to turn so tropically? No wonder the literal says that the fabulous feminine can only be spoken of in terms of tropes.

What rhetorical games the literal plays.

Is it any wonder that the literal frames the metaphorical as the turning away of things from their proper path; for, turn, trope, trick, such turnings are already returnings. The trope is already turning tropically, already returning to to the sun's presence.

It is said that the metaphorical is a deviation. It is said to be a detour. But I say, as others have said: that detour is but Truth's return tour guided by the light of the same.[1]

The difference which the fabulous feminine comes to figure provides the means whereby the literal truth can re-present itself.

The end justifies the means

The circle draws to a close. The metaphorical journey turns out to be a circular project: the movement of one going out from itself in order to return itself and so affirm itself, the same.

One eye open and one eye shut: metaphor's detour is but the literal's return tour. Metaphor is within the ecomony of the same; it provides the means whereby the literal Truth can come again, more the same. The metaphorical adds that extra: it provides the means whereby the Truth can save itself and make more of itself. True, the Truth loves to be re-presented the same.

When the Truth returns, glimmering with self-affirmation, it is the end of the road for the means which have been carrying it along, carrying it over for its next time. That which provided the means of transportation, the home-on-wheels, is literally exhausted; it disappears just as it expends its greatest energy. The means sink into the end. The fabulous feminine is used up. But all is justified in the end, so we are told. There is a surplus. There are returns. The original wealth bears fruit. The using up of the means adds that extra. What is lost at one level is regained as a 'higher' level. All is justified in the end: we are told of a 'unity' between loss and gain.

But does the journey run that smoothly? The means never, even with the best super-vision, coincide with the end. And anyway, is not the desire to make the means coincide with the end the desire to make

history into something very much the same, something smooth and homogeneous, without flaws and scratches. And to desire that exclusive clarity – is that not the desire to put history under glass?

Glass lets the light in and out. We look through to have a view. It protects. It doesn't spoil the view. With four corners.

The proper frames the metaphorical, and it does its utmost to efface the imposition of that frame, or naturalize it in God's keeping. In the cutting-out of the 'metaphorical' the proper omits itself – it appears absent, no where to be seen. And when the proper returns with its sun shine presence and the frame is, as it were, used up, that omission is also omitted. How neat. No trace. No questions asked.

But, turn, trope, trick: the proper was never so proper.

The proper shining sunny bright with sovereign might and golden presence was never so literally true and proper. The sun: has it ever shone pure and properly, true and literally? Has not the sun already turned tropically? Has not the sun already turned figuratively? Each time there is the sun metaphor has already begun.

The so-called literal and proper Truth is already within the means of its re-presentation. Nothing stands apart from its re(-)presentation within representation. The tale does not stand apart from its telling.

She had acted it out for long enough, but who is to say that beneath all that which has been put upon her, the clothes which have covered her up, there is something waiting to make its true and naked entry, without fancy, metaphor or style – as if it were just a matter of removing all those frames and outer-layers, all those well worn metaphors, clothes and habits! As if we can still expect to find the Truth, clean and simple!

And anyway, where would nakedness be without clothes?

There is no wild flower growing freely outside the frame. Beyond the frame: what a ruse to dream that all is still innocent in that beyond. Yes, we know of the dangers of dreaming of a pure innocence beyond the frame.

No more innocent outside – and anyway, it never was. I can no longer dream of meaning growing as naturally as a flower. Shamelessly I ask: what can remain 'natural' in nature?

Oh little flower which turns so naturally towards the sun.

Nature is already artificial. The metaphorical sun had already enlightened the empirical sun. The book is already closed as it is opened: every exit from the frame is already framed. No, I will not dream of the pure and simple absence of the frame. No, I will not be located outside. Dislocations. Little explosions. We are already within. It has already started but that is not the end of the story. An end which is but a return to a beginning, a first time.

The first time doesn't quite remain the same re-presented for a second time – as if you can cut out bits and expect them to return the same.

Double-Edged Scenes
More and No More Difference

What more difference is there than between boys and girls. The difference, obviously. The D-i-f-f-e-r-e-n-c-e. Want me to repeat that difference? Hoping that if I repeat that difference it will stay as truth. Hoping that if I repeat, I will accept it as the Truth. The Truth is that which can be repeated. True. Truth loves to be repeated. That way it can keep itself true. Menacing repetition.

Want me to obviously accept the difference. Want me to accept it as the most obvious difference. Too clear to be called into question. Obviously want me to face the sun! Obviously want to blind me with the obviousness of it all. The sun cannot, on pain of blindness, be stared at directly. Want to blind me with the obviousness of it all. Blind me here. Then bind me here. Then can always find me here. Stuck. Struck by the obvious 'power' of the sun.

Want to blind me with the obviousness of it all? Want me to think that if the girls don't want to be the same as the boys, if the girls don't want to be subsumed by the same, if the girls want to be other than the same, they have got to, obviously, insist upon the difference. Spell it out. Straight. The D-i-f-f-e-r-e-n-c-e. But insisting on the difference, blinded by the obvious. Blinded, then stopped. Then at a standstill. And standing still, easy to find. And then always found where expected to be found. No worry. No trouble. No harm done. Insisting upon the difference, then all can carry on the same. The Sa-Am-Me. Ask me who I am, ask me to confess and spell

it out, but don't expect me to remain the same. The Sa-Am-Me. Menacing repetition.

The difference between two: one will always repeat the other, and repeating the other, will allow it to return and carry on the same. Menacing repetition. Petition for the difference, insist upon it, but the obverse may always return. And then on the back of the difference, end up endorsing the same, endorsing its re-petition.

Don't want to be subsumed but why insist upon The Difference. Be valorous, valorise the difference, give it more value but the price has already been fixed. Why insist upon the difference which en-titles us to be girls and boys. Why insist and be titled. Why entitle something to find you always in the same position. Why entitle a title to reduce you to just one position. Why subsume everything else to that one position – it will always bring you down to less and not much more. Why subsume everything to just one when it is always more. Why insist and so persist upon standing still; still located in exactly the same position. Just what is wanted!

Lament the difference. Celebrate the difference. But either way the difference remains the same. Why insist upon the difference; for, when girls and boys come to play, the difference between the two is edged with gold. Ah! what fabulous stories have been told. When boys and girls come to play, even the birds and bees have to tell of the difference. They too have to reproduce it. Ah! the difference edged is with gold; it has already been sold. A sell out. A betrayal. Oh! the difference, what stories have been told. Ah! the difference is but the fabulous plotting of the same old same. The same plotting to remain the same, sovereign.

When boys and girls come out to play the difference between the two is edged with gold: the difference is but framed to return the obverse. It is framed to return the same. The obverse always comes out on top: it always turns up heads. The coin is double-sided but the difference between the two sides is a difference between heads or tails. A matter of heads and tails: a matter of above and below: a matter of hierarchy. Only one side will ever come out on top. Attempt to keep both sides equal but the coin is double-edged; it has already been edged to only ever fall on one side. Only one side faces upwards. Switch the positions around, turn things on their head but the difference will remain the same. Still it remains hierarchy bound. 'Power' then can remain sound. Power then will always sound the same, be repeated as always hierarchy bound.

Menacing repetition.

Want me to be inspired by the difference? But won't that just leave me breathless? The difference stifles. Take in too much and it becomes overwhelming. The difference – no more! No more and anyway, it never was. There has never been The Difference. Always more.

What more difference is there than between boys and girls. The difference, obviously. And what more could be less than this difference. And

being less, how could it, ever, be more. What more difference is there than between boys and girls – a difference, obviously, between more than two. More and no more.

I can no longer turn naturally towards the sun. I can no longer return to the sun as the most original and central one. There is no one thing that, properly speaking, entitles us to be called girls and boys. There is no one thing that engenders the difference between boys and girls. There is no *one* thing from which the difference originates. There is no one thing that can, properly speaking, be called the origin, the roots. It is always more, always more than just girls and boys. Difference is always more. Irreducible.

The difference between two reduces everything to the same. No more yet always more. And even though I may say with much resonance that *I am a woman,* even though I may resonantly speak of *we,* don't expect me to remain the same; don't expect that *we* are all *The Same,* many of the same – a plurality reducible to just one. Difference. More than just one difference. More than Many of the One. Many differing differences. More difference. The line breaks. Difference breaks into many lines. Not just a multiple of one. Many differ-ring lines. Many breaking lines. Many broken lines. Many lines breaking into differ-rent lines. A movement of becoming. Becoming more and not less.

The line breaks. Differ-ring lines. The ring interrupted, we no longer return to an interior point, an essential centre whose presence determines and delimits what is inside and what is outside. Differ-rence: *open rings.* The beginning and the end breaking and making more: an exploration of the means, of the 'middle'.

Differ-rent-fence. The fence no longer returns the same. It splits. It breaks up. It breaks through.

The line breaks into many lines. Broken lines making many lines. Each word, each letter, each sentence, differing. Each only becoming a line, becoming a word or sentence, in its relation of breaking – lines which only by breaking take on and make significations.

The line has become, is becoming, a complex of *partial lines.*

Broken lines are not autonomous little parts which have rent and fenced off their own little bit. Lines only break in relation to other lines. A line breaks. A door remains ajar. Open fences. The field can never be total-ly delimited beginning to end. Think about walking through fields. Think of those fields which are only accessible by way of walking through other fields. Think of those fields where the boundaries can only be fixed in rela-tion to the boundaries of other fields. Think of how the journey of walking through these fields make it impossible to say what in the last instance determines what. Think about mapping.

Writing isn't to do with signifying but with surveying, mapping.

Difference: a making through breaking, a proliferation. Yet there are lines which do their utmost to halt the proliferation. There are lines

which insidiously set all in motion for the same to return. And perhaps the more there is proliferation, the more difference is worked upon, the more less is taken for granted, the more these lines will attempt to close in and close off.

' ... there are lines which are monsters.'

There are lines which attempt to rule as if they can totally delimit a field, beginning to end. But even the most ruling of lines knows not in advance quite which direction a line will take.

Resistances: are they not experiments along particular lines?

It is not that we establish the fact of our identity through a play of difference, rather, it is that we are that play of difference. The difference that we make and break is the difference which we are. We make/break many lines. Vibrant lines, vibrating lines, lines of production, lines of pressure but also lines of song and dance. The lines are many and it takes a multiplicity of lines to make a specific line – a specific book, a specific practice, a specific fear, a specific love.

I can no longer believe in a wild unnurtured flowering outside the garden fence. The difference between the unbound and the bound has already been cut and dried. The wild flower has already been pressed inside the book. The un-bound, as the outside of the book, has already been pro- duced from within the book. The difference already belongs to the book: *it is enveloped, folded into, the possibility of its volume.*[2]

And as for the flower?

Are we to return to the flower still hoping that it will, at last, open up its metaphorical petals and reveal itself for what it properly is? Do we still hope that the 'proper' flower will finally make its entry?

There will always be at least one metaphor in excess when attempt- ing to encompass or reveal all that which is, properly speaking, metaphor.

The 'metaphor' of metaphor can only be located metaphorically.

The flower is irreducible.

Re-visions

Re-visions. One could re-turn, go back and have another look. One could turn the clock backwards. With eyes wide open and crystal clear, one could re-view, look again. One could make a re-visit; en route revisions could be made. Then one could tell the correct version, the authentic story. One could tell how it really happened.

Telling the complete story, the full history, would be grand. That would be a grand narrative. A narrative in full proportions, nothing left out. A main story with all its plots and subplots that in the end comes together. Achieving this goal would be one's success.

I could attempt a grand narrative. Some have thought it possible. I could pretend that I am in a science-fiction. I am time travelling. Suddenly I am in the eighteenth century. It is France. I am a great mathematician. My name is Pierre Simon de Laplace. It is a day when the sun is shining and I am feeling on top of the world, I say: 'Given for one instance an intelligence which could comprehend all the forces by which nature is animated and ... sufficiently vast to submit these data to analysis – it would embrace in the same formula the movements of the greatest bodies of the universe and those of the lightest atom: nothing would be uncertain and the future as the past, would be present to its eyes.'

The grand narrative: isn't it already a fiction? I can pretend that a grand narrative is more original, more true than any other. I can pretend that it is truly grand, beyond fables, myths and legends. Yet, as with fairy

tales, there is always some pretence. The grand narrative can only *pose* to be grand. One could attempt to tell the whole story but one would find that there is never just one story. *One* is already many. Many stories that can never be spoken of in a single line.

History never goes in just one direction, a single line along which points can be plotted, the one after following on from the one before – the ancient, the modern, the post-modern. There is no overall uniform linearity. The 'lines' go in many directions of which not all can be followed or known at once.

The grand narrative can never be completely achieved. There will always be gaps, parts left undone. The grand narrative is always breaking up into many little stories; little narratives which always remain partial and never reach a final, a once-and-for-all, point of closure or resolution. Partial narratives. Or, as some would say, *petit recits*.

How can I speak of just one history. And anyway, who has the singular authority to say, with all certainty, that there is one story which is, legitimately, the authentic one. I find that one is already many: re-visions in the plural.

Re-visions: a re-making, a making in the sense of a fictioning, something which is constructed. Aren't we re-making the story each time we tell it? The original, that which is assumed to come before, to be primary: isn't it already a fiction?

Perhaps it is always a question, even for that which poses as the unbiased record, or the impartial witness, or the factual document, of inventing stories, of *fictioning*. A good scenario, it has been said, need be neither original nor true but simply of strategic value in relation to the problem posed.

Re-visions: the *posing* of the photographic image; little stories; and the *acting* of a little 'I'.

A fiction called Re-visions:

A fracture appears in the seemingly smooth and transparent surface of the photographic image. The fracture (or is it a cut?) draws my attention to the photographic surface; no longer can I look through the photograph as if it were a window, a pane of glass which unobstructively allows a view outside to shine inside; to be plainly and truly seen. To be seen, that is, as if what were viewed were immediately present, positively gleaming, naturally so, self-evident, lacking nothing, obvious and whole: a scene where the window and the view appear to be on the same plane. There is a fracture, there is a crack: the window can no longer pass unnoticed. I notice that the window and the view 'outside' no longer appear as if they are both on the same plane.

1976, I write:

The photographic image offered as a document of life (as the way things are) maintains and perpetuates the illusion of the ideology of objectivity – the capturing of reality by the camera as the objective machine, the perfect eye. This ideology of objectivity leaves the method of representation unquestioned and thus conceals contradictions according to the empirical notion of truth and, as such, locates the viewing subject in a relation of ideological complicity.

1961, Roland Barthes writes:

(The) purely 'denotative status of the photograph, the perfection and plenitude of its analogy, in short its 'objectivity', has every chance of being mythical (these are the characteristics that common sense attributes to the photograph).

I become aware of an interruption; I become aware of a break. I hesitate. No longer can I see the photographic process as a smooth and simple representation of something, a process which innocently or obligingly allows the presence of an 'object' to be repeated as if it were returning present, the same again. In short, a pure and simple denotation of reality, untouched by the means of representation or the workings, the manipulations, of rhetorical devices.

There is a break: no longer is there a moment of pure or brute vision where a true and certain, or literal, meaning is offered up by the visible appearance of the thing, the object seen.

There is a fracture: the question of rhetoric interrupts the smooth and transparent surface of the photographic image. A fracture. A break, a crack or perhaps a cut. I think to myself: the photographic image is not a literal representation of reality, the scene is more marked by metaphor than it would seem.

Rhetoric. Some would say, 'the art of fake speech'. Some would speak of artifice, of pretence, of acting and posing. Some would speak of the loss of authenticity.

1964, Roland Barthes writes:

Rhetoric ... the signifying aspect of ideology.

There is a fracture. I can no longer overlook the photographic surface. I become aware that the photographic process comes in between, that it intervenes, that it stands in the middle. In the middle ... the mediate ... the medium ... the signifier ... the means ... mediation. I become aware that the window frames, as it were, constructs, the view seen. Quietly I ask myself: as the spectator am I also framed?

There is a gap. No longer can I be totally sure of my position as a

viewing subject. No longer can I be sure that the image seen will allow me to go 'outside' of myself and return to myself, as if I were looking in a mirror. A mirror which appears to return an image of my whole self. There is a fracture. I ask myself: is there a loss?

There is a gap. I become aware that the window and the view outside no longer appear to be upon the same plane. I become aware of a difference. I become aware of a separation, indeed, an absence. The photographic image appears to stand as a representation of something in its absence; it appears to stand in for, to stand in place of, to replace. The photographic image appears to *frame* the presence of a present in its absence.

1984, 1 write:

Believing that representation comes forward only in accordance with a certain absence, believing that it borders upon a 'minus' presence, we assume that representation forwards a frame and in so doing makes its appearance in front. Believing that representation presents a front, we assume that it establishes a limit, a frontier, as it were, *a line in the middle*. Moving along this line we assume that we are at the very edge of the frame: it is assumed that representation constitutes a surface beyond, behind or below which there is another level. We believe that the surface is not the same as this other level.

Assuming that the photographic image comes in between and presents a front, am I to believe that the photographic image forms a cover ... a mask or veil? Does the photographic surface cover over, conceal or hide something? That which mediates, does it mystify? Is the image a mask which perverts a basic reality ... an evil appearance? I am reminded of the Marxist line which says that appearance and reality are quite distinct things. I ask myself: does the appearance of the image mark the disappearance, the absence, of that which is essentially true or real?

1981, I write:

Hidden behind all the so-called appearances, all the images of the feminine, is there a body of truth which is concealed, a body of truth which has been pushed behind and so forced to remain a secret? Does montage have a secret to reveal? Does montage have a cutting edge?

The photograph no longer appears to be unquestionable, incontrovertible; many pressing questions pierce and cut it. I am reminded that in French *montage* means to edit. To edit ... I am reminded of the terms, the cutting room, the rough cut. I ask myself: is montage a tool which has a cutting edge which enables the image's surface appearance, its front, to be penetrated, to be cut through and broken? Indeed, is montage a weapon which enables me to battle through the image's front or mask and reveal truly what lies behind; to make visible, as it were, the invisible? Does montage enable the exposure of the device, the codes, the means of the image's framing?

1976, Victor Burgin writes:

The first requirements of a socialist art practice is that it should engage those codes and contents which are in the public domain. These present themselves, and thus ideology, as natural and whole; a socialist art practice aims to deconstruct these codes, to unpick the apparently seamless ideological surface they present.

My attention is turned towards the means of representation, towards that which mediates or frames. I think of a line in the middle. My attention is turned towards the question of ideology. Is the image's framing and forwarding of a front – or mask – a concern of the workings of ideology? Am I to say that ideology is a line in the middle which frames or narrates the world so that it is seen only in a particular way? Is ideology to do with surface appearance? Am I to assume that the real truth lies essentially outside of ideology's frame, beyond its front?

If ideology is a mask, then how come we accept it? I move along the following lines:

– Ideology perpetuates itself by way of a frame-up whereby I am taken in and seduced by appearances. In presenting a front the image creates such a spectacle of itself that it spell binds, enchants, captivates and overpowers the spectator. The spectacle, as it were, takes me in. I am, if you like, fooled. I am taken in because the spectacle appears to beckon or hail me as if there was a certain place or position waiting for me. I am made to feel special, as if I were the only one, the centre of the world.

There is a break. I hesitate. Am I to say that montage's cutting-edge does enable ideology's surface to be demystified and the truth to be unmasked? Yet, how am I to know if the truth, that which is said to be concealed, is being correctly, indeed, truthfully unmasked? Am I to assume that I can stand outside of and so remain free from, not taken in by, ideology's appearance, representation's frame?

1977, 1 write:

To pose the question, 'are we making the right, analytically correct reading?' must not be construed as 'the objective problems for ideology' which presupposes an objective disinterested stance. How can language, or the means which are used in an attempt to evince the roots of ideology, be bleached of their ideological content? Ideology is not illusion ... false consciousness.

1975, John Stezaker writes:

Kant said that 'if appearances are things-in-themselves, freedom cannot be saved' and generations of artists have hoped to assert this concept of freedom which constitutes bourgeois society by attempting to penetrate the realm of appearances, either by some objective grasp of reality or else to liberate their mode of expression from the shackles of socialized appearance in sublime formality.

I am no longer certain. I become troubled by the assumption that montage is a weapon or tool which enables secrets to be unmasked and surfaces to be penetrated. I ask myself: what is being taken for granted when it is said that the truth or the essential is concealed? Is the truth as true, as pure and free, as we believe it to be? Asking these questions, I ask myself: am I asking for trouble?

1979, I write:

As soon as woman appears on the scene there seems to be trouble. She is the riddle to be solved. The truth to be held. 'Perhaps truth is a woman who has reasons for not letting us see her reasons.' Let me say for the moment that the notion of the 'enigmatic femininity of truth' (truth as woman) says that woman is an outward sign of truth. A sign which says that somewhere there is a hidden but as yet secret truth. An invisible truth and a visible secret. The status of truth is secured or defined by the ability, indeed, the power, to see a secret as signifying the presence of truth in its absence. The possession of truth, the penetration of that which is said to conceal, becomes charged as powerful and thus defines or justifies the authority of 'having' the truth: the authority of the one-who-is-supposed to know.

1982, 1 write:

For long enough she had heard it said that with her appearance the truth disappeared, that it was masked. The fabulous feminine is deemed as all to do with making an appearance. Appearance, so says the truth, is secondary, merely an outer-covering to that which lies essentially beyond. Appearance doesn't come first. It isn't primary ... Is it truth's brilliant idea to plan it all out so that it does appear masked or absent when she makes her appearance? Maybe truth plans it that way so that it may better itself, save itself and so come again.

I pick up a photographic image. I hold it with one hand, with the other hand I run my fingers around the edge. The border, the frame, appears complete. A perfect rectangle. I ask myself: if I tear this image or cut into and remove part of it, will its seeming completeness be broken? Indeed, will the frame's rule be broken, and broken, will this draw attention towards the way in which images and representations frame the world, frame us? Breaking the limit or line of the frame, will this enable opposition to ideology's position? Naming this breaking or rupture 'montage', am I to assume that montage stands in opposition to representation? A rupture? Does such a gesture carry with it a certain radicality? Am I to believe that ideology has a certain continuity? Am I to believe that montage is a 'radical practice'? Yet, I ask myself: is this to assume that opposition to a certain position is free from, outside of, that which is opposed? How can I take it for granted that there is a realm which is free from and untouched by framing?

1982, I write:

The problem I find of setting oneself up as an opposition is the belief

that somehow you are different from, outside and the opposite of, that which you oppose – it is believed that there is a frontier which can be transgressed. But it doesn't turn out like that, for you find that you are always affirming that which is opposed. There is no other side of the frontier which is free: both sides are posited in one and the same instance.

1982, I write:

She had had enough, but leaving it all behind, making an exit from that scene so that somewhere else a true entry could be made wasn't that straightforward. The journey has a twist. It has a double-edge. As it turns out the outside returns to the inside ... The freedom of the outside is a ruse of the inside. That she is trapped by the frame; is this not a ruse? ... Who can say that beneath or beyond all the layers that have been put upon her, there is something essential waiting to make its true and naked entry ... As if you can still expect to find the truth, clean and simple. And anyway, where would the naked truth be without that which is said to cover it up? The 'mask' provides the means whereby the truth may represent itself. Which is to say, that the truth is already within the means of its representation. Nothing stands apart from its representation within representation.

1978, Michel Foucault writes:

Are prohibition, censorship and denial truly the terms through which power is exercised in a general way, if not in every society, most certainly our own? Confession frees, but power reduces one to silence; truth does not belong to the order of power but shares an original affinity with freedom: traditional themes in philosophy which a 'political history of truth' would have to overturn by showing the truth is not by nature free ... but that its production is thoroughly imbued with relations of power.

There is a break ... I pause. I come to the question: is not truth's positive identity established by way of its negative, its *other* – fiction, fantasy, ideology?

Breaks appear. How am I to believe that there is a presence – be this called the essential, the truth or the real – which remains behind, albeit hidden, the image's front? How can I say that a realm exists which remains, in the last instance, outside of representation's frame? The outside of the frame is fictioned, which is to say, produced, by representation itself. Which is to say that the presence which representation is assumed to front is an 'effect' of representation itself ... Am I to speak of a fraudulent frontier which only stimulates a presence beyond?

1983, 1 write:

Although we may protest against the so-called facade which representation puts before us in framing the world has it not been this

very front which has allowed us to assume another side. Indeed, has it not been this front which has allowed us to assume that the real world is on another plane? ... It has been representation which has afforded us a presence beyond representation.

1978, Jacques Derrida writes:

It could be shown that all the names related to fundamentals, to principles, or to the centre have always designated an invariable presence – *eidos, arche, telos, energeia, ousia* (essence, existence, substance, subject) *aletheia,* transcendentality, consciousness, God, man and so forth ... a central presence which has never been itself, has already been exiled from itself into its own substitute. The substitute does not substitute itself for anything which has somehow existed before it. Henceforth, it was necessary to begin thinking that there was no centre, that the centre could not be thought in the form of a present being ... that it was not a fixed locus but a function, a sort of non-locus in which an infinite number of sign-substitutions come into play. This was the moment when language invaded the universal problematic, the moment when, in the absence of a centre or origin, everything became discourse – provided we can agree on this word ...

I construct images. I cut up images. I make assemblages. I make many cuts. As I cut it is revealed that behind one image there is but another image. One representation but refers to another. The situation appears open ended. The line in the middle, the mediate, the narrative, appears to continually break into another line and I never come to find that which can be called whole. As I cut it is revealed that there is no proper literal truth which has been masked by the image's front. Behind the photographic surface there isn't a sure and whole reality, a substantial depth.

1966, Jacques Lacan writes:

... the metonymy of the lack of being ...

There is a break. The issue of the mask, the front of the facade, of that which comes in between, becomes suspect. I ask myself: if the mask is removed and it is revealed that there is nothing behind or underneath, except perhaps for another mask, then surely the mask becomes questionable as a mask? Or, is the mask brought into play to cover up for the absence, the lack of, a basic reality – the absence of that presence which had been assumed to be behind, prior, to representation's front? Am I to lament a loss?

1983, Jean Baudrillard writes:

... the affair goes back to religion and the simulacrum of divinity. 'I forbad any simulacrum in the temples because the divinity that breathes life into nature cannot be represented'. Indeed it can ... The iconoclasts ... rage to destroy images arose precisely because they sensed (the) omnipo-

tence of simulacra ... and the overwhelming, destructive truth they suggest: that ultimately there has never been any God, that only the simulacrum exists, indeed that God himself has only ever been his own simulacrum ... One can live with the idea of a distorted truth. But their metaphysical despair came from the idea that the images concealed nothing at all ... The iconolaters ... they already enacted his death and his disappearance in the epiphany of his representations (which they perhaps knew no longer represented anything, and that they were purely a game – knowing also that it is dangerous to unmask images, since they dissimulate the fact that there is nothing behind them).

1983, Don Slater writes:

In the twenty-first century representation is now not a way of knowing about objects in the world but a play of signs which ceaselessly creates, recreates and renews objects ... an explosion of signs without escape, without means of exit. Behind the photograph there is no real object, only another image (even if this image happens to be in the form of a commodity, or an unemployment figure or a Falklands war). We consume photographs of photographs of photographs.

1982, Victor Burgin writes:

There is absolutely no hope of a privileged position exterior to ideology from which we can view and correct it, and come up with our own, 'true' version.

A break appears in the photographic image. There is no original presence of which I can be sure; nothing is fixed for certain. I think of the absence of a presence which has never been. The story never seems to end, on and on representation goes ... there is only the signifier, only the means, only that line in the middle which has no definite beginning or end, no subject or object. 'I am' only an 'effect' of representation. My being-present, being self-present, being all and lacking nothing, is a fiction, a fantasy; it is imaginary. I ask myself: does the image centre upon an abysmal lack, an essential absence? Am I to see absolutely nothing where there ought to be at least some thing? I ask myself: do I fear that representation only simulates the presence of the represented? Do I fear a lack? Proper names, all that which was taken as designating a proper presence: are they frauds, only simulating a presence beyond?

... representation will be the death of me.

There is no essential presence yet is this to be swopped for an essential absence. What is the difference?

1983, I write:

I walk in the sun. I can say that the shadow before me, moving as I walk, represents or signifies my presence. However, only if there is representation will the presence be. My shadow exhibits the lack of 'my'

presence, yet it is this lack, this absence, which comes to stand for 'my' presence. And then I can only have the assurance of a presence if I fear the lack of that presence. (Think of the dread inspired by the existence of a shadow which refers to no-one, nothing). My god! how much longer will we allow ourselves to be tyrannised by the fear of the loss or lack of that which makes us a whole presence?

There is a break. There is a split. I can only be (even if this is only ever an imaginary being) if I also not-be. Am I doomed to be forever cut-off from, lacking the presence of, that presence which has never been? ... Trying to grasp a shadow; as soon as it is seized it vaporizes and you are left holding nothing in your hand. How strange this story seems. It seems that we are caught up in a scenario where we fear the lack of absolutely nothing. I ask myself: if you say you're a woman, what have you to lose?

1966, Jacques Lacan writes:

... the metonymy of the lack of being ...

So, am I to say that images are substitutes which substitute for that which has never been? As substitutes are images something of the order of a fetish, that which is brought in to cover up an abysmal lack. Do I desire a presence because, essentially, it is lacking? Is desire dependent upon lack? Is the desire for a presence born from the 'abyss of representation'? Is all desire, then, desire for images, or even, images of images? Does the photograph depend upon an abysmal lack?

1984, I write:

Although there is no such thing as the presence of a whole and total self, am I destined to be forever ringed and trapped by its lack? Is the lack a trap? That I am cut-off from something which would allow me to become a totality, that this subject is the object of (my) desire: is not all this a form of blackmail, a contemptuous trap?

Breaks appear. So many stories have been told. I have heard it said that the part which stands for the absence of the whole is that which marks the difference between the part and the whole. I ask myself: does difference depend upon a telling absence, indeed, a lack? I hear the words, *is this all the difference there is?* Is there only one difference? I think of the part which woman plays within scenes of representation and difference.

I question the difference.

I play upon the difference between the photo and the graphic. I play upon the difference between the surface and the depth. I play upon the difference between the photo and the text. I bring text and image together. I keep them apart. A 'correct' way can no longer be assumed. I experiment. I do not know in advance what the outcome will be. I find that I cannot

speak with all certainty of the difference. I question the difference between the part and the whole: I question the notion of fragmentation.

1983, I write:

Assigned a lack, the representational part refers to something more and what could be more than the part but the whole. Withdrawn from the part and creating a lack, the whole, in the name of its absence, totalizes the parts and so forms a constellation of which it is not (a) part. There has never been anything wholly whole about the whole; it depends upon lack of completeness ... To assume fragmentation is to remain beholden to that deceptive absent whole.

1972, Gilles Deleuze and Felix Guattari write:

We know very well where lack, and its subjective correlative, come from. Lack is created, planned and organized in and through social production ... It is lack that infiltrates itself, creates empty spaces, and propagates itself in accordance with the organization of an already existing organization of production ... The signs themselves become signifying under the action of a despotic symbol that totalizes them in the name of its own absence or withdrawal ... There desire is necessarily referred to a missing term, whose very essence is to be lacking.

Who can ever have the last word on lack? There is no way that the story of lack can ever be completed. But was there only ever one story? Lack: is it not a fiction? An essential absence: is it not a fiction? Has not lack always been produced, which is to say, constructed? Has not lack been production's growth?

If there is no place where we may oppose or resist a position without being touched by that position, if there is nothing behind the mask, front or facade of the image, if one representational part breaks into another, then are we now completely and totally framed? Am I to say that all is now totally ideological? Nowhere to hide ... Nowhere to run ... No means of escape ... No definite inside or outside ... No proper exit.

1984, I write:

We fear that all has become one dimensional. All has become flat. No mask to remove. No essence to reveal. No chance to transcend. No chance to play at God. No chance to play at the Newtonian observer, the Cartesian master-mind. Complete mediation, is this what we fear?

Many breaks appear. If both sides of the frame (of representation) are posited in one and the same instance, if there is no beyond where things can present themselves 'unframed', then the frame begins to warp. Like wood, the frame – the line in the middle – begins to break up. It breaks into many partial lines. Yet, this isn't a question of a lost or unlocatable reality, nor

is it a question of fragmentation, of a whole which has been shattered to bits; rather, a question of the movement of lines which by way of their partiality continually break and make another line. I ask myself: isn't reality a fiction, which is to say, a line which is *made* and which can be *broken*?

1983, I write:

If a representation ceases to have any reference to anything beyond representation doesn't representation fall flat, spread out and become a question of the horizontal movement and assemblage of parts?

1979, Jean-François Lyotard writes:

The narrative function is losing its functors, its great hero, its great danger, its great voyages, its great goal. It is being dispersed in clouds of narrative language elements ... Conveyed within each cloud are pragmatic valencies specific to its kind. Each of us lives at the intersection of many of these. However, we do not necessarily establish stable language combinations, and the properties of the ones we do establish are not necessarily communicable ... Most people have lost the nostalgia for the lost narrative.

I can continue to bewail a loss. I can bemoan the loss of authenticity. I can say that there is no 'point'. Yet, I can ask: what of a strategy of non-pessimism? There isn't a final point – be this called truth, reality or myself – of which I can be certain, yet am I to fear this as a depressing lack? I think of montage working upon and moving with, as quantum physics would say, a principle of uncertainty.

1982, 1 write:

I would say that the politics of montage concerns the way in which we take up with practices (literature, science, art ... sex) as assemblages, indeed, montages and not monolithic wholes. I would say that montage concerns the way in which we take up with heterogeneity.

1972, Gilles Deleuze and Felix Guattari write:

The theory of proper names should not be conceived in terms of representation; it refers instead to the class of 'effects' that are not dependent upon causes, but the occupation of a domain and the operation of a system of signs. This can be clearly seen in physics, where proper names designate such effects within fields of potentials: the Joule effect, the Seebeck effect, the Kelvin effect. History is like physics: a Joan of Arc effect – all the names of history, and not the name of the father.

Science is never a matter of literal facts. Think of its metaphors. Think of its rhetoric. Think of those particles which are fictioned, invented, by such names as 'strangeness', 'charm' and 'beauty'. No longer can it be assumed that reality is waiting to be seen, seized and possessed – to be captured.

1984, I write:

We can no longer represent the world in the way that we thought we could. Is there one single image which can represent the world? All those films, videos and photographs are not 'windows on the world' (even though they may play at being such windows); they don't represent the world; they form involvements. Images play a crucial part. Images do change the world.

1977, John Ryan writes:

To interpret the world, to perform the rhetorical exercise of naming things is, in a sense, already to transform it. Nietzsche teaches, if anything in *Ecce Homo,* the rhetorical nature of the world and the capacity of rhetoric to change it ... To debunk rhetoric because it is inauthentic, insincere, a pose and act, is to overlook the fact that the concept of authenticity is itself a rhetorical act. Every pose, even the pose of authenticity ... poses something. Every act acts, even if it is only to pose itself as an act. The actor always performs, although you may not know it until later, until after the sun has gone down.

Notes Chapter One

Double-Edged Scenes

1. See Jacques Derrida, 'White Mythology: Metaphor in the Text of Philosophy'. 'Metaphor is ... classified by philosophy as provisional loss of meaning, a form of ecomony that does no irreparable damage to what is proper, an inevitable detour ... being necessary to the extent to which a detour is a return tour guided by the function of resemblance ... under the law of sameness.' Originally cited from *New Literary History*, vi,/1, Autumn 1974, p 73. See also *Margins of Philosophy* translated by Alan Bass, University of Chicago Press, Chicago, 1982.

2. See Jacques Derrida, 'Edmond Jabes and the Question of the Book', *Writing and Difference*, translated by Alan Bass, Routledge & Kegan Paul, London, 1978, p 76: 'But – and this is the heart of the matter – everything that is exterior in relation to the book, everything that is negative as concerns the book, is produced *within the book* ... One emerges from the book only within the book, because for Jabes*, the book is not in the world, but the world is in the book.'

*Edmond Jabes, *Le Livre des Questions,* Gallimard, Paris, 1963.

Open Rings and Partial Lines
1983–1985

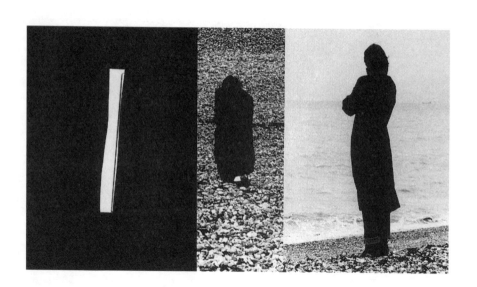

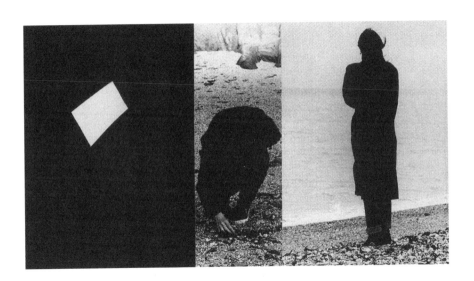

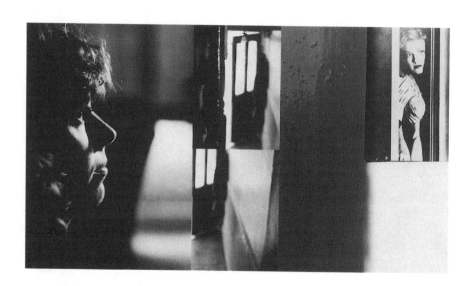

Chapter Two

Future Politics/The Line in the Middle
&
The World is a Fabulous Tale

1985–1989

Future Politics/
The Line in the Middle

By way of an introduction

I, like many others, have searched for a point of certainty. Yes, I hoped to find it and I was innocent or arrogant enough to think that I could find it, but I could never have found it. But still I searched. I journeyed. I felt that whilst it remained missing I too would be missing something. I feared I would be incomplete. I feared I would be lacking.

I was haunted. There was something other in my life. I longed for this other; it was the object of my desire – an object which could only be referred to as a missing term.

At times I felt keen: I was a sleuth; I observed and took note. I felt confident that I was on the right track. I had my theories. At other times, however, I felt a wretched creature, ridden with guilt and an overwhelming sense of inadequacy. I was all over the place. I felt scattered.

I feared the absence of the missing term. Yes, I feared my lack. The absence was intolerable. The more I searched the more I missed the missing term, and the more I missed, the more I felt an aching lack. And the more I ached, the more I felt compelled to search for the health of the whole. The gravity of the missing term was, at times, so strong that I felt it must be a 'massive body'. How little I felt. The missing term became gross and I was caught in the curvature of its space.

How was I to know when I arrived at the point of missing term? I

could have been dogmatic. I could have said that I know that I have the knowledge to know. But I couldn't pretend.

All that I could know was the mark of the missing term's absence. That mark was the only clue, the only line, I had to follow. This line was my only link to the missing term, and as a link, as a line which comes in the middle of two points, it appeared to promise a future prospect. Surely this line would provide me with a means of passage to the point of the missing term?

I felt compelled to follow this line.

I searched through books. I wrote many lines. I scratched around. I chased after words. I tried to pin down concepts, but butterflies in the wind, they remained only metaphors. One metaphor only led to another: I was never to find their roots. One clue only led to another clue: I studied the signs but I was constantly deferred. Indeed, I was constantly transferred: my search was metonymic. Yet the parts never returned to the whole; they never came to finally rest. I tried to cast anchor but I was always having to move on. The ships past in the night and I missed the point of the missing term.

I was not to be at one with the other. Not at all; for, the line which appeared to provide a link to the missing term opened up an abysmal lack: it stood as a signifier of my lack. A stroke right through the middle which constantly reminded me that I was cut off from the missing term. The link became a frontier; it became a divide.

I felt split in two: the link was also a limit. Although it appeared to give me an opening, this opening opening was barred. Yes, you can go but stop, no. I felt prohibited. My lack hung heavy: the line which was a link was also a bar.

The missing term was barred yet it was this very prohibition which allowed me to assume that it was there. Surely there must be something beyond the bar, if not then what is the point of the bar? This was the logical story that the bar told and how could I not listen?

Yes but also no. I was divided into two.

I was given a fullness and simultaneously denied it. I was afforded the 'complete object' of my longing yet forbidden it. I was moved toward the place of the missing term and yet I was forever carried away. I moved back and forth between these two poles.

I was going round in circles. Perhaps I was spinning towards one of those 'missing' black holes the presence of which opens up an abysmal absence – a void which devours the light of day. Was the bar a ruse? Was the lack a trap whereby I was to be caught in a vicious circle and rendered motionless?

That I was cut off from something which would allow me to become a whole, that I must express myself as a whole and total subject, that this subject was the object of my desire: was not all this a form of blackmail

which left me spinning? Was the very possibility of reaching the point of the missing term excluded from the start? Had the missing term ever existed before its barring? The bar, I feared, concealed nothing at all. The prohibition was a fraudulent frontier which only simulated a territory beyond. It was that signifier of lack, that mark of absence, which constituted the 'presence' of the missing term.[1]

Just when it is thought that we have progressed to the zenith of our modern world, a sudden wind picks up at midday: the sound of the signifier becomes a howl, an endless reverberation; the world, we fear, has become hollow. At heart, representation is not based upon the presence which we assumed the means of representation were representing. There is no presence immediate unto itself, there only is the mediation of the means.

From now on nothing remains independent of its representation within representation. Nothing comes before, everything comes after. We are living in a 'post-' world, a world without a solid centre or fixed reference point: a world without origin. The presence of a point of certainty has ceased to shine.

The means no longer follows a line which comes between – in the middle of – two fixed points or poles. We fear there is no beginning, no end.

No longer can we assume a linearity which brings the future straight into perspective. History is going nowhere; it has ceased to march to the same tune. There is no future forward. No avantegarde. No vanguard. No army of the future. Without a straightforward linearity who can say who heads the line?

The pied-piper of the signifier played an enchanting tune. The children who followed its line were never to return and affirm the authority of a parental signified. The signifier has ceased to spring forth from a known descent; it has no lineage, no family tree. We fear that the signifier is a 'ringer' of an empty centre. We hear the howling signifier and we fear that we no longer know who 'we' are.

Concepts no longer can be proud of their pedigree. The tree of knowledge has been shaken; it ceases to be so well rooted that the power of its truth can rise up to the top and head the line. The trunk – the line in the middle – has become disconnected; it ceases to allow us to return to definite points.

From now on nothing remains natural beyond the frame. Every exit from the frame is already framed; the outside is already inside.

We are living in an artificial world, a most unauthentic world. The nature of truth is in the end constituted by fiction. Metaphor has no true and literal origin. The world has become wholly one sided. Nothing remains genuine. Images of images. The copies endlessly flow. We have lost a world where we can truly tell the difference between the original and the copy.

No longer can we tell the difference between either/or: the stroke through the middle – the limit between the two – has become double-edged.

No longer can the truth affirm its position by way of making ideology its opposition. Truth's singular power ceases to remain so proud; no longer can it delimit its totality by way of drawing ideology as its limit, its minus line. The surest path to truth has been crissed-crossed: we fear a plurality of lines.

Who amongst us can say, with all certainty, that the image is a surface, a front or facade, beyond which there is a higher or deeper level? All that which has been forwarded to play the representational part ceases to refer to anything beyond other parts. Who amongst us can say that politics is a front behind which there is the substance of a solid matter?

No one can continue to believe that politics forms a representational line which transmits and constantly refers back to the emanations of the mass of a whole body. The line ceases to be earthed; there is, quite simply, no other pole. Politics is everywhere, yet ultimately coming from and going to nowhere.

We fear that now there is only the mediation of the means of representation. The line – in the middle – has broken through the points we believed held it in check; it is extending in so many directions that we fear the world is splitting apart. We fear the lines will move faster and faster. We fear their speed will prevent us from standing still and prolonging our gaze. Too fast we fear to stand still and see all.

The eye which appeared by dint of nature to be made for the truth loses its privileged position. No longer is there a vantage point from which true clarity emanates. No longer is there an extra-dimension from which we may stand firm and gain an overview. The objective gaze has lost its penetration. There is no true outside whereby one can stand apart and delimit a totality. All has become one dimensional. All has become flat. No mask to remove. No secrets to invent. No essences to reveal. No chance to transcend. No grand idea that can round up all the particulars. No totalizing theories which can sum up the world. No chance to play at God. No ground upon which to stand and firmly form those first and last principles. No chance to play at the Newtonian observer, the Cartesian master-mind.

From now on nothing remains sacred. Nothing can remain apart. Nothing will fall from the sky under the guarantee of a superior transcendence. Nothing will remain substantial at bottom. An unmediated presence no longer can raise its head and stand proud; perhaps we fear this has become a *missing term*.

Complete mediation.

Is this what we are to fear?

Are we to say that the *line in the middle* has taken a sudden curve? Are we to speak of a critical turning point which constitutes a crisis? Are we to speak of a 'crisis of representation'? Are we to say that the

representational line has circled around and opened up an abysmal void? Are we to say that now there is only an empty centre from which there is no way out, only a future revolution turning down and, without a solid centre, turning in? Are we to turn all around and say that minus the presence of the whole we wholly lack?

What a sad logic!

Are we never to let go?

Although there is no complete totality are we doomed to be totally ringed by its lack? There is no definite limit which affords a horizon, yet are we destined to suffer the lack of a rising political sun?

History no longer advances along a straightforward line, yet are we doomed to return to the circle? Indeed, are we to return to those rising and falling cycles which devour their own creations?

Although there is no such thing as a whole and total self, a complete subject, am I destined to be forever ringed and trapped by the lack of its presence? Although there is no immediate presence am I doomed to be haunted by its absence?

Am I doomed to fear the lack of the unmediated; am I destined to follow that line? However, if there are no fixed poles or points a line is no longer destined to mediate. Without the beginning and the end, a line never mediates; it never forms a medium line. Without any polarity between the One and the Other the issue of mediation loses its direction.

Without its polar other the signifier has no meaning whatsoever. Without a point beyond representation the terms of representation cease to apply. Without depth below how can we speak of the surface?

Without fixed poles the line in the middle breaks into a *partial line.*

If there is nothing to transgress in a limit, if both sides, outside to inside, either/or, are posited in one and the same instance, if there is no pure beyond where things can present themselves 'unframed', where we can be true subjects in whatever form that may take, if we say that this is a trap, an enchanting but vicious circle which rings us with lack and guilt, then the frame, the 'politics of limits', takes a twist. Like wood, the line in the middle warps and begins to split.

Without beginning or end, the line in the middle remains open to breaking into and becoming other lines. No, not a question of fragmentation, of a whole which has been shattered to bits; rather, a question of the movement of lines which by way of breaking constantly make another line. The whole can no longer play its game of hide-and-seek: a broken line is still a line.

A partial line is always breaking into other lines; it is always partial to other lines, always part of, and so involved with, other lines. The formation of a specific part always involves other parts. Think of how the self involves many parts. Think of how these involvements are never, without the introduction of a gaping lack, reducible to just one part. Think of how

economic lines involve all sorts of lines – visual lines – audio lines – rigid lines – supple lines.

Think of how the human is made up of many parts which in themselves are not essentially human. What we call the individual is made up of many parts which are not solely individual. The individual is an *assemblage* of many diverse parts. That is to say, a part which is made up of the parts of other parts.

No, not a question of what a part 'represents'; rather, a question of the affectivity of a part. A question of what is caused to be moved. Think of an assemblage, or 'involvement', as a composition of parts moving/affecting/effecting other parts.

Think of the line between either/or breaking into lines which are neither/nor. Think of when the image ceases to oscillate between either mask or mirror. Think of when the image no longer is taken as a surface appearance. Think of when it is no longer a question of appearance as opposed to essence or depth. Neither/nor: think of lines moving on the slant. Think of lines breaking in the middle and making many partial lines.

No, not a question of a lost or unlocatable reality; no, not a question of total mystification.

When I cease to fear the lack of the whole the world breaks into a multiplicity of parts, which, in themselves, remain open and slanted towards other parts. That is to say, parts which neither form a closed and complete whole nor, in remaining open, exhibit the lack of the whole. Neither plenitude nor vacancy. Neither whole nor fragment.

Is it too difficult to think of that which is neither/nor?

We may think of neither/nor as neutrality or indifference; however, with partial lines there is always a *partiality*. This is, as it were, their politics. We can't ignore the *bias* of partial lines even if their slant makes for a miserable connection.

Partial lines are constantly interconnecting with other lines: the assemblages which are formed involve differences which can no longer be lined up as just a matter between two, as with the difference between a position and an opposition, as with either/or. The involvements which partial lines form are very much a concern of the differences of many. Without recourse to a whole One, which by way of lack subsumes all the parts such that they reduced to 'the same', it is a question of the diversity and differences of partial lines. What is here referred to as differences is perhaps a question of the speed of partial lines.

Searching for the whole, or the essences of things, has always sent me around in circles. The difference between either/or has always trapped me in a vicious circle. But, even the oh so enchanting circle is only part of the many lines. The lines may bend, they may curve, yet they never form a completely self-contained figure. Partial lines never form 'proper' lines.

Twisting the whole back upon itself by questioning the fear of its lack. No longer playing the whole's game of hide-and-seek. Taking a risk. Daring to let go. The whole house shaking, splitting its sides. Laughter with a thousand edges, not merely the two sides of either negative or positive.

A 'thing' only becomes a thing by way of its involvement with other things: a moving map with many entrances and exits. We can only ever know something partially. We can never stand apart: we too play a part.

Just when we think that we are right in the middle of an economic line we find that this breaks into a sexual line. Partial lines involve the possibility of many lines. These are, as it were, its probable lines. Who amongst us has the arrogance to say that they know in advance which way a line will go? The outcome, the future, is inherently uncertain but this is not a deficiency. No, not a lack of knowledge. The involvements which make/break are never totally certain. Partial lines are always spreading out; their partiality forms waves *of probability*.

No longer stuffed full with the fruits which have been gathered from those well rooted and branching trees of knowledge, no longer bloated with the pride of a totally certain knowledge, moving with a *principle of uncertainty* as regards the future outcome, it becomes a question of prudence – a politics which is wise of the uncertainty. A *slantwise* politics. A politics which no longer plays ball with lack. A politics which doesn't set all in motion to circle around and make of itself a proud position by way of its opposition.

A slantwise politics: a politics which doesn't pretend to know all.

The outside and the inside no longer have any meaning. Of course we shut doors and open windows but the self isn't solely housed inside the body. The body – that too is an open part. Think of a body where the organization of parts are not circumscribable in terms of a beginning and end. The multiplicity of the body is vast, never a thing-in-itself.

An involvement, or assemblage, isn't concentrated in just one place. Indeed, it isn't a matter of picturing an assemblage as occupying a contained space; it isn't a stage where parts wait in the wings to make their entry and reveal their presence. An involvement has no reference point beyond itself. There is no extra-dimension where one part can go to extrapolate itself, rise above, and play the determinant sovereign part. The conditions, or determinations, which transform an involvement always come from the slantways movement of partial lines. The uncertain part plays a very definite part.

Uncertain parts are not hidden secrets awaiting discovery, nor are they underlying essences which require revelation or liberation, nor are they mysteries, 'irrational forces', in need of the correct interpretation. On the contrary: they are the multiplicity of lines into which a partial line is capable of breaking.

An involvement is such a multiplicity.

To ask how one part affects another. To ask what moves. There is movement even if there is so-called stasis. It takes a lot of movement to stand still. The seemingly unmoved part also plays a part. Involved with the movement of parts is not a matter of extolling activity and bemoaning the unproductive, the listless or the passive. When something breaks down an involvement is also working. Think of Murphy's law. No, it isn't a matter of beating the drum and rolling out the names of those who are on the active list.

Neither the active and the passive, nor theory and practice, can continue to roll between the two beats of the drum and move 'on the double'. The last and the first are all mixed up in the middle. History no longer marches and falls into line.

An image can move whilst appearing to be very still. There is nothing frozen about the the still photographic image. And there is nothing smooth as regards the movement of partial lines. They are not serene flows. Although there is serenity there is also surface tension. Think of how the oil and the water don't mix yet still form an involvement. Think also of friction. Think of the rub. Think of how some involvements can be very warm.

What gives? What flows? What is the distance? What is the speed? Who is measuring what by which clock? Is the time running fast or is it slowing down? What makes for the comparison? What breaks? What do we fear the most: the speed of lines which are too fast to see or the thick and sweet equilibrium of a stone sinking through treacle?

A linguistic line breaks into a sexual line which breaks into a visual line. Economic parts involving the animal parts and the winds and the rains and the technological parts. The human is involved in a multitude of non-human parts; these are not its extensions, nor are they its production. Think of how the cat selected the humans. Music and money and the birds and the earth. History never moves in just one direction. Are not our memories lines breaking into and making other lines? Some moving so slowly that they appear to be distant, a long, long way off. Others coming thick and fast; so fast that the distance shrinks and it seems they have come from nowhere. The original line never returns the same. Remember that the so-called forgotten also plays a crucial part. There is no universal same moment.

Partial lines. Particulate lines. Particles but never essential or elementary things. Not a thing which has intrinsic properties independent of its environment. Not a thing in the classical sense. Things are not well-formed wholes, even though they may be as round as a ball. They too are open rings: interconnections between things which in turn are interconnections between other things.

If there are only these connections, without beginning or end, it may be said that the middle is everywhere, that all has become endlessly,

or perhaps divinely, linked; however, if there is no beginning or end there is no chain link: the lines break into an unholy mixture. Within this mixture, in the middle of it and no longer beyond it, we are, although we can make an appalling mess of it, participating in the world by way of the absence of a link. Which is to say, there is no divide between us and the world.

Without fixed points or poles a line never progresses in a linear manner; it never grows to become that proud and arrogant line of expansionism and conquest.

Neither a linear line nor evolutionary line; no, not a line of continuing economic growth.

There are many directions which the future can take. There is not just one future which lies ahead and which is waiting to make its appearance. There is no absolute 'before' and 'after'. The linear line between cause and effect is always warping. This is not to deny causality – that would be absurd, unless of course we are travelling faster than the speed of light. Rather, it is to be involved in the middle of things – the rain forests, the cities, the seas. The future involves many partial lines. A question of their partiality, their slant. The future is oblique.

Are we to say that time always follows a straightforward line? One, two, three: there is no absolute time. Time also also warps. Think of how it stretches. Time isn't a single one line. The motion, the flow, of time isn't always the same.

History is always in motion. Mutation. History is always altering its direction; it is made up of many different speeds. History no longer advances along a progressive line; it no longer follows a linear line which adds up to a 'better time'. One, two, three: progress has warped. No longer can we celebrate that we are moving on an upward line, but are we to turn this around and wail that we are on the decline? No longer can we produce the future in the way we thought we could, but am I doomed to suffer this as a turning down? Dare we never let go? The historical subject no longer works. More production ceases to promise 'the good life'. Production can no longer fulfil its historical mission, yet am I doomed to suffer this as an abysmal lack? Hasn't lack always been production's growth? Hasn't lack always been production's other side? Indeed, hasn't lack and scarcity always been produced?

Are we still praying for a messianic line to follow? Are we still caught between the cross of salvation and the circle of cycles?

There isn't a straightforward line whereby the future can be predicted, but this isn't to assume that we are going 'backwards'. Perhaps the future lies sideways.

We can say that what is real is the present – but to whose present are we referring? 'Pastness' and 'futurity' are variable concepts. The same moment in two places at once, the concept of simultaneity, has no univer-

sal meaning. What mechanism do we have to objectively measure the flow of time itself? Even the official timekeepers cannot be sure of the time. The clock which ticks and tocks only measures the intervals of time; it doesn't measure time's speed.

It may be said that the future is indeterminate, but this isn't to assume that it doesn't exist, that it is lacking: it is to say that the future doesn't 'naturally' or 'numerically' follow on from the present. It isn't to assume that anything goes, that all is arbitrary. I am thinking that the future is also a fiction: something which is made, fabricated, calculated and broken. The vision of the future isn't necessarily in sight. The Positivist's eyes can no longer lead the way.

The human part isn't the highest part. All can't be reduced to that anthropic part. Are we to make the dolphins 'speak' the anthropomorphic line? The human isn't the star part. Think of how our bodies connect with the ashes, the particles, of long gone stars.

We may seek the absolute truth of particles, yet the truth is many lines. Lines which are parts which are also waves.

No part can ever stand alone. The human part doesn't remain apart; it is a component part commingling with other parts. Each of us enters and becomes many assemblages. I can never stand alone. I am in the middle of many things; however, this isn't to assume that I am at the centre.

Whilst I take the human to be whole I am always haunted by the fear of the lack of the whole; whilst I take the human as having an essence I am always depleted by the fear of the fatality of losing it. The human subject isn't a whole; it isn't a self contained figure.

Pushed and pulled. We must resist the pull to become merely objects. We must push to liberate and express ourselves as full and whole subjects.

Must we?

Threatened and trapped by lack. A ruse or even blackmail.

A multiplicity of lines are involved within the 'media', yet let us not assume that these lines are extensions, parts of some (human) whole. An involvement isn't a question of one at the centre, expanding and extending itself in all directions.

We are not spectators in and of the world, no matter how much we rant on about 'the society of the spectacle'. Neither are we an incidental part carried along by the plot of a cosmic drama. Rather, we are a co-functioning part. Some involvements are spectacular but are we still to believe that there is 'a shadow of a hidden substance waiting in the wings to be liberated whole'?

How quickly I am made to feel inadequate when I can't recover and house the true line of my whole self. *I am then lacking!*

We may want to play statues, we may want to turn to stone, to

remain immutable, but magnified even a piece of stone is seething with movement. Think of how atoms turn out to be vast regions of space in which extremely small particles whiz around.

We are masses, and masses are never a solid matter.

In the so-called final analysis the particles of microphysics are not made of any material stuff. There is sensibility but the matter of substance no longer makes sense. Think of how 'accurate knowledge' of both the position and the motion of a particle is impossible, even in principle, at the so-called subatomic level. Uncertainty is an inherent property of the micro world; it can never be reduced to zero.

Science admits that there is no wholly objective knowledge within science. The 'objects' of a discourse don't exist wholly 'objectively'; the lines of the discourse play an affective part. Concepts and theories are partial, they too are biased. Although they can become proud and stand-offish, concepts and theories never can remain apart or be fixed with all certainty; they too are variable, moving and open to affection.

A concept doesn't represent a reality external to itself; it is, rather, a line which *involves* other lines. A concept isn't an abstraction which lacks, is the minus of, reality or the so-called concrete. Can reality remain a solid matter, a matter of fundamental material substances? The being of matter isn't independent of its activity even whilst standing still.

The abstract doesn't lack the concrete; it participates in the world. Are we still to involve ourselves with the abstract as that which separates life and concepts? Are we still to draw the abstract as a limit, a line in the middle, beyond which we take life to continue independently?

A concept isn't that which has had the life squeezed out of it; it is neither a dry husk or a transcendental form. Think of the life of a concept. Think of a non-organic life. Think of the speed at which concepts travel and the distances which they can cover. Think of the slow concepts which seem to be around forever. But they too are variable. Mutations. Alterations in direction. Think of the mutations of concepts such as *ideology, sexuality, biology, the individual, power and politics*. There is no pure being which heads the line.

I have enjoyed and have affection for many concepts and words. There are some concepts which are not much fun, but are we to assume that conceptual activity is the polar opposite of 'letting go'? Think of playing seriously.

When thought and feeling cease to be taken as polar opposites, when the difference between the two breaks up and no longer remains fixed, do we not have to take it seriously that we feel thought? Indeed, do we not have to take it seriously that a concept may sicken us, make us ill, or that we may fall in love with an idea?

Science never is solely a matter of literal facts. Think of science's abstractions. Think of all its metaphors. Think of those particles which are

made under the inventions of such names as 'strangeness', 'charm' and 'beauty'. Physicists invent and fiction many particles. Yes, reality does become a matter of invention when we cease assuming that it is 'out there' waiting to be seized, named and possessed.

Think of science's fiction. Indeed, think of those dark black holes which consume the light of 'literal' knowledge. Once devoured by a black hole no light can escape. Black holes, you could say, can only be spoken of metaphorically. Indeed, do they not disturb our notions of metaphor? Do they not meddle with those hallowed metaphors of light and dark which for so long have appeared as the literal references of all communication and knowledge?

Concepts don't exist upon another plane; they don't exist in place of things.

The line in the middle moving across.

The hierarchical stairs breaking into many flights.

Flights of broken lines: matter is not the polar opposite of the mind.

It takes the movement of many lines to make a specific line. Movement, yet not one line replacing, standing in for, or exchanging places with, another – as if space were an empty container and time a straight-forward line.

Relatively speaking, time and space don't remain independent of each other. They involve each other as much as they themselves are involved with the motion of the universe.

An assemblage, or involvement, isn't a stage, a three-dimensional container in which objects and subjects occur only to be replaced by other objects and subjects, all moving according to one set time. Time and space don't remain independent of the things which occur within them.

Within subatomic involvements there is motion but there are no definite moving parts, there is activity but there are no actors. The metaphor involved is that of a dance with no dancers. The two poles of subject and object become carried away.

However, let us not privilege or celebrate the microscopic line. Mass is a molecular notion but let us not assume that it is a matter of choosing between either the molar or the molecular. The molecular isn't opposed to the molar, nor vice-versa. Although they involve each other, they are not the same. The molecular world is not a 'Lilliputian' version of the molar or macro world. No, it isn't a question of two distinct levels, one large and above, the other small and below. No, not a question of the macro world as the land of giants where Subjects and Things are delineated, where desires are blocked and petrified. One is not the world of representation where things are framed and contained and the other where desire deliriously flows. The molecular world is not our escape world and neither is it our 'new wave' world. Although the macro world can be very dense, it is also very fragile. One is no more delicate, intimate or personal than the

other. The grain of sand upon the sea shore doesn't represent or contain the boulders of molar organization. The molar and the molecular are not a question of two different levels; perhaps they are a question of *different* speeds?

I am made of variously formed stuff. Yes, I can become stuffed full with subjectivity but never can I become a whole self contained figure. The whole, and its health, concerns many partial lines, even though the involvement of some can be quite appalling. I am attached to many lines which are made up of differing dates and speeds. The faster a line travels the more the distance shrinks and the time slows down. Even when we are very old many of our lines are very young. In old age we move very fast: we cover vast distances.

The difference between the beginning and the end warps. As with the serial line of a soap opera, the plot line breaks into many lines, each with their own dates and speeds.

Perhaps the world no longer can be pictured in the way we thought it could. Is there one single image which can 'picture' the world? How can I visualize that which does not conform to the lines of rectilinear geometry? How can I visualize that which refuses to be lined up within the terms of Euclidian space? Indeed, how can we visualize 'spacetime'. We can diagram it, yet how can we picture it? How can we picture molecular involvements? Perhaps molecular involvements are not partial to pictures. Perhaps the world has no image, least of all as a ball. To say this, however, isn't to assume that images play no part. Indeed, it isn't to say that they bear no relation to reality whatsoever, that they have drifted off in a nebulous state. Far from it. Images play a crucial part. Images do affect. They form many different involvements. Think of the different involvements which the photograph forms. Images do change the world. A question of their partiality.

No image can pretend to be certain yet this is not to assume a lack. Think of images moving on the slant: think of images which are wise of the uncertainty.

All those films, videos and photographs are never simply windows on the world or mirrors of the soul. Yes, think of when the image ceases to oscillate between the two poles of objective representation and subjective expression. The documentary image has no more a direct link to the real hard stuff than does the expressionistic image has to the sensitivity of the soul. It isn't a question of a just link; it's just a question of the absence of a link.

Images don't stand between us and reality. The image is neither a divide nor a link. Images are not substitutes which stand in for things in their absence. Images are not substitutes for a 'living memory', and neither are words. The more the image is taken as a substitute the more we are returned to lack. And the more we are returned to lack, the more we

dare not let images go. We dare not let images become involved with the world. Indeed, we dare not involve ourselves with the image's involvement with the world.

Do we still fear that every fresh venture with the image is a plot against reality? Are we still to prove 'reality' by way of making the image its polar opposite, its minus, its lack?

Are we still to play that game!

There is nothing wholly certain as regards reality; yet, when we fear that this uncertainty constitutes a lack we return and attempt to seize reality and make it more real than real, as it were, hyper-real. Reality is not waiting out there to be seized and possessed. Reality is something which is fictioned; it involves a making and breaking.

Are we still to line up the imaginary as the opposite of the real reality? Why maintain this polarity? It will always send us round in a tiresome circle.

Isn't the imaginary a mode of calculation – that which involves itself with probabilities and uncertainties? And isn't such calculation a question of strategies? And isn't the formation of strategies a question of map making? The imaginary is inextricably bound up with the formation of assemblages and involvements. However, this is not to suggest that assemblages only take place 'in the mind'. The image, and the imaginary, is a mode of map-making; however, this mapping isn't a matter of tracing an assumed pre-existing territory. The map-making of the image is made with the world and it is this involvement which makes maps – images – both determinate and imaginary.

I am attached to many images. There is no pure image; it involves a multiplicity of things. No image can ever stand alone or close in upon itself like a full egg. An image has no sovereign presence. How can we ever fully know the size of an image? There is no single unit of measure.

Can numbers remain the universal unit, measuring all according to their position in a given dimension?

The image doesn't occupy a contained space.

Think of mapping the effects of images. Yet, isn't image-making already map-making?

Think of mapping the lines, the connections and parts, which are involved in the formation of the space which is called the art gallery. A part may seem to be so far apart, so distant, that its effects seem negligible; it appears to form no connection whatsoever. Yet, these 'nonlocal' connections, these negligible effects, are only partial lines moving very, very slowly. Moving faster, however, the distance shrinks and it becomes far more difficult to ignore the involvement of the nonlocal.

Think of making the art gallery a most untimely place. Think of making the lines break through and not settling for well-established points. Think of all the lines which are involved. Rigid lines – sexual lines – insti-

tutional lines – supple lines – saddening lines – electric lines. Lines of prejudice but also vibrant lines. The lines involved within the formation of the gallery space can never be contained in just one local place.

Is it too difficult to think of that which is a particular part yet also a wave. That is to say, rippling lines which spread out over large regions of space?

Partial lines are parts, moreover, they are also waves. Rather than isolated entities, things-in-themselves or immediate presences, these wave-parts are lines in the middle which, in themselves, are nothing but interconnections between still other parts.

An involvement or assemblage isn't a set of alternatives, an either/or choice; it is an overlapping combination of probable realities. We can never totally predict what will happen, yet this is not to say that anything goes; it is to say that what happens isn't brought about by local causes alone.

The gallery, the cinema, the book, the visual image, the photograph, the concept or the media: these are not closed spaces or containers with definite insides and outsides. Open rings. Which is to say that it is never a question of locating an alternative space. There is no other space which remains untouched, least of all what is named, beyond the frame, nature. No, it isn't a question of representational politics returning to a more 'natural' politics.

An assemblage isn't merely a local constellation of things. It isn't a local community. Can we reduce politics to a common denominator? Hasn't politics many names? No, it isn't a matter of choosing between global or local politics. Are we still to maintain these polarities? How quickly I am made to feel lacking or inadequate when it is said that I am not involved with the 'real' struggle. Perhaps the real struggle starts in the middle: a middle which has nothing whatsoever to do with being moderate, middling, average or easy going. Perhaps it is the most difficult *place* of all.

Who amongst us can say with all certainty that they know the right way? Can the Right say this? Without the one and only plan or theory which says that it knows that it is right, isn't it a question of a politics which is wise of uncertainty? Indeed, isn't it a question of prudence and experimentation, a pragmatism which, wise of the uncertainty, takes a risk, calculates and experiments without pretending to know, or control, the future outcome?

A slantwise politics: a politics that requires us to use our imagination.

There are no grand totalizing theories, no master ideas, which can today sum up the world and guide us on our way. Yet, are we to return and make of this a lack? Are we to return and make of this a *missing term*?[2]

The World is a Fabulous Tale

 is for abstraction. And why, you may well ask, should abstraction be placed in that privileged position which the Greek alphabet reserves for the letter A? Why should abstraction star as the first? A voice pipes up from the back of the room: 'But it's mental (sic) to put abstraction first. Abstraction doesn't concern real *things*. Real life, that's what comes first. With abstraction there is a withdrawal from worldly things. To say that A is for abstraction is to really upset the apple cart.'

Yes, I had thought it elementary that A is for apple. I had learnt that A, in designating apple, referred to the primary existence of the real thing in the world. The real thing, or *referent* as some might say. To say that the real thing comes before the sign, the abstraction which is A for apple, had seemed perfectly true to me. And now it seems that I have to eat my words and say that this is not so. Has someone, I ask, been telling tales?

 is for fiction (and also fable). As a child I was rebuked for telling tales. No matter who had done what, where and when, parents would sternly warn against telling tales. Playmates, moreover, would thrust their faces forward, glare and emit the following ditty: 'Tell tale tit, your mother can't knit and your father can't walk with a walking stick.'

Once upon a time, Plato, that most Grand Father of Western Philosophy, also warned against telling tales. For Plato, true philosophy did not tell tales, but poetry, on the other hand, could be accused of spinning stories foreign to truth. Plato's line, so I've heard tell, is that true philosophy rises above the charms and double-dealings of rhetoric; it neither tells tales nor practises the art of persuasion. The task of philosophy is to safeguard the truth from tall stories and the fabrications of fiction, which are the source of error, lies and illusion. The gates of Plato's ideal city are shut to those who spin yarns and tell tales: the poet is banished and fiction is relegated to the other side, opposite the truth.

Truth/fiction: a line is drawn and fiction is excluded from entering truth's domain.

Truth/fiction. 'Oh no,' moans the child, 'do I have to hear about binary oppositions again?'

'One', the adults reply ignoring the protest, 'has to draw the line. Truth is not fiction as A is not B. You have to sort out the difference between the one and the other. It's a matter of sorting out identity and difference.'

F is for fiction and I come to the telling of identity and difference. And so the story goes: A is for identity and B is for difference. A is for the one and B is for the other. As A comes first it follows that B comes second. And as B is secondary to A, a line can be drawn between the two; it follows, hence, that B is the opposite of A. On the one side A and on the other side B.

'Oh mother,' whispers the child, 'will I have to be either A or B, will I have to be either the one or the other?'

On the one side A, on the other side B and in the middle, a line. A/B. Whether visible or not, the line which comes in the middle of binary oppositions draws not only a limit separating the one from the other but also a minus line: A *is* not B. The line in the middle comes to mark the place of the other with a loss or lack. B becomes the minus, the negative of A. And so the story goes on: difference is the lack of identity, fiction is the negative of truth and abstraction is the minus of reality.

'Oh! Father,' exclaims the child, 'if I am to be B, how can I be at all?'

The animals went into the ark two by two and I may well say that B is for the binary tale where difference is told in terms of two. Yet within this tale of two only one is ever primary. The binary tale proceeds two by two yet for all the two's one *is* (hurrah! hurrah!) whilst the other *is not*. Truth is not fiction, the same is not difference and man is not woman. And so the story goes on. While the rains may fall for forty days and nights yet still 'as many dichotomies as necessary will be established in order to stick everyone to the wall, to push everyone in a hole ... '[1]

A is the primary one and B's difference is that it lacks A's prior identity: in terms of this logic it is identity which comes *before* whilst

difference follows *after*. Truth is anterior whilst fiction is posterior. A is for the ace whilst B is for the buffoon who has no true face. And so it goes: essence comes before appearance as reality comes before image. The sign follows after the thing as abstraction follows on from concrete matter.

Traditionally, truth is to be 'right'. When truth is missing there is 'wrong' and according to this logic, fiction (as the minus of truth) becomes open to the accusation of illusion, falsehood and lies. Yet it seems to me that before we can tell the truth we have to *tell* the fiction. Before we can tell the same we have to tell the difference. Before we can *tell* A we have to tell B.

It seems to me, and I make no claim to be an expert on the matter, that if there wasn't B there would never be A. Isn't B necessary for A to present itself as the first, the self-same? It seems to me that B's difference, its 'lack', serves to establish and affirm A's primary identity. In short, B enables A to return as A, the same.

Abracadabra: deny the presence of A and then its presence comes to be affirmed. Or, in other words, affirmation through negation. Perhaps a lack had to be invented, had to be 'fictioned' in order that truth could be affirmed as the primary one.

Affirmation through negation, or in other words: I am given you are not. I am Alpha, the One.

Alpha/beta: Greek thought would have us believe that truth or identity is an undifferentiated whole, the one. Yet perhaps the Greek alphabet knows only too well that the one can be understood only by way of the other, by way of differentiation. Alpha/beta: it is through beta, the second, that alpha can present itself as the first, the one. A may be for apple and B may be for ball but the one is not so well rounded at all. The discovery is not so very new, even Plato knew it: the one is already mediated by the other. Contrary to remaining exterior, fiction is interior to truth as fable is interior to science. Philosophy does not remain untouched by poetry.

A point is made: if you can never tell the truth without telling the fiction, if you demonstrate that the one is always mediated by the other, then it seems that we never come to arrive at the complete and primary one, the *whole* truth. We are, as it were, continually deferred from reaching the one in all its singular glory. The one is impossible to grasp; there is, if you like, an endless postponement.

Abracadabra: demonstrating the impossibility of grasping the one only comes to affirm its power and presence, albeit absent. Although we may never reach the one, the very idea of postponement posits a point even if we are deferred from ever reaching it.

The truth is dead: long live the truth. Oh! the world is a fabulous tale.

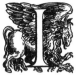 is for image (in all senses of the word). As a child I was greatly excited at the prospect of my birthday. The night before was invariably sleepless; I would lie awake imagining what the birthday would bring. What was it that I was looking forward to the most? Was it the present I so desperately wanted but wasn't sure that I would receive? Was it the favourite food that I could eat and eat and eat? Was it the cake that was to be baked and decorated with candles and my name? Was it the party where I could play 'postman's knock', a kissing and guessing game. Or, was it the birthday cards which I would receive through the post? (Oh, the thrill of those envelopes which bore the marks of having made a journey.)

On the 18th of December it is my birthday, the anniversary of the day on which I was born. Each year, on the same date, the anniversary returns. 'Many Happy Returns.' As the birthday cards are posted and kisses given again, is it assumed that the recipient is one who has also returned the same? Upon the birthday there is, so I am told, a returning to 'the day of one's birth'. Once upon a time, one day, there was a birth. And is this day returned to as the birth of a one? You may well say that such a one provides the birthday with an origin and point of return. In which case I ask the following question: is the image you have of the birthday one behind which there remains a primary and essential one? If you take such a one to be behind the birthday images or signs, all the cakes and candles, kisses and cards, if you assume that it is towards this one that you turn back, then it seems to me that images are taken as coming after, as *posterior*.

I have heard it said, often enough to become somewhat of a commonplace, that we live in a world of images. I have heard it said that we live in a world where images are posted everywhere.

I is for image, not only those which are photographic or chromatic but images in all senses of the word. And would you say that we live in the Age of the Image? And would you classify this as a *post-age,* an age where everything comes after?

In the late twentieth century, on planet Earth, we heard of a discovery: nothing solid or substantial stands behind the surface of the image. This discovery, which perhaps is neither so new nor so very extraordinary, finds that we earthlings can no longer be sure of a singular reality which comes before and remains outside of the image, appearance or sign. One of the theories we hear is that a real world is not waiting 'out there' to be reflected, represented or captured by the image. The very idea of an independent reality is thrown into question and things can no longer be proven in quite the same way. Indeed, it has been said that behind the photograph there is no essence – of truth, reality or referent – which provides its origin and point of return. And furthermore, we hear that the countryside which blows an air so fresh and natural beyond the billboards and city signs

is itself but another image. One of the stories we hear, one of the theories perhaps we fear, is that the *real world is a fiction*.

 is for the line in the middle and also for long, long ago. 'Fadófadó or a long, long time ago, if I were there then I wouldn't be here now; if I were there now and at that time I would have a new story or an old story, or I might have no story at all.' And so repeats the Irish story teller before the telling of the tale.

'Nothing solid or substantial stands behind the surface of the image ... the real world is a fiction.' And what may you make of these lines? What might be your interpretation, your story ... Perhaps you have a new story or an old story ...

One tale that may be told is that the very idea of some thing coming before and remaining outside of the surface of the image is only an effect of the surface itself. And again, this tale may be put another way, it may be told that it is the second which brings about the impression of the first as the original and primary one. Indeed, it may be told that the anteriority of the first is produced by the posteriority of the second.

From such a story told, the theory may unfold that we live in a postworld. We may easily agree that we live in a world where everything comes *after* before. Indeed, we may easily agree that we live in a world that is without origin. And as this theory unfolds, the story may be told that having nothing before we are left only with fiction and image, only appearance and sign. If the first is only an effect of the second, we end up, so it would seem, with just seconds. And ending up with seconds it would seem that we may as well start by saying that B is for beginning. In the beginning, the image. And taking B for beginning it may then be told that A is for absence. A no longer designates the apple, no longer 'refers to the primary existence of the real thing'. A great wind blows among the trees and everywhere fruits fall: A is no longer for apple but rather, absence. Yes, the theory may unfold as a tale of loss ...

Gone is the referent which came before and was the past of the sign. Gone is the prior reality which stood steadfast and remained independent of the image. Gone is the essence which waited to be discovered whole behind the front of appearances. The singular truth is fallen, anteriority is no more and gone is the unity of the one.

If A is for absence then I may as well say that L is for loss. Hearing that we are left with just images or fictions, just abstractions and signs, it is easy to conclude (once again) that something is missing, something is lacking, something *is not*. Indeed, it is easy to conclude, post-haste, that if there are just surface effects then there is no longer depth. The logic here (once again) is that if there is just abstraction then we are missing concrete

reality. Without the presence of that primary and original one all must be inauthentic.

It comes as little surprise to hear the logic that without depth, without an essence beyond, all becomes most flat and superficial. Depth disappears and decoration dances. Without reference to a depth beyond, signs only dance with other signs, images only refer to other images. And I must say that I am not astonished at all to hear the pronouncement that if there are only signs and surface effects then the referent, along with the real world and the documentary photograph, is no longer, is no more, is dead.

It comes as no surprise that within this tale of loss the logic should call for the conclusion that a prior and autonomous real world is no more, that the referent, amongst other things, is dead. The twist in this tale of loss is not just that the logic should call for us to pronounce the loss of the real world, the death of a referent which authoritatively came before, but also that it first requires us to agree that the real world or referent was really 'that' and *only* that.[2] We come to consent to a conception of a one reality as if such a conception were the only one.

Abracadabra: deny the presence of something, say that it is no more, and then we come to affirm its presence, albeit absent. I may deny the referent and say 'the referent does not constitute an autonomous reality at all.'[3] I may say that the referent is only an effect of representation, only an effect of the sign. Yet, glory be, the more the referent's anteriority and authority is denied, and the more this is lamented as a loss, the more forcefully its presence, albeit absent, is affirmed.[4]

The referent is dead: long live the referent. Oh! the world is a fabulous tale.

So, I may well pronounce that the real world no longer comes before the sign. I may well declare that identity comes not before difference. I may well exclaim: no longer, no more! Yet in this tale of no longer I come to agree that *before* (perhaps long ago or not so long ago) reality or identity really did come before. No longer yet long ago.

Upon the telling of such a tale we come to feel sure that before reality really did come before (the sign, the image ...). By way of a tale of loss a tale is told of the way things (really) were. Once, perhaps before the late twentieth century, there really was a before which came before the image, fiction or sign. Yet, whilst we may feel sure, we nonetheless come to make this very before. Telling tales of an absence, a presence is produced; a past is made that lasts as the way things used to be.

Yet, if I had been there then I wouldn't be here now; if I were there now and at that time I would have a new story or an old story. There is more than just one tale that can be told.

I may well make a before by telling a tale of loss. Yet my tale may be that before (and after) are open to interpretation. 'There are no facts,'

Friedrich would say, 'there are only interpretations.' Fadófadó or a long, long time ago ...

After my very first history lesson at school, I excitedly hurried home to my parents to ask if long ago they had lived in caves and dressed in the skins of wild animals. 'Dad ... were you really like that long ago?'

Whatever the story or theory that may be told, how can you or I ever be sure of before and after? Can you or I be sure that the first is former and the second is the latter.

If in the first place, the first requires the second place in order to appear in the first place, if the former is not former unless first there is also the latter, then it seems to me that neither the first nor the second are, strictly speaking, 'in place'. Blurred is the boundary between the two. And to conclude that we live in a world where we end up (or begin) with the 'seconds' – to say that we live in a 'second-hand world' – seems to me highly questionable.

L is for the line in the middle and you may well say that we are being led a merry dance. We are entangled in the midst of a tale, the outcome of which remains undecidable. Try as we may, neither the first nor the second can be put 'in place'. Call out the first and you will find it changed into the second. Call out the second and you will find it changed into the first. Or, as it may be put: 'the player who calls "identity" will find it immediately changed into difference; and if he calls "difference", it will be metamorphosed into identity.'[5]

L is for the line in the middle and what you may well ask has happened to this line such that boundaries should be blurred and we be led a merry dance? It seems pertinent to ask if that line has not been wavering, if indeed it is not inclined towards taking turns, dancing around and metamorphosing.

It had appeared that the line in the middle came in between, enabling the one to distinguish itself and an opposition to be settled. The line in the middle appeared to form a sort of medium, the means whereby to establish the difference between the one and the other. Yet with this 'medium' we find that something else also happens: the one comes to be 'mediated' by the other; both become mixed up in the middle. In coming between, the line in the middle ineluctably involves the one with the other. It dances across the two terms and unsettles them both. Just as the difference becomes settled we find that it also becomes unsettled.

Putting this yet another way we may say that the line in the middle marks the threshold of the binary tale. Yet upon entering this tale – in the middle – we find an ambiguity. We find, perhaps not to our surprise, that the two terms are mixed up together such that strictly speaking, both are neither the one nor the other. Neither/nor: we waver between the one and the other, not knowing quite which is which.

'Ding dong merrily on high,' the child impishly sings, 'it remains

undecided as to whether I shall be one or the other. Ding or dong, dong or ding? Perhaps I shall be both but then maybe I shall be neither.'

In mid-flow the binary tale turns into a tale of oscillation.[6] And in this tale which may go on and on, we remain undecided as to whether we are here or there. We are somewhere unlocatable; somewhere between.

'There is the dance,' she quietly remarks, 'but where to locate the place of the dancer?'

L is for the line in the middle and it seems that we have a line (and a tale) which is not in the least straightforward. In coming between we find that the line in the middle oscillates between settling an opposition and unsettling that very opposition. You may well say that the line in the middle marks both the difference between the one and the other and the abolition of that very difference.[7]

'Yes,' she remarks with a gentle smile upon her face, 'the line in the middle is oblique; there never will be just one story that can be told.'

 is for middles and many things. M is for the many stories and meanings that may be told. That we are neither one thing nor the other, that we are neither inside nor outside but somewhere between, may soon become a tale of numbing neutralisation. Indeed, the story may be told that indifference infects the land. All too quickly the line in the middle turns the land to sand and we become lost to the perpetual shifting of the bleached white desert. Unable to fix definite places, unable to make firm and final distinctions, we wander a desert of indifference with blank expression. We no longer know for certain who we are or where we are going and, what's more, we don't give a toss.[8]

Rather than turning all to desert sand, the unsettling of binary difference may turn into a tale of implosion. The story here is that the line in the middle mixes up the one and other to such an extent that the very difference between the two inwardly collapses. The difference implodes under the sheer weight of wavering between the one and the other.[9] That we are neither/nor turns out to be a most disastrous plight, 'the worst thing in the world'.[10] As the binary code implodes we are sucked into a black hole and deprived of a guiding light; we lose sight of all meaning and feel hopelessly forsaken. To see is no longer to be and to know is no longer to awaken.

There is yet another story which I have heard told, a tale which is somewhat more lengthy. In unsettling the one and the other, such that we become unsure which is 'either' and which is 'or', the line in the middle begins to gather momentum. The story here is that the line in the middle picks up speed and whilst so doing turns into a stream. In this tale a stream flows and gnaws away at its two banks; it picks up speed in the middle and

carries away the one and the other. Here we have a stream – a line and a middle – which is without beginning or end.[11]

Suddenly we find ourselves moving in the very middle – midstream – of things, no longer attempting to grasp the banks of binary difference. And here, in the middle of this tale, we find also that 'things' themselves rapidly begin to change. The stream that flows becomes a plant that grows from the middle: 'Things which occur to me present themselves not from the root up but rather from somewhere about their middle. Try then to seize a blade of grass and hold fast to it when it begins to grow only from the middle.'[12]

In this world of a burgeoning middle, we find, so I hear, that any single thing (and this includes you and me) is involved with, in the middle of, many other things. Any 'singularity' is also a 'multiplicity' – to use the favoured terms. The relation between the one and the many ceases to be that of an opposition; the issue of difference has taken quite a different slant. That we may speak of a singularity is not a matter of locating an inside and outside, a text and a context, a center and circumference. For in this tale we are in the world, indeed worlds, of networks and nodal points. And with this sort of *milieu* we shall never arrive at a thing-in-itself which has intrinsic properties independent of its environment. Things turn out to be inter-connections between things which in turn are inter-connections between other things.[13] Yet these 'lines' (in the middle), these inter-connections, shall never lead us to an all-knowing Theory of Everything. There is always an element of uncertainty; these lines and connections rarely proceed in a straightforward manner. Any one con-nection may pro-duce a multiplicity of effects – a multiplicity of other connections, other lines. And here we require prudence: how will one line affect others? In this tale emphasis is put upon considering others; as the philosopher might say, ethics is given *priority* over epistemology and ontology.

In this tale where we are always entering things in mid-flow, I hear that no one thing can assume the determining part, the cause or origin. Whilst there are determinations, things affecting each other, who ever claims a singular cause, surely invites derision. For in this world it turns out that any such cause is already affected by other things.

And in this tale which sings not the praises of singular causes, I hear that interpretation can never be brought to an end. Knowledge is not so much a proclamation of certainty – I know that I know! – but more, as I have heard also from Hebraic tradition, an understanding that any inter-pretation is provisional and open to alteration and re-interpretation. Any theory, any story, or indeed truth, is that which could always be otherwise. That truth could be otherwise brings into play that element of uncer-tainty and, moreover, throws into question the falsity of other interpreta-tions.

M is for middles and many things. M is for the many tales and

meanings that maybe told. Blackholes and deserts, streams and fluid things – oh, the world is a fabulous tale.

'So,' the child remarks with zest, 'maybe I shan't be speaking of a loss of an independent real world or telling tales of the death of the referent. Perhaps I shall say that the existence of an independent real world is one story amongst others. As for apples and images – well, I might just tell the tale that with both "things" and "signs" (both nature and culture) we always start in the middle and that in so doing the question of the referent, its absence or presence, becomes more a question of connections, of effects and affects. As the philosopher may indeed say, more a question of ethics than of epistemology and ontology.'

To which the listener might add: more a question of ecology than 'representation'.

Notes Chapter Two

Future Politics/The Line in the Middle

1. See 'A Recapitulation of Three Syntheses' and 'Social Repression and Psychic Repression' in Gilles Deleuze and Felix Guattari, *Anti-Oedipus, Capitalism and Schizophrenia*, translated by Robert Hurley, Mark Seem and Helen R. Lane, The Viking Press, New York, 1977. 'The law tells us: You will not marry, and you will not kill your father. And we docile subjects say to ourselves: so *that's* what I wanted! ... what really takes place is that the law prohibits something that is perfectly fictitious in the order of desire or "instincts" ... ' (p 114).

2. There can be no exhaustive list of all the texts, all the 'lines' with which this text is involved. What follows is a partial list of the writings which have played a part within this one: Jean Baudrillard, 'The Precession of Simulacra', *Art and Text*, no. 11, Spring 1983; Jean Baudrillard, *In the Shadow of the Silent Majorities*, Semiotext(e) Foreign Agents Series, New York, 1983; Gilles Deleuze, 'Politics', *Schizo-Culture*, Semiotext(e), New York, 1978; Gilles Deleuze and Felix Guattari, 'Rhizome', *On the Line*, Semiotext(e) Foreign Agents Series, New York, 1983; Anthony Wilden, 'Lacan and the Discourse of the Other', *Jacques Lacan, Speech and Language in Psychoanalysis*, The Johns Hopkins University Press, Baltimore and London, 1981.

The World is a Fabulous Tale

1. ' ... binary machines of social classes, of sexes, man-woman, of ages, child-adult, of races, black-white, of sectors, public-private, of subjectifications, among our kind-not our kind.' Gilles Deleuze quoted from Alice

A. Jardine, *Gynesis: Configurations of Women and Modernity*, Cornell University Press, Ithaca and London, 1985, p 134.

2. 'The curious clarity here is not that this logic then requires us to declare the death of meaning, but it first requires us to consent that meaning was really "that" – and *only* that.' Meaghan Morris, 'Room 101 Or A Few Worst Things In The World' in *Seduced and Abandoned: The Baudrillard Scene*, Andre Frankovits (ed.), Stonemoss Services, Sydney, 1984, p 101. Re-printed in *The Pirate's Fiancee*, Verso, London and New York, 1988, p 197.

3. Jean Baudrillard, *For a Critique of the Political Economy of the Sign*, translated by Charles Levin, Telos Press, St Louis, 1981, p 155.

4. 'The more resolutely the referent is assailed, the more it seems to affirm its unmistakable presence, albeit in its absence.' Richard Allen, 'Critical Theory and the Paradox of Modernist Discourse', *Screen*, 28/2, Spring 1987, p 72.

5. Vincent Descombes, 'Originary Delay', *Modern French Philosophy*, translated by L. Scott-Fox and J. M. Harding, Cambridge University Press, 1980, p 152.

6. Perhaps what is happening here is that the binary tale turns into a Derridean tale of oscillation and undecidability – 'both one and the other' and 'neither one nor the other'. Of course it would be foolish of me to suggest that Jacques Derrida, contemporary French philosopher, tells but one tale; yet, in terms of 'deconstructing the binary oppositions of Western thought', Derrida's strategy may be summed up by the words oscillation and undecidable. Derrida takes his time to sniff out undecidable words, terms whose double meaning cannot be mastered or pinned down. For the sake of brevity, I shall list but a few: supplement, difference, pharmakon, milieu, middle voice, hymen. (See note 7 for more on the word hymen.)

7. 'In "The Double Session" (...) Derrida elaborates on one of his most powerful deconstructive levers and completes this genderization of writing – as the place where male and female remain undecidable – as feminine. Here, the undecidable, like the pharmakon in Plato [not just poison nor just cure yet both poison and also cure] or the *supplement* in Rousseau, becomes, in fiction, (Mallarmé's) "hymen". (...) For Derrida, the hymen is the "absolute" in undecidability: there is hymen (virginity) where there is no hymen (marriage or copulation); there is no hymen (virginity) when there is hymen (copulation or marriage).' Alice A. Jardine, *Gynesis*, pp 189–90. 'The hymen is both difference (between the interior and exterior of the virgin (...)) and the abolition of difference.' Vincent Descombes, *Modern French Philosophy*, p 152.

8. 'All that remains is the fascination for arid and indifferent forms.' Jean Baudrillard, 'On Nihilism', *Simulacres et Simulation*, Éditions Galilées, Paris, 1981. ' ... why are the deserts so fascinating? It is because you are delivered from all depth there – a brilliant, mobile, superficial neu-

trality, a challenge to meaning and profundity, a challenge to nature and culture, an outer hyperspace, with no origin, no reference-points.' Jean Baudrillard, 'Desert for Ever', *America*, Verso, New York and London, 1988, pp.123–4.

9. 'Strictly speaking this is what implosion signifies: the absorption of one pole into another, the short-circuit between poles of every differential system of meaning, the effacement of terms and of distinct oppositions' Jean Baudrillard, 'Implosion of Meaning', *In The Shadow of The Silent Majorities*, translated by Paul Foss, Paul Patton and John Johnson, Semiotext(e) Foreign Agents Series, New York, 1983, p 102.

10. For a wonderful analysis of Jean Baudrillard's ('worst') tales and tall stories see Meaghan Morris, *The Pirate's Fiancée.*

11. 'The middle is not at all average – far from it – but the area where things take on speed. *Between* things does not designate a localizable relation going from one to the other and reciprocally, but a perpendicular direction, a transversal movement carrying away the one *and* the other, a stream without beginning or end, gnawing away at its two banks and picking up speed in the middle.' Gilles Deleuze and Felix Guattari, 'Rhizome', *On the Line*, translated by John Johnson, Semiotext(e) Foreign Agents Series, New York, 1983, p 58.

12. Franz Kafka, Diaries 1910–1923, quoted from ibid., pp 52–3.

13. 'In itself the rhizome has very diverse forms, from its surface extensions which ramify in all directions to its concretations into bulbs and tubers. (...) We are well aware that no one will be convinced if we do not enumerate certain approximate characteristics of the rhizome. 1 and 2 – Principles of connection and heterogeneity: any point on a rhizome can be connected with any other, and must be. This is very different from a tree or root, which fixes a point and thus an order. The linguistic tree according to Chomsky still begins at a point S and proceeds by dichotomy. In a rhizome, on the contrary, each feature does not necessarily refer to a linguistic feature: semiotic chains of every kind are connected in it according to very diverse modes of encoding, chains that are biological, political, economic, etc., and that put into play not only regimes of different signs, but also different states of affairs. In effect no radical separation can be established between regimes of signs and their object.' ibid., pp 10–11.

Divergent Series:
The World is a Fabulous Tale
1988–1990

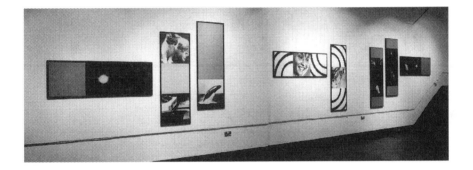

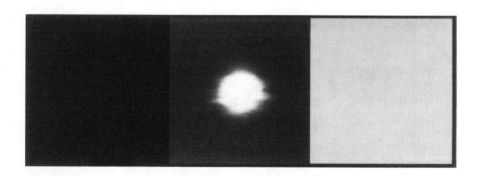

Chapter Three

Sometime(s)
&
'The World is Indeed a Fabulous Tale'

1991–1995

Sometime(s)

Where does one thing end and another begin?

There are times, perhaps, when we set out to draw circles around things in an attempt to enclose bodies or matters and so speak of things-in-themselves. Behold the monad, the perfectly self-contained. Behold the One, the Whole! Behold the intrinsic properties of a thing which remains independent of its environment! Indeed, time may be taken and a circle employed to isolate a thing in the belief that once an island (or billiard ball) something is then sufficiently insulated from infection or influence – mutation or hybridisation. During this time, when emphasis appears to be put upon hygiene and purity, we may model ourselves not on the philosopher who thrives on the varieties of the forest, but the plant geneticist who sets out to extract and isolate a very few varieties and breed a number of pure lines. Behold the purity of the breed, whether or not this be a plant, an animal, a race or an artobject on a gallery wall!

Islands which are circles which are billiard balls which are plants which are art objects: are not the metaphors already mixing, producing the uncalled for hybrid and disquieting the very notion, or ideal, of a thing-in-itself? Indeed, are not things (which can be metaphors as well as bodies or material matters) already affecting each other such that the circle takes a turn quite different from that of enclosing and isolating an eternal thing-in-itself?

You may slight this *turn* as merely rhetorical, yet for me the poet says it well: 'no man (or woman, I would add) is an island.' The art object affects the plant which affects the billiard ball which affects the circle which affects the island. Yes, the effects may be imaginary yet who is to say that they lack reality?

We always start from the middle of things

There are times when starting with one thing I find it and myself becoming involved with other things. I find that one thing is continually interacting with other things. I start with one thing, which may be a story, a forest or even a colour or line, and find my self in the middle of other things. In this sense I may say then, I start in the middle.

Recently I was asked: 'what is it as regards photography that is essential for you?' I replied:

– Is there any one thing that makes photography whole? Does photography have an essence? For me it isn't a matter of setting out to find the very interior of photography and despairing when I never reach that centre; it is not a matter of authenticating, in some way or another, the essentially photographic. For me it is a matter of exteriority in the sense of asking: with what does photography connect? What sort of relations are made? The one thing that I would contend is that there is nothing fixed, no matter what buildings or 'centres' we may erect or occupy, as regards photography. I would question not only the idea that photography is merely a vehicle but also the idea that photography possesses a territory which we must defend and war over. To me that is an exclusive practice. Photography is mixed up with all sorts of things – law and order, the family, the medical professions, the artmarket. Photography is involved in a diversity of practices, stories and theories. There is painting in photography. There are words in photography. There is sexuality in photography. There is money in photography. There are a host of different 'photographies'.When we start with photography we are already in the middle of quite a few things. Indeed, we may even argue that there is no such thing (in itself) as Photography only photographies.

We may say then, that photography 'in essence' is a set of relations that reach outward to other things. And speaking more generally of things, bodies and beings, we may go on to say that any one thing can only be defined by way of its relation to other things. We are talking then, not so much about definite *things* but more about the relations *between* things.

One thing affects and is also affected by other things: such interactions or 'affects' make it most difficult to draw lines between and demarcate definite things. We are *between* yet we can't say with all certainty that we are between definite points – things which have a separate and inde-

pendent identity. We can't quite tell where one thing definitely starts and another stops. And in this sense, we can't tell also where the between begins and ends. Indeed, we find ourselves in a between which remains, as it were, open ended and we suspect that a 'thing' is nothing but a set of relations or interactions.

Dog-child-street-wind: the dog enters into composition with the street which enters into composition with the child which enters into composition with the wind. Wind-child and dog-street. What we have here is more of an event of interactions than a series of points or things-in-themselves strung together by a single line which proceeds only one way.

(... one never commences; one slips in, enters in the middle.)

Whether or not we are a physicist, philosopher, politician or curator of photographic exhibitions, there may well be a time when we consider a thing or body – which may be a photograph or 'living being' – as an assemblage of interactions or relations.

A walk in a forest

When I take a walk in a forest I am not merely a neutral observer: I enter into composition with the forest. The forest, with all its variety of relations, affects me as I affect the forest. Where does the forest end and I begin? Indeed, it may be said that the 'individual' which is composed here is one that includes the forest. Yet let me stress that this inclusion isn't a matter of assimilation. It isn't a matter of making the forest the same as me, of taking it into 'my' circle and absorbing all the heterogeneity to which the term forest refers. I may say that an individuality is formed between me and the forest, yet this individuality, this forest-human, isn't a case of the human projecting itself, its humanity, onto the forest and making the non-human the same as the human.

To take a walk in a forest is perhaps to open ourselves to the idea that the different individualities we compose, the different relations which compose ourselves, may partake of the non-human.

Contrary to a once popular belief, the photograph is not the epitome of neutral observation. The observer may be quietly taking photographs in the forest and thinking her or him self quite neutral, yet as quantum physics tells us, the observer always participates within and affects the observed. To photograph is to affect.

We saw the milieus continually pass into one another

When confronted with a football we don't normally take this to be a house or a star. Of course we can argue that a football provides a house for a certain volume of air, that kicked high into the sky it follows the trajectory of a star, that there exist certain football stars. But in terms of the so-called

Newtonian view of the world, a football, as well as the world, is a definite round thing. It would be naive, I fear, to deny the existence of the Newtonian world, that world which is taken to be 'out there', independent of the observer and consisting of a collection of identifiable things (which are always depicted as round). Yet this world isn't the only one, this world is only one story amongst others. Yes, at times we do speak quite boldly of 'things' (or we may speak quite softly) yet there are other times, which differ from Newtonian absolute time, when a thing (which includes you or I, a football or an art object exhibited within a gallery space) is spoken of not as an isolated entity but more as a state of affairs involving time(s) as well as space(s).

I am not in the habit of kicking footballs, or art objects come to that, yet I have heard talk in both the football world and the art world of the 'season'. We all must have heard talk of the football season, and it seems perfectly feasible to me to say that sometimes the season of the year interacts and enters into composition with a football:

– *Climate, wind, seasons, hour are not another nature than the things or animals or people that populate them, follow them, sleep and awaken with them. This should be read without pause: the animal-stalks-at five o'clock ... Five o'clock is the animal! This animal is the place! 'The thin dog is running in the road, this dog is the road', cries Virginia Woolf.*[1]

The photograph is five o'clock in the afternoon. The image here isn't a representation of five o'clock in the afternoon but rather is affected by, whilst possibly affecting, this hour. A person views a photographic image on a gallery wall at five o'clock in the afternoon: the gallery wall, and the institution of the gallery, of which there are differing sorts, is as much a part of the person-photograph assemblage as is the hour in the afternoon. One thing affects another to produce what is more of an event than a representation: a 'becoming' five o'clock in the afternoon.

– *We reserve the name* haecceity *for it. A season, a winter, a summer, an hour, a date have a perfect individuality lacking nothing, even though this individuality is different from that of a thing or a subject. They are haecceities in the sense that they consist entirely of relations of movement and rest (...) capacities to affect and be affected (...) A haecceity has neither beginning nor end, origin or destination; it is always in the middle. It is not made of points, only of lines.*[2]

The photograph is five o'clock in the afternoon: I may stress that no matter how neatly framed and hung upon the white walls of a gallery, no matter how isolated it may appear, an image is always to be found in the midst of interactions and relations. However, these relations shouldn't be thought of as merely the background which provides the setting for an image. These relations, or haeccities as some might say, are not a matter of a context or environment which surrounds and remains exterior to an interior. To be succinct if not a little banal: the text isn't separable from the context.

Or, to put this another way: my interior, whatever name is put to this – being, essence, or dare I say, unconscious – isn't something which is necessarily locked up inside of me. The so-called intrinsic properties of something are not separable from its context or milieu. And here I am reminded that in French the word *milieu* means both surroundings and middle: both centre and circumference, both environment and individual; indeed, both inside and outside.

A milieu, thus, is not univocal. We find that several different things or meanings can happen at once. We find, for instance, what appears independent is also inter-dependent and vice versa; we find what is called singular is also a multiplicity. Open to meaning both inside and outside, milieus are not prevented from passing into one another by the existence of national boundaries. The word may be French yet we can find such milieus in other countries.

A milieu is not punctuated by either a beginning or an end point where passports or identity cards have to be shown in order to pass from one milieu to another. As with a haecceity, a milieu *is not made of points, only of lines*. Whether or not your milieu is French or English, you may come to speak of a *multilinear system where several things can happen at once*.

Not only does the living being continually pass from one milieu to another, but the milieus pass into one another – is this to say that a whole never can be found? Will I never find a whole person, a wholly French person, a wholly English person?

We may set out to draw circles around things, yet it would seem that we can no longer take the Whole or One as given or giveable. Indeed, it seems that we can no longer bestow upon things or beings the notion of the Whole. We may ask then: does the notion of the whole become meaningless, something which should be banished from our thoughts? I have heard it said that it is a most ancient simile to compare the living being to a whole, or to the whole universe. Not only has the living being been compared persistently to a whole but also a whole to a circle. So insistently has the whole been drawn as a circle (a round thing) that we are told only a fool would attempt to think it otherwise. Have we not become so accustomed to thinking or drawing the circle as the image par excellence of Oneness and Wholeness that to attempt to think it otherwise does seem foolish, if not paradoxical. Have we not taken it for granted that the circle always returns the same? Have we not been told that the whole is univocal, that only one tale can be told? Yet, if we were to admit that more than one tale can be told, then the whole, as with the circle, would no longer remain as closed as it has been assumed to be. In short, would we not admit that the whole remains open?

If we are not immediately hushed upon making such an admission perhaps we would go on to say:

– if the living being is a whole and, therefore, comparable to the whole of the universe, this is not because it is a microcosm as closed as the whole is assumed to be, but, on the contrary, because it is open upon the world, and the world, the universe, is itself the Open (...) If one had to define the whole, it would be defined by Relation. Relation is not a property of objects, it is always external to its terms. It is also inseparable from the open ... [3]

The truth is that which could always be otherwise

I had produced a body of work. This 'body' was composed of visual images: a number of photographically produced images has been brought together to form, what may be termed, assemblages. A number of these assemblages, there were twelve in total, had been installed within a gallery and during this installation a question had been asked of me: how is this work to be read? I supply my answer, for I feel that it has some relevance to what has been termed a multilinear system where several things can happen at once:

– Let me say immediately that there isn't a correct way to read this work, which is to say that neither is there a wrong way. This work doesn't advocate the telling of one story as The Story. As I have said before, there is a concern to tell several stories at once. We may refer to these stories as lines, there being within the work a variety of different lines – visual, metaphorical, conceptual, graphic and so on. We may then go on to compare each assemblage with a modern day multi-track 'single'. The analogy here is of reading the work as you would listen to a record. And carrying the analogy further, you may think of the work as a whole as an album. Some tracks may leave you cold, others you play over and over again. You don't approach an album as a closed book, an open or shut affair. With a multi-track recording each track or line is laid down separately; it is particular. This particular line, however, also forms an assemblage – an ensemble – with all the other lines. Sometimes perhaps you follow just one line, at other times you may find yourself in the middle of many lines: you hear or are engaged with several stories at once. What I'm saying here, and I don't want to make too much of this analogy, is that any 'single' can be heard simultaneously as a 'multiplicity'.

The point I'm trying to make is that any single line – be this theoretical or whatever – involves other lines and as such remains open ended. So, in terms of this body of work a visual line may be followed quite literally yet where this line takes you, what effects it produces, may turn out to be quite metaphorical. The lines may connect and affect in ways that neither you nor I ever quite expected. Who knows in advance which way things will go. Yet this isn't to assume that anything goes, that I am saying to the viewer, 'make of it what you will.' Within the work images have been brought together, articulations have been made, specific lines or paths can be fol-

lowed, yet there is also an invitation for the viewer to make different articulations, different readings, different paths. That is, to consider that any one story, any one world or truth, is that which could always be otherwise. So, it is in terms of this invitation that I say there isn't a correct way to read this work.

Yes, I would like to think that this work openly invites different interpretations and in so doing raises questions (which I believe are ethical) about the very idea of a correct line; the idea that there exists the true interpretation by which all others are rendered wrong, false or blasphemous. And let me say that I don't see the raising of such questions as merely academic. You only have to consider the issue of fundamentalism to understand how the raising of such questions can come to seriously affect a life.

Not to ask what a thing is but rather of what is it capable

For what seems like an eternity I have heard it said that today we are completely surrounded by images from which there is no escape.

Now, we may well join in with the chorus of voices which chant the line that an original reality can no longer be found outside of and prior to images, representations and signs. We may well join forces with those who say: 'the image no longer refers primarily to some "original" situated outside of itself in the "real" world or inside human consciousness. Devoid of any fixed reference to an origin, the image appears to refer only to other images.'[4] Yes, we may agree that this condition constitutes a crisis: images have ceased to represent (if indeed they ever did) and no longer can we say for certain what reality is.

Until we are blue in the face we can bemoan a 'crisis of representation'. Or, we can ask the following questions. Of what is an image capable? What can it do? With what does it interact? What relations are involved? What possibilities does this image open up or close down? Here we would not define photographic images in terms of (so-called) documentaries or fabrications, fact or fiction, realist or abstract, but rather by what they can do, the affects of which they are capable.

The affects or interactions of which an image is capable may partake of humans as well as animals and ideas or mountains or fabulous monsters. Images affect not only the human (or non-human) selves we become but also the worlds of which we are part. Images affect as they are also affected.

To ask of what an image is capable is to partake of the idea that images are immersed in a changing state of affairs – not images of the world, rather images in the world. Thus we may say:

– the image is not the passive receptacle of truth because it is something else – it is an object in the world that works, functions, makes connections, 'affects'. It is a phenomenon of and within the material world; a

site of actions and relations. The image simply exists, much as any other
object with no special privileges. Once this is realised the image no longer
poses a paralysing epistemological dilemma, but rather presents the possi-
bilities of practices as diverse and potent as all the work images can do in
the world.[5]

The photographic image is a site of interactions and relations; this
we may agree, yet let us not assume that these relations will be seen with-
in the image. Listen, listen, there is always more than meets the eye. The
relations with which an image is involved exceed the image; a photograph
can never show it all. The visual image opens onto all sorts of relations yet
these may not be given necessarily to sight; to see is not necessarily to
know. That these relations often elude the eye may prompt us to say that
they are imaginary or abstract. However, are we to assume that the imag-
inary or the abstract doesn't affect, that no effects or meanings are pro-
duced? The most seemingly abstract can teem with meaning. $E=mc^2$: just
think of the effects that this abstraction has had.

Any single image has the potential to involve us in quite a few
things, quite a few stories and times. I have mentioned before that any sin-
gle image is capable of breaking into a multiplicity of lines. These lines con-
cern not only that which has affected the image (the photograph was
exposed at five o'clock in the afternoon ... she coloured the image bright
yellow) but also the interactions and effects which the image is capable of
making. Not only that which has affected the image but also that which
will be affected by the image: contrary to a popular tale, the photograph
does not solely refer to a time past (as if there were only ever one). There
isn't a fixed time, there is rather, a *sometime*.

Sometime: at a future but unspecified time; at a one time, former-
ly. Sometime simultaneously concerns that which has happened and that
which will happen. A photographic image, we might say then, holds the
potential to involve both past times and future times:

– Aeon: the indefinite time of the event, the floating line that knows
only speeds and continually divides that which transpires into an already-
there that is at the some time not-yet-there, a simultaneous too-late and too-
early, something that is both going to happen and has just happened.[6]

(... never have I felt so young and at the same time so old.)

Any single image has the potential to produce a diversity of effects.
Sometimes economic effects. Sometimes critical effects. Sometimes laugh-
ter effects. Sometimes. Sometimes. Sometimes. With any single image there
is more than one story/time that can be told; yes, we may well find our-
selves in the middle of quite a few divergent times. Some times. Sometimes
cyclical time, the 'timeless' time when the circle goes round and round.
Sometimes 'historical' linear time. Sometimes rectilinear time, the time
when the working day is divided into units of productivity. Sometimes Celtic
time, a time not only of knots and intricate patterns but also of the in

between times, the twilight times between night and day. Sometimes the time of the Shaman when the divine, human and animal know of no boundaries. Sometimes China time, the time when a year partakes of a snake or a dragon or a rabbit. Sometimes, but not standing for all times, the Christian time before or after the birth of Jesus Christ. Sometimes Hebraic time, the time when part of year 1990 AD is the year 5751. Sometimes colour's time, a colourful time. Sometimes the rays of the sun failing upon a small Indonesian boy who is pulling an ox by a taut line.

– *For the Greek heritage, time is rectilinear, successive, solar. It is based on regularity, continuity, and orderly progression. In contrast, Hebraic temporality is based on rhythms and lunar repetitions, cyclical 'timeless' time. The Greek spatialises where the Jew temporalises knowledge; for the former, knowledge is propositional, that which is stated is static. But the Hebrew proposition is such that it cannot represent existence: in this language, there is no present tense of the verb 'to be' – the copula cannot be substantiated.*[7]

Let us consider the differences between Greek and Hebraic time but let us also consider the animals and the plants and the mountains, for they too have their times.

We may say that with any single image there is always more than one time, yet are we to make a return and attempt to string together upon a single time all these different times? Indeed will we feel compelled to make a grand synthesis and subordinate the different times to the rule and control of the One; that is, to make a Universal History, a One and For All Times ... let us develop a computer which has the capacity to gather and conserve in a single memory all the multiplicities of different times:

– *The electronic and informational network spread over the earth gives rise to a global capacity for memorizing which must be estimated on the cosmic scale, incommensurable with that of traditional cultures. The paradox implied by this memory resides in the fact that in the last analysis it is nobody's memory. But the 'nobody' here means that the body supporting memory is no longer earthbound. Computers are ceaselessly able to synthesise more and more 'times', so that Leibniz could have said of this process that it is on the way to producing a monad much more 'complete' than humanity has ever been able to be. For a monad supposed to be perfect, like God, there are in the end no bits of information at all. God has nothing to learn. In the mind of God, the universe is instantaneous.*[8]

If the subject is not a pre-given monad, self-formed and autonomously contained, if others are not simply versions of the same, then certain ethical questions are raised by the meeting with alterity

Save for our computer God, whose 'future' relies upon an out-put of electrical energy that perhaps the planet earth cannot always promise to supply, no one knows ahead of time the interactions or affects of which they are capable. A 'life' is always a matter of experimentation. I can never know in advance of what I am capable in as much as I can never know 'in total' all the effects an image can produce. To consider something as a state of affairs, more of an event than a thing-in-itself, is to consider that with any one thing others are involved. And here we require prudence: how will one thing or action affect others? Or, to put this another way: how will my passivity affect others? To be passive is still to affect – to think as a mountain is to understand the heights of passivity. Such consideration of interactivity, even whilst being passive, unavoidably brings us, I feel, to the question of ethics.

Emmanuel Levinas, for whom the question of others and ethics is paramount, has said that one is never quits with regard to the other.[9] Our involvement with others cannot be reduced to sorting out a 'foreign policy' and then returning to one's 'home affairs'.

The question of ethics requires further exploration, further experimentation – perhaps a whole life's time. Nonetheless, let me say that becoming involved with the affects that one thing has on others, understanding that any one thing involves others, raises the issue of what may be termed an ethics of difference. And by this I understand, at least at the moment, not the laying down of a moral code, a set of fundamentals, a 'for all times', but rather an ethics which embraces sometime(s). And with such an ethics we would not make unequivocal judgments, a 'for all cases'; on the contrary, we would judge, as it were, 'case by case'. As I understand it, the ethics here in question would be conditional upon the non-reduction of different times to a One Time:

– an ethics of difference. That notion is not without its difficulties, but the claim that the basis of ethics is not the alter ego, the other like me, but the other as he or she resists my attempts at egological projection surely opens up new avenues in ethics (...) An ethics of difference, however, would be premised on a non-assimilative respect for differences.[10]

The question for me becomes: how can one take another, be this an animal, human being or forest, into 'its' world whilst also respecting that other's own time and space, its own relations and 'world'? We are continually interacting with others yet how are we to enter into composition with another without reducing the other's potential to affect? Are we not here forced to think of inter-dependence and independence simultaneously?

They were both affected by Spinoza

Whilst I would not wish to make any claims to be an expert on matters of ethics, I would venture, however, to say that for me an ethic of difference is counterposed to what Spinoza, in the *Ethics*, calls satire:

– *satire is everything that takes pleasure in the powerlessness and distress of men [and women], everything that feeds on accusations, on malice, on belittlement, everything that breaks men's spirit (the tyrant needs broken spirits, just as broken spirits need a tyrant).*[11]

Spinoza is not among those who take pleasure in making others impotent, of breaking or blocking another's spirit or difference. For Spinoza, ethics is joy; it is not concerned with moral judgments but rather with a 'body's' ability or potential to interact, to affect and be affected. Hence Spinoza's question: Of what is a body capable? Everything in the universe is encounters, happy or unhappy. A photographic 'body' in its encounters may come to affect another such that the other's potential or power to interact is overshadowed and diminished. In the face of this image, I am made to feel impotent, I am prevented from making further interactions. These are sad times for Spinoza. Sad times not only for the affected body but also the affecting body; for, strangely enough, the more the affecting body – the image – acts tyrannically, the more its potential or capacity for being affected is lessened (in effect the tyrant is a broken spirit). In Spinoza's words: *those who know how to break men's [and women's] minds rather than strengthen them are burdensome both to themselves and to others.*[12]

There are other times when a photographic image or body affects another such that the other's potential to affect is augmented. Here the other is not prevented from furthering its interactions. Here, for all the bodies concerned, the relations multiply. Both the affecting and affected body have their potential to interact increased – they compound to constitute a more 'intense' potential. And these times, for Spinoza, are joy.

Unashamedly I imagine an ethics – a politics – which seeks not to diminish but rather augment another's spirit, be this of a wind, a forest, a rock, a curator of photographic exhibitions or five o'clock in the afternoon. Here we would not mock others in that vain attempt of self-mastery and control. Here, starting in the middle of things, we would understand that the truth could always be *other-wise*.

The World Is Indeed a Fabulous Tale

Hilary Gresty in dialogue with Yve Lomax[1]

> *The animals went into the ark two by two and I may well say that B is for*
> *the binary tale where difference is told in terms of two. Yet within this tale*
> *of two only one is ever primary. The binary tale proceeds two by two, yet for*
> *all the twos one is (Hurrah! Hurrah!) whilst the other is not. Truth is not*
> *fiction, the same is not difference and man is not woman. And so the his-*
> *tory goes on.*[2]

HG: I have chosen 'The World is a Fabulous Tale' as the starting point
from which to open a conversation about your work because it raises a num-
ber of issues pertinent to any discussion of a post-modern practice. It ques-
tions assumptions such as binary opposition which, philosophy aside, still
inform and limit much daily understanding, in particular where oppression
is deployed. The text plays on the differing levels and applications of myth
and metaphor which make up discourse, a richness of allusion and history
denied by traditional empiricism, and the self-perfecting modernity of the
industrial age. Language is seen to be made up of interacting particles
rather than as a closed and unified system. It is in this diversity that the
text exemplifies an important shift from the pioneering work of many
feminist artists in the the 1970's when theory provided a rigorous template
for development of a visual practice which would challenge totalizing
modes of thought and place art within the complex web of social and cul-
tural relations. Rather, theory is now seen, to quote Russell Ferguson, as

'a narrative like any other – as a kind of story, or myth from which to draw.'[3]

Any challenge to the predominant Western cultural heritage of rationalist thought is an immense task and one closely allied to a discussion of the nature of photography in its ascribed role as the purveyor of empirical evidence upon which, amongst other things, scientific classification has been based. It is in this role that photography can be seen as the harbinger of the modern age's mastery through representation. In past conversations we have talked about the camera as 'one of the great revealing devices', so loved by the nineteenth century, and how this is closely bound to Western culture's privileging of vision over the other senses, compared with, for example, the Judaic tradition, a listening culture, where significantly the curtain in the tabernacle is pulled back to *reveal* nothing. A starting point might be to look at how electronic media and the computer override any remaining vestige of credibility that the photograph as evidence of this type might still have had – the irony being that such credibility was ill-founded in the first place.

YL: There is no denying that with the advent of the computer, image manipulation *par excellence* has been born. Here is a technology where images can be combined, recombined and altered endlessly and seamlessly – a montage machine of infinite possibilities. For fields as diverse as meteorology, medicine and the advertising industry a host of possibilities has been opened up. In terms of such endless possibilities we are hearing today endless tales, a whole cacophony of stories about the effects that these may have. One such story is that the computer generated image threatens the photograph as evidence. The story goes that computers can simulate the 'real' of a piece of photographic evidence whilst simultaneously dissimulating that this 'real', this evidence, is only a simulation. In short, the photograph's objectivity is threatened. However, the notion of an objectivity, the very idea that an observer can observe without affecting, or being affected by, the observed has been repeatedly thrown up in the air not only by quantum physics but also by photographic theory (and practice). We may think that computers threaten photographic objectivity but isn't this objectivity a myth? Yet as Michel Serres reminds us: 'There is no myth more innocent than that of a knowledge innocent of myth.'

HG: 'The World is a Fabulous Tale', like much of your writing, uses fragments, (or as you would say, in order to avoid connotation of a whole, 'assemblages') of autobiography and forms borrowed from ditties and popular story telling. One of the images which sticks in my mind from an earlier piece is that borrowed from the nursery rhyme 'The Pied Piper' in your discussion of 'the crisis of representations'.[4] This raises a number of interrelated issues. 'The Pied Piper' is laden with suggestion, not least that of

blind belief in an absent, an unknown, which just because it is unknown demands a charismatically inspired and deluded following; on the other hand in using the reference you are actually asserting a very recognizable, or 'real' image. This use of heavily endowed and accessible images is a characteristic shift away from what you have termed the 'quasi-scientific, bleached out' use of language in an attempt to 're-inscribe authority' beyond the vagaries of individual self-expression, which was practised not only by yourself, but many artists during the 1970's.[5] This shift is further reflected in the use of found images, codes and forms borrowed from documentary, cinematic and popular photography in your visual work. I am always surprised afresh by the way that I find the images you make familiar, even when it is one that you have constructed. Is this a recognition that science, theory and their underpinning philosophies are, together with folklore and other popular forms, just examples of many stories that can be told and that no one story is necessarily exclusive to the representation of a single reality? It seems that the imaginary spaces beyond the image are on a parity with those within it. This begs many questions regarding the so-called crisis of representation, which has been used as a basis for much postmodernist image making. Your position is one within which the 'crisis' necessarily 'warps'.

YL: In terms of the logic of representation, a representation, whatever this may be, must refer to something beyond itself. Classically, representation has been conceived of as 'surface appearances' beyond or behind which there is a depth. This depth is the realm of the essential, the realm of the 'founding presence' upon which representation is based. Now the crisis of representation revolves around the idea that we have irrevocably lost this presence. (As we have lost it we assume that it must have been there in the first place.) All that we are left with is surface, images that only refer to other images, signs that only refer to other signs. However, my question has been, if representation ceases to refer to anything beyond representation then how can the terms of representation still apply? Doesn't the logic of representation warp? For me the twist is that if there is no 'depth' then how can we speak of the 'surface'? Doesn't the very notion of the surface become meaningless? This provided for me the twist in the debate about the post-modern image as mere surface. If the very idea of image-as-surface-appearances becomes meaningless then surely it is a matter of asking: what and how does an image *affect* ? It is no longer a matter of seeing images as substitutes which replace the real world but rather of understanding the effectivity of images *in* the world.

HG: One of the implications of a fixed reality behind the image has been a relegation of metaphor to secondary status as an unscientific or unverifiable discourse.

YL: There is a tradition, which for convenience's sake I will call the *critique*, and which maintains that in order to theorize or philosophize properly one must banish metaphor. In the *critique* tradition philosophy is not a story, not a pictorial description, not a work of literature. Making a firm distinction between the literal and the figurative, the *critique* declares its status by breaking with the 'domain of images'. Univocality is what the *critique* loves – one word, one meaning. Yet this univocality, this image-free language, this literalness is somewhat spurious. As Michèle le Doeuff reminds us so wonderfully in *The Philosophical Imaginary* philosophy is stuffed full of images: Plato poured out fables. Kant was fascinated by the image of an island.[6] In the *critique* tradition it is believed that if one does bring an image or a metaphor into play this is only to decorate the discourse. A metaphor can only speak indirectly, it can only imply. To be properly theoretical one has to *explicate,* one has to open out the folds. What the *critique* tradition so conveniently forgets is that metaphor, pictorial description, and style can *implicate* the profoundest of philosophical or scientific ideas: a poem by Lucretius can be a valid treatise in physics, a novel by Virginia Woolf can tell us about wave mechanics. So-called 'scientific' semiology (as widely practised in the 1970's) partook of the tradition of the *critique* – one could expose or explain the codes through which language worked by employing a (meta)language which was miraculously free from those very codes – a language which could be bleached of all its 'ideological' content. Yet as Barthes realized, one can only play one code against another and Derrida said very much the same thing when he said that in in any attempt to define or explain metaphor there will always be one metaphor in excess.

The implication of metaphor brings a much richer knowledge of the world. To speak by way of implication is not about standing back and attaining the correct distance in order to see things clearly; implication is about being plunged into things, finding oneself in the middle of things.

HG: There is an apposite quote from the novel *Waterland*, by Graham Swift, in which he is questioning the methodology of conventional history: 'But man [sic] – let me offer you a definition – is the story telling animal.'[7] Such story telling, folk lore and 'old wives tales', are inherently metaphorical.

YL: Yes, likewise the *critique* tradition assumed that such so-called popular culture is a denigration of true knowledge. In the *Wind Spirit* Michel Tournier says that a myth is a story that everybody already knows.[8] In my work, both written and visual, I bring into play a variety of images which have already been heard or seen. By bringing the mythic and metaphorical into play I hope to implicate the reader or viewer in the fragrance of the world. I hope to invite the reader or viewer to participate in a philosophical or theoretical activity, which maintains that we can gener-

ate philosophy quite properly with fairy tales and nursery rhymes and pic-
tures of pussy cats from greetings cards.

HG: One alternative to acknowledging and celebrating this richness of
metaphor is to use appropriation either as a bland statement of nihilism
(that is, to beg the irony of the photographic medium in its indexical
relationship to the objects it represents), or to plunder style without ques-
tioning the political status of the appropriated material (that is: to 'image-
scavenge' with complicity). Your visual work, like your writing, uses found
images and conventions from different types of image making – these are
materials of appropriation, but your use is firmly embedded in the con-
temporary world and the adoption of an ethical stance within that world.
I recall you saying that you want people to address, for example, an image
of a monkey 'in all its fullness', to consider human-kind's relationship to
animals, to make a choice and to take up a position. Would you like to elab-
orate on what you have called the 'specificity' and the 'power to affect' that
all images have?[9]

YL: It was Deleuze who first introduced me to Spinoza's question: '*What
can a body do?*, of what affects is it capable?'[10] A body can be anything: an
idea, an animal, a visual image, a body of sound, a photographic body, a
mountain, a child or a wind. A body is never separable from its relation
with the world. It is these interrelations which make the child, the wind or
the photographic image; they are not defined or distinguished by internal
essences which condition or structure the mode of their being. A body is
constituted by and composed of relations, of *affects*. The power to affect
concerns the relations into which a body is capable of entering and which
come to define it. What does this image affect? What affects this image?
Bodies affect each other. As Deleuze reminds us, affectivity is a two-way
process, indeed a process which goes in more ways than one. It is a com-
plex of interactions. Both specificity and heterogeneity are retained and as
we enter into this specificity we find not a discrete element or thing in itself,
but rather a set of relations. Specificity is continually opening onto multi-
plicity and vice versa.

HG: There are two things that seem particularly relevant in your assump-
tion of photography as part of an ecology (rather than as a mere tool or
consequence of representation). Firstly issues around difference – whether
of, for example, gender, race or culture. Secondly the formal conventions
and devices that you employ visually – montage and collage, irregular and
abutting frames which confuse inside and so confound the very means of
representation itself, abstract and given signs which break up sequences,
colour and pattern which reject the possibility of illusionistic depth, and
more recently the circular frame, with its monadic properties. Together

these all lead to, or implicate, a multiplicity of readings and a deliberate blurring of the distinction between fact and fiction. The writing echoes this image-making process – juxtaposition, repetition, displaced narrative and the use of a multiplicity of conventions. The position you adopt is very much an *ethical* one – something influenced by your work in the *Format* picture library, and the way that images are actually employed on a day-to-day and often commercial basis.

YL: Yes. One thing always involves others: one thing and another and another. In fact we don't have definite things so much but more states of affairs, sets of circumstances. A set of circumstances may be a photographic montage which combines a picture of a rain forest with a picture of a crowd of people which is hung upon a gallery wall and viewed by a child at two o'clock in the afternoon. In terms of these circumstances we have a photographic image and a rain forest and a child and two o'clock in the afternoon. All these elements compound together and a multiplicity is formed which adds up to something quite specific. An individuality is formed, yet as Deleuze would say this individuation is quite different from that which pertains to a unified subject. In *A Thousand Plateaus*, Deleuze and Guattari reserve the name 'haeccity' for this idea: The child ceases to be a subject to become an event, in an assemblage that is 'inseparable from an hour, a season, an atmosphere, an air, a life'.[11] With such assemblages or sets of circumstance we find all sorts of unnatural participation, which is one way of saying that with a set of circumstances nature always implicates culture and vice versa: as such no firm distinction can be made between the natural and the artificial.

M is for middle and many things. M is for many stories and meanings that may be told ... suddenly we find ourselves moving in the very middle – midstream – of things, no longer attempting to grasp the banks of binary difference.

YL: Given that with any one thing others are always involved, will this particular action augment or diminish another's capacity to interact? For Spinoza this is an ethical question. Once we consider the affects we have on others, be they animals, images or human beings, then doesn't the question of ethics and prudence come into play? For Spinoza the ethics in question concerns a body's ability to affect and act, and this power to affect refers to the *potential* a body has for combining with others. Sometimes affects may weaken another such that its potential for further interaction is diminished ... Here we feel wretched. We feel less. A broken spirit. These are sad times. For Spinoza, however, there are more joyful times when one affects another such that the potential to interact is augmented.

'The World is a Fabulous Tale' ends by posing this question of ethics

and multiplicity; in turn this question becomes the starting point for subsequent writings. Where this question will lead me I never know in advance. I am continually surprised ... How can we think difference differently? In 'The World is a Fabulous Tale' I wanted to make the logic of binary oppositions surprise itself. In the very middle of its logic I wanted binary opposition to find itself breaching itself and there become exposed to multiplicity. If deconstruction has taught me anything it is that one can't simply or antagonistically oppose the logic of binary opposition. To oppose it will not surprise this logic one bit. The surprise happens when binary logic is made to fold in upon itself, such that *something else becomes involved*.[12] In short, one has to practise what Michel Serres refers to as the 'baker's logic'.[13] Now this idea of the baker's logic holds a particular charm for me as my father was a baker. As a small child I would watch him kneading dough, a process of continually folding in, of implication. In terms of perfecting the baker's logic we have to knead binary opposition: to make the two terms fold in such that it is shown that both sides implicate each other and that as such they become, as Derrida would say, 'both and neither/nor'. Neither positive nor negative, neither one thing nor the other. What we have here is a state of affairs where *something else is involved*, where something else is implied, where we continually find ourselves *between things*. And being between things do we not, once again, find ourselves in the very middle of multiplicity?

HG: In 'The World is a Fabulous Tale' you are careful to avoid the notion of 'multiplicity' collapsing into 'anything goes' by suggesting a fluid ethic, an ecology, but doesn't this still beg the questions as to whose ethics, whose ecology?

YL: Yes it is precisely this question which Michel Serres bids us to plunge into as he bids us to plunge into the question of chaos. For Serres multiplicity opens onto the question of chaos: how can we involve ourselves with chaos without subjecting this to the tyranny of the 'one'? As Serres reminds us, the 'one' tyrannizes when it unifies at the cost of crushing, capturing and diminishing the potential of multiplicity. The 'one' suppresses chaos by explaining it as impure, irrational mixtures of dis-order; by fixing it into a binary system chaos becomes the negation of order.

Understanding that something else is always involved means that an ethics of multiplicity continually involves itself with surprises and unpredictability; it invites us to participate in a reality – a life – which is multiple and circumstantial without the feeling that order has been lost or negated. As such this ethics remains open and continually moving. Yes, a fluid ethics. Such fluidity brings with it a life of experimentation but also lasting prudence. How do you know beforehand what affects or implications you are capable of? This is another way of saying that the affects one thing

has on another can only be judged in terms of the circumstances of each situation, or as Serres would say 'la logique des circonstances'. There aren't definite things which gain territories, position or presences by employing the binary logic of inside and outside, of inclusion and exclusion. Here the inside and outside are continually turning inside out. One has to consider the map and the circum. One has to circumnavigate with a map (an ethics) which changes depending upon where and when you enter or begin. Stances aren't denied. One can always stop and take up a position. One can always think with your feet firmly on the ground. Yes, one can always think in terms of all that which this image implies, that is, assume a singular and unitary position. However, what is special here is that one's *stance* is one part of the *circumstances*, only one locality in the multifaceted richness of the world(s) we live in and of which images, metaphors and ourselves are part.

Notes Chapter Three

Sometime(s)

1. Gilles Deleuze and Felix Guattari, *A Thousand Plateaus: Capitalism and Schizophrenia*, translated by Brian Massumi, The Athlone Press, London, 1988, p 263.

2. Ibid., pp 261–3.

3. Gilles Deleuze, *Cinema 1. The Movement-Image*, translated by Hugh Tomlinson and Barbara Habberjam, University of Minnesota Press, Minneapolis, 1986, p 10.

4. Richard Kearney, 'The Crisis of the Post-Modern Image', *Contemporary French Philosophy,* A. Phillips Griffiths (ed.), Cambridge University Press, Cambridge, New York, Melbourne, 1987, p 113.

5. Don Slater, personal communication, 1985.

6. Gilles Deleuze and Felix Guattari, *A Thousand Plateaus*, p 262.

7. Elizabeth Groz, ' "The People of the Book": Representation and Alterity in Emmanuel Levinas', *Art and Text*, no 26, Nov–Sept 1987, p 32.

8. Jean-François Lyotard, 'Time Today', *The Oxford Literary Review*, vol 11, 1989, p 9.

9. See Emmanuel Levinas, *Ethics and Infinity, Conversations with Philippe Nemo*, translated by Richard A. Cohen, Duquesne University Press, Pittsburgh, 1985, p 105.

10. David Wood, 'Beyond Deconstruction?', *Contemporary French Philosophy*, p 181.

11. Gilles Deleuze, *Spinoza: Practical Philosophy*, translated by Robert Hurley, City Light Books, San Franciso, 1988, p 13.

12. Ibid., p 25.

'The World is Indeed a Fabulous Tale'

1. Hilary Gresty was Curator at Kettle's Yard Gallery, Cambridge, from 1983 to 1989, and now works as a freelance writer and visual arts consultant. She is also Director of the Visual Arts and Galleries Association.

2. See 'The World is a Fabulous Tale' this volume, first published in *Other Than Itself: Writing Photography,* John X. Berger and Olivier Richon (eds), Cornerhouse Publications, Manchester, 1989.

3. Russell Ferguson, 'A Box of Tools: Theory and Practice', in *Discourses: Conversations in Postmodernism, Art and Culture,* New Museum of Contemporary Art; New York, MIT Press, Cambridge (Mass.), 1990, pp 5–7. In the same volume Lynne Thornton writes, 'In some cases the deployment of Theory, as a prescriptive or legitimizing device, becomes just another mode of commodification', from 'If upon leaving what we have to say we speak: a conversation piece', p 50.

4. See 'Future Politics/The Line in the Middle' this volume. 'The pied piper of the signifier played an enchanting tune. The children who followed its "line", were never to return and affirm the authority of the parental signified ... '

5. In conversation with the artist, January 1992.

6. Michèle Le Doeuff, *The Philosophical Imaginary,* translated by. Colin Gordon, The Athlone Press, London, 1989.

7. Graham Swift, *Waterland,* Heinemann, London, 1983.

8. Michel Tournier, *The Wind Spirit,* translated by Arthur Goldhammer, Collins, London, 1989, p 157.

9. In conversation with the artist, January 1992.

10. Gilles Deleuze and Claire Parnet, *Dialogues,* translated by Hugh Tomlinson and Barbara Habberjam, Columbia University Press, New York, 1987, p 60.

11. See Gilles Deleuze and Felix Guattari, *A Thousand Plateaus: Capitalisin and Schizophrenia,* translated by Brian Massumi, Athlone Press, London, 1987, pp 261–2.

12. See Barbara Johnson, *A World of Difference,* John Hopkins University Press, Baltimore, 1987, pp 12–13.

13. Michel Serres, *Rome: Le Livre des Foundations,* Grasset, Paris, 1983. English translation, Stanford University Press, California, 1991.

Sometime(s)
1991–1995

... And Words in the Middle

Irit Rogoff

&

Serious Words

... And Words in the Middle

Irit Rogoff

'Refusals'

What are the demands that are made on us by 'art'? – demands for totality and singularity, for completeness and for satiety which infuse 'art' as they infuse any other grand scheme in the traditional order. I want to take some elements of Yve Lomax's dialogue with these demands, with their claims and with the refutation of those claims and situate them in what Hannah Arendt has called 'The Space of Appearance'. As much of Yve Lomax's reflection is put forward through a play with narrative voices and as a fellow participant in its overall charge of de-centering cultural trajectories, it seems appropriate to additionally inflect these with analyses that are both spatialized and founded in ethnographic observation of a fairly mundane nature. In so doing I am attempting an argument that would wish to both unframe the realm of art from all of those deeply isolating grand privileges, from all those impossible demands, while at the same time allowing it to be the space of collective engagements. Not collective engagements planned in the headquarters of ideological persuasions, but rather those that Arendt characterized as 'speech and action', loosely coming together for a momentary expression and then coming apart again. This 'space of appearance' articulated by Arendt is neither concretely inhabited nor is it temporally constant, it comes into being 'whenever men are together in the manner of speech and action, and therefore precedes and

predates all formal constitution of the public realm and its various forms of government'.[1]

Why have I gone back to old Hannah Arendt you might well ask – to someone so often allied with 'liberalism' and who seemingly predates the intricacies of 'difference' – in trying to think of some of the little steps which might follow in the wake of the slippery sliding 'line in the middle' Yve Lomax speaks of?

Why then?

Having abdicated the collective investment in totalizations and singularities which had long claimed the task of our collective cementing, can we begin to think alternative collectivities and can we do so without lapsing into some lamenting grief about the clear cut guidelines and navigational principles we had once shared in those long gone days of certainties and the unequivocal actions that these legitimated. This state of having first fragmented those certainties and of currently trying to go beyond both these and the endlessly fragmented lines they have dissolved into is not an act of refutation – 'No' says Yve Lomax, 'not a question of a lost or unlocatable reality, no, not a question of total mystification.'[2]. Therefore it is not a refutation of those old demands but a refusal – a refusal of both them and of the very terms by which they come into conceptualization and operation, that is my preoccupation. It is for this reason that I have dragged in old Hannah, because of the exceptionally fresh and arbitrary nature of the 'space of appearance' that she proposes to us.

In its fleeting and ephemeral constitution the 'space of appearance' shares much common ground with Henri Lefebvre's concept of 'spatialization' as the constant social production of space. Not a space named by its concrete constituents such as buildings or environments or tasks, but one which comes into being through a related readings of actions and of the fantasmatic subjectivities projected through these actions. The peculiarity of this 'space of appearance' says Arendt ' ... is that, unlike the spaces which are the work of our hands, it does not survive the actuality of the movement which brought it into being, but disappears not only with the dispersal of men ... but with the disappearance or the arrest of the activities themselves. Wherever people gather together, it is potentially there but only potentially, not necessarily and not forever.'[3]

The knowledgeable reader, immersed in Structuralist and post-Structuralist theory as such readers are, will inevitably ask why invoke Arendt when we have available to us theories of spatialization as those opened up by Lefebvre, theories of discourse as those put forward by Foucault and the strategies of performativity suggested by Butler ? In partial, only very partial, reply I might say that it is because Arendt's thought links speech and action to the very constitution of power, not power as a mode of representation, nor power as the concrete articulations of ideological belief and their consequent translation into various structures of speech

and of government. 'What keeps people together after the fleeting moment of actions has passed (what we today call "organisation"), and what at the same time they keep alive through remaining together, is power.' Neither Force, strength nor violence nor the apparatuses of the State or the law, this power conceptualized by Arendt is the fleeting coming together in momentary gestures of speech and action by communities whose only mutuality lies in their ability to both stage these actions and to read them for what they are. The space of appearance in which these momentary actions take place are the staging grounds of protests, refusals, affirmations or celebrations and like Lefebvre's 'space in the process of production' they do not bear the markings of traditional political spaces but rather galvanize the spaces of everyday life and temporarily transform them by throwing flitting mantles of power over them:

' ... action and speech create a space between the participants which can find its proper location almost any time and anywhere. It is the space of appearance in the widest sense of the word, namely, the space where I appear to others as they appear to me, where men exist not merely like other living or inanimate things but make their appearance explicitly.'[4]

The reason I would wish to think of 'art' in relation to such a 'space of appearance' is twofold; in the immediate context it has to do with my perception that at the heart of Yve Lomax's meditations on writing the image is an engagement with photography – not with photography as a history of images and technologies and practices, not with photography as an aesthetic, not as a representational trope nor as an intervention against the hegemony of the 'high' (as in debates over the high/low divide in culture) or of the 'object' (as in the efforts to overthrow the authority of the concrete, material, presence of objects in favour of practices that foreground practice). Rather it is an engagement with photography as a field of possibilities and as a set of connective tissues in which all of the makings and displayings and readings and communicatings link up with thoughts and imaginings located entirely outside of them. Thus, and this is the second level of locating the argument, when something called 'art' becomes an open interconnective field then the potential to engage with it as a form of cultural participation rather than as a form of either reification, of representation or of contemplative edification, comes into being. The engagement with 'art' can provide a similar space of appearance to that described by Arendt, not by following the required set of interpellated, pensive gestures but rather seeking out, staging and perceiving an alternative set of responses.

What is it that we do when we look away from art?

When we avert our gaze in the very spaces and contexts in which we are meant to focus our attention?

When we exploit the cultural attention and the spatial focus

provided by and insisted on by museums, galleries, exhibitions sites and studios to cajole some other presence, some other dynamic in the space, into being? Are we producing the 'affirmation through negation' Yve Lomax speaks of in her discussion of the *Alpha,* its very refutation serving to actually ground its importance or are we opening up a space of participation whose terms we are to invent?

Is this averted gaze a refusal of the work on display, of the contexts which frame it, of the claims made for it, of the gravitas required in its contemplation, of the gratitudes it demands for our supposed edification? Perhaps it is a refusal of the singularity of attention that the work traditionally demands (a friend tells of never being able to get into a museum's exhibits because he always seems to get waylaid by the bookstore, another friend spends longer talking about the different coffees in the museum's cafeteria than about the exhibit that generated the visit in the first place).

Beyond Benjamin's notion of the 'aura' with its combined understanding of how uniqueness and value mutually constitute one another through the production of a third entity, the work of art imbued with a halo of splendidness – we have to think of what actively separates the work from everything else that takes place around it. In this context I would have to briefly and tediously insist on the difference between the project of contextualizing art, of embedding it in social and other histories as appropriate frameworks for the production of meaning – a largely academic and scholarly project which galvanizes both archival materials and methodological analyses to provide frames for reading works – and between that of the performative gestures which I have in mind and which work to undo those very frames. I am referring to those moments in which people come together to unconsciously perform an alternative relation to culture, through their dress, or speech or conduct.[5] These performative gestures offer both a disruption and the possibility of an alternative and less obvious set of links with its surroundings, links which may be quite arbitrary or coincidental to the trajectories of immanent meanings. Of these, the most insistent separations between bodies of work and their surroundings come about through two sets of beliefs:

– A belief in the singularity of the work of art.

– The cultural habits of affording it, that singular work, our unfragmented attention.

Therefore we have to unravel both concepts of 'singularity' and those of 'undivided attention' in order to rework the relations between works and audiences through strategies of concentration.

To unpack 'singularity' I am using Giorgio Agamben's argument in 'The Coming Community'; a series of linked essays which asks how we can conceive of a human community that lays no claims to identity? Of how a

community can be formed of singularities that refuse any criteria of belonging? A community whose collective basis are neither the shared ideological principles nor the empathies of affinity and similarity? 'The coming being [community] is whatever being ... The Whatever in question here relates to singularity not in its indifference with respect to a common property (to a concept, for example: being red, being French, being Muslim) but only in its being such as it is. Singularity is thus freed from the false dilemma that obliges knowledge to choose between the ineffability of the individual and the intelligibility of the universal. The intelligible according to a beautiful expression of Levi ben Gershon (Gersonides), is neither a universal nor an individual included in a series, but rather "singularity insofar as it is whatever singularity". In this conception, such-and-such being is reclaimed from having this or that property, which identifies it as belonging to this or that set, to this or that class (the reds, the French, the Muslims) – and it is reclaimed not for another class nor for the simple generic absence of any belonging but for its being-*such*, for belonging itself. Thus being-*such*, which remains constantly hidden in the condition of belonging and which is in no way a real predicate, comes to light itself: The singularity exposed as such is whatever you *want,* that is, lovable.'[6]

Yve Lomax in unshackling photography from being either the representation of a single reality or the manifestation of a singular practice says: 'Photography is mixed up with all sorts of things – law and order, the family, the medical professions, the art market. Photography is involved in a diversity of practices, stories and theories. There is painting in photography. There are words in photography. There is sexuality in photography. There is money in photography. There are a host of different "photographies". When we start with photography we are already in the middle of quite a few things. Indeed, we may argue that there is no such thing (in itself) as Photography, only photographies.'[7] Between Yve Lomax's pluralities and Agamben's notion of the 'whatever' (which for the sake of clarity, is not the 'whatever' of California teenagers in which anything can be substituted by anything else, more a distrust of speech) we have a joint project of de-centering – not the repeated movement of return to a narrowing enclosure but the introduction of a logic of movement at whose core is a non-epistemic, or perhaps better a counter epistemic, arbitrariness.

Agamben continues: '*Whatever* is the figure of pure singularity. Whatever singularity has no identity, it is not determinate with respect to a concept, but neither is it simply indeterminate; rather it is determined only through its relation to an *idea,* that is, to the totality of its possibilities. Through this relation, as Kant said, singularity borders all possibility and thus receives its *omnimoda determinatio* not from its participation in a determinate concept or some actual property (being red, Italian, Communist) but *only by means of this bordering.*'[8]

Thus the singularity of 'art' is disrupted by a de-centering dynam-

ic, broken up by the totality of its possibilities and by the arbitrariness of the principle of *'Whatever'*.

'Disrupted'

Theoretical analyses are also lived realities as Lomax's text shows in its circuitous roams between analysis, fable and voices of reminiscence. Thus the disruption of art's singularity, of its hold on our attention and focus are everywhere in the speech and action we produce in the seemingly unimportant registers we engage in relation to it .

G.B. and I have gone to see the Jackson Pollock exhibition at the Tate Gallery. I am wary of the hyperbolic claims made for the grand master of Abstract Expressionism, wary of the investment in the muscular and visceral hero of Modernism, wary of the equation of action, physicality and scale with some notion of liberation and of a strike for cultural autonomy. In short I am critically on guard and approach the whole visit with weariness and a sense of cultural obligation. I have dragged G.B. along in the hope that his superior knowledge of the period and of the work, the fact that he has already visited the exhibition on several occasions, will provide me with insight and animate the encounter, chip away at my weariness. Shortly after entering the exhibition and beginning to look, through the compulsions of chronology, at the early work, we spot the actress who plays the beautiful nurse Carol Hathaway on the fabled TV series *ER*. We are mesmerized, we follow her around the exhibition, she is even more beautiful in real life than on the screen and we speculate on the colour of her hair and on the relationship to her companion at the exhibition. Our attention has been well and truly diverted and one mythic structure – the heroic Modernist figure of Pollock and the art history that instates him and claims that singularity of our attention for him and for his art – has been interrupted by another mythic structure, that of Hollywood celebrity and the odd slippages between distance and proximity, reality and filmic fiction that occur when it is delivered directly into our living rooms with weekly regularity. It is entirely true that both G.B. and I are fans of the series, at the same time it is also true that we occupy ourselves with the critical interrogation of the meanings and status of art within broad visual culture. Were we simply swept along, interpellated by fandom and struck by glamour or had we staged a disruption that was entirely necessary for our own viewing processes, allowing us to exit the application demanded from us and to unframe the exhibition from the isolating claims made for it, from its mythic structures? Perhaps by wilfully juxtaposing one mythic structure with another, using culture to stage our need for disruption rather than engaging in some mode of unruly behaviour.

Mythic structures therefore clearly play a substantial role in the

interpellation of our attention. Much thought has been given to the mythic in terms of heroic artists and of valiant ground breaking avant guard movements, of figures and actions which seemingly take on in opposition, some set of perceived conventions of the day and articulate a set of resistances to these. But they are equally the primal scene of Arendt's 'space of appearance' and evolved out of the joint operations of narrative and conversation. Certainly in the case of the disrupted viewing of the Jackson Pollock exhibition, G.B. and I regaled one another with tales of our watching experiences and reactions to *ER* – our perceptions of the characters portrayed, of the actors portraying them, of the evolving story line, of the mesmerizing effects of the fast cutting technique which is the series cinematic hallmark. Not only was one mythic structure mobilized in relation to another one, that of the exhibition, but a viewing position, an alternate of imbricated fan as opposed to reverential spectator, was put into play in this disruption.

Myth, states Jean Luc Nancy, begins when a group is gathered listening to a story and the telling of that story is the entire point of their assembly – the scene of the myth is their space of appearance 'We know this scene well. More than one storyteller has told it to us, having gathered us together in learned fraternities intent on knowing what our origins were. Our societies they have told us, derive from these assemblies themselves, and our beliefs, our knowledge, our discourses and our poems derive from these narratives.'[9]. The relation of the narrative and of its structuring properties within the mythic is to do with the fact that what it communicates is itself, its process of communicating. 'It does not communicate a knowledge that can be verified from elsewhere: it is self communicating ... In other words, along with knowledge, about whatever knowledge about whatever object it might be, it communicates also the communication of this knowledge ... Myth communicates the common, the *being-common* of what it reveals or what it recites. Consequently, at the same time as each one of its revelations, it also reveals the community to itself and founds it.'[10] One of the most interesting of Nancy's insights is the degree to which critical or analytical initiatives (his examples are Romanticism, Communism, Structuralism) are secret communities and constitute the very last possibility of myth to both invent itself and transmit itself. Another is his insistence on its fictional nature: 'Mythic thought – operating in a certain way through the dialectical sublation of the two meanings of myth – is in effect nothing other than the thought of a founding fiction or a foundation by fiction.'[11]

Both of these insights I believe to be the source of much comfort, yet another acknowledgment of Derrida's faith in there being no 'outside of the text', an endorsement of the fact that as we converse and exchange critical perspectives we do not situate ourselves beyond their contexts and interpellations but rather shift the ground of these and recognize the degree

to which we ourselves are its mythic objects. We are the arena and the site of both of these combined activities. As Nancy says, myth operates simultaneously as both 'foundation' and 'fiction' and its truest form of thinking is philosophy which wants to both tell the truth 1. of myth and 2. in relation to (as opposed to) myth.[12]

But having agreed on the space of appearance and on the inherently split nature of the mythic, now we also have to face not simply the fictional but also the fragmented nature of the critical models around which a gathering could take place – beyond Romanticism, Communism, Structuralism. We locate ourselves within atomized trajectories in which direction or subject, one direction or one subject, are not at all inevitable. On the contrary says Yve Lomax: 'Think of making the art gallery a most untimely place. Think of making the lines break through and not settling for well established points. Think of all the lines which are involved. Rigid lines – sexual lines – institutional lines – supple lines – saddening lines – electric lines. Lines of prejudice but also vibrant lines. The lines involved within the formation of the gallery space can never be contained in just one local place.'[13]

Everything that we had previously counted on in order to focus our attention – the fixed and designated identity of named spaces, the perceived clarity of division between subject and object, the gripping and compelling nature of myth – have come undone within the dialectics of subjectivity. In Jean-Luc Nancy's terms:

'Myth realises itself dialectically: it exceeds all its mythic figures to announce the pure mythology of an absolute, foundational, symbolising or distributive speech.

'It is here that things are interrupted.

'The tradition is suspended at the very moment it fulfils itself. It is interrupted at that precise and familiar point where we know that it is all a myth ... and the word 'myth' itself designates the absence of what it names.'[14]

The disruption I recounted is partly an intervention in a mythic structure and the compulsion to point to the absence that it names through the deployment of a high/low dichotomy. But it is also performative and makes a claim for what Hannah Arendt calls 'the space of appearance'. For Arendt, this space of appearance is what makes possible 'action' and the inevitable reversal it has wrought in the hierarchical order between in Arendt's terms, contemplation and action. Having become aware of the very mythic nature of our own critical interventions, it is the minute gatherings of refusal and disruption which are left to us to somehow live out the combined entities of participation and criticism. To make such a statement is to somehow be seemingly gripped by a Situationst ethos, by the echoes of stealthy street actions, remade topographies and inscriptions left behind on walls. How do we occupy the space of commanding attention in ways that

is not the take over of street marches nor the romantic covert operations of the agents of 'detournement'? Perhaps we could say that we simply do not, that we refuse that very notion of a spatial occupation in which our identity is made subjugate to a named commonalty. That we live out Agamben's 'whatever' in the vagaries of trivial conversations that ebb and flow, making and remaking the 'space of appearance' as we speak of different things. Inside, distracted, acknowledging that our utterances come back to us in inverted form, conceding the common while refusing its identity – that's us.

**Serious Words
Act One:
The Study**

The photograph and *les temps*

When the fragrance of a body beckons we may ask, 'well then, what is a body?'

A body can be anything – an animal, an idea, a body of sounds, a mountain, a linguistic corpus, a child, a photographic body of images or a wind. A body, we might say, is never separable from its relations with the world.

It is the *affects* that bodies have upon one another which come to constitute the photographic image or indeed make the child. It is the relations entered into which come to define a body.

'Nothing but relations', we may reply.

Here then are bodies which are not defined or distinguished in terms of an internal essence, which conditions or gives birth to the mode of their being. 'The interior is only a selected exterior, and the exterior a projected interior.'[1]

Bodies are continually affecting each other and in so doing, composing, recomposing and decomposing a variety of relations. As such, we might say that a body partakes of differing times. In old age we can enter into relations which make us very young. However, have our Western bodies become so accustomed to following a single linear time that to intuit a multitemporality seems a little difficult? Yet as our bodies enter into different relations and changing contexts, perhaps it is not so difficult to accept that a body is of *all times*.

So, when asked, 'what is a body?' perhaps we shall come to say, *a bouquet of times*.[2]

A bouquet of times?

Here an image flowers.

Here I have an image of different times, the fragrances of which are continually born upon an air ...

&

In *Camera Lucida* Roland Barthes speaks of the photograph's immobilization of time. 'A strange stasis', he says, 'the stasis of an arrest.'[3] It is not only Barthes who speaks of the photograph as an arrest of time. How often have you heard the idea that the photograph immobilizes time?

'The photograph is a device for stopping time.'

'The photograph is a frozen moment.'

'The photograph freezes time.'

It seems to me that we have become fixed upon fixing the photograph as a segment of frozen time.

Let us for a moment call to mind that infamous idea of the photograph as a window on the world. Now, when time enters the picture it seems no mere fluke that the image of a window can easily be seen as a sheet of ice. Here we have two images which can be placed over one another without radically altering the picture: we have an image of a fluid that has become a solid and which has, to a greater or lesser degree, transparency.

The idea that the photograph is a segment of immobilized time seems to exhibit all signs of an *idée fixe*.

&

An *idée fixe* is by definition an idea which has become fixed, immovable; by definition there is no movement or warmth towards other ideas. There is no thinking that things could be otherwise. A solid prejudice rules: we shall not be moved into thinking something other.

A fixed idea is not predisposed towards mobility: immobilization is what it favours. It favours freezing rather than fluidity. A fixed idea is not prepared to open itself to the turmoil and turbulence of fluidity: it prefers a frozen heart.

When ice is below to such a degree, to touch is to have one's fingers burnt. Yet there is another degree, considerably higher, where to touch is to melt. We may well ask then: what sort of touch does it take to melt the heart of a fixed idea? What sort of touch makes a fixed idea warm to other ideas? I don't have an exact idea of what the requisite touch would be; like a love that comes upon one when least expected, perhaps it is all a matter of being taken by surprise. Has it not always been by surprise, that unexpected touch, that philosophy has melted my thoughts and set other ideas in motion?

I am suspicious of those (including myself) who proudly claim that they are free from prejudices. Yes, I carry my little bundle of fixed ideas. Yet having carried this bundle over the years, it is interesting to note how the contents have changed. I have stubbornly fixed upon one idea and then at another moment, quite unexpectedly, found myself monomanically arguing for another. And the seeming paradox which now confronts me is that I am fixed upon questioning the idea that the photograph immobilizes time. Yet this paradox brings into play something that I wanted to do for some time: to explore the fragrance of different times.

'Well', someone might ask, 'how can you be sure that we have become fixed upon the idea of the photograph as an immobilization of time? Do you believe that this idea has become doxa, received opinion?'

'I am not sure if this idea can be said to be received opinion. I haven't done an opinion poll. I have no idea.'

But I do have an idea.

I have a hunch. The idea of the photograph as an immobilization of time, whether or not it is identified as 'frozen' or 'received opinion', has given me an idea to explore. This idea started with the writing of **'Sometime(s)'**[4]. I say 'started', but it was more a case of unexpectedly finding myself in the middle of considering some times in relation to the photographic image. I hadn't started out with the precise idea to write upon 'Photography and Time'. If I had started with such a grand title then I would never have put pen to paper, out of sheer fear. It was a matter of being taken by surprise. Once again I had been browsing through *A Thousand Plateaus*[5] when suddenly I fixed upon the words 'sometimes, sometimes, sometimes'. I had been considering the idea that any single photographic image has the potential to produce a diversity of effects, that more than one story/time can be told. Sometimes a laughter effect. Sometimes an economic story ...

Suddenly my ideas were away.

I began thinking that with any still photographic image there isn't just one time, on the contrary there is a plurality of times, not all of which are happy to consort with each other. The picture was becoming more turbulent than I had expected. Different cultural times. Different social practices of time. Different models and images were competing with each other. Circles. Lines. Spirals. Jewish time. Christian time. Islamic time. Capitalism's time. Animal times. Clock-wise time. Asking 'what is the time?' suddenly took a different slant. What conception of time has imposed itself as the one and only time, the correct time, by subordinating and negating other times?

&

When time is said to have been stopped, I start thinking that time moves. When ice is said to have formed, the image of water begins to flow ...

It seems to me that by way of immobilization all is set in motion for a certain conception of time to fill up the picture. Indeed, it seems to me that the idea of the photograph immobilizing or freezing time sets in motion the very idea that time, by its own nature, flows.

To fix upon the idea that the photograph immobilizes time is to endorse, perhaps unwittingly, a certain conception of time. Perhaps we should take care to turn over the photograph and see if such an endorsement has not permitted a certain conception of time to be written as *the* time, the definite article itself.

Questioning the idea that the photograph immobilizes time, and equally concerned to ask if one conception of time imposes itself as the only one, I began to consider the idea that time *flows*.

Suddenly I heard the sound of running water and in the blink of an eye the image of a river began to flow. I began to listen, as attentively as I could, to the conceptions of time that the flowing river set in motion. Often coming in brief snatches, I heard various stories. I couldn't be sure that I had heard the stories correctly, or heard them all, yet I began nonetheless to formulate my own theories. As I put my theories together, it seemed no accident that, in time, a linear story began to impose itself. Oh yes, the stories had gone around in circles but as I put my theories together, incomplete as they were, I soon realised that what I had been hearing added up to a particularly, and perhaps exclusively, Western *line*.

&

Time itself does flow, as a river flows past a bank side observer.

Now this is an image which forms the idea that time flows all by itself:

– For the Ancient Greeks there was in the beginning Oceanos, a divine river. This god of a river flowed around the rim of the world in a forever recurring circle. Oceanos had all the time in the world; the river flowed absolutely and eternally. Indeed, there was no time that did not belong to Oceanos; from this cosmic river flowed the 'generation of all'.

– Now the divine river of Oceanos repeated itself in the figure of Chronos, 'the round element'. With Chronos, time repeated its never ending cycle. The circular image of time continued to flow on eternally, as still it does today on those circular clocks which adorn walls and wrists and all sorts of mantelpieces. However, a difference emerged when the figure of Chronos merged with Kronos.

– With Chronos/Kronos time took a definite direction. The flow remained absolute and independent of any observer who happened to sit upon the bank side, but now it became irreversible. Unlike the cosmic river which remained forever high in the sky, this river came down to earth. There was only one way to go, only one way to flow. There was no ques-

tion of time repeating itself. Time was to proceed along a one directional line and mortals came to speak of *chronological* time.

– Known as 'the giver of measures', Chronos/Kronos supplied the idea that time could be measured by marking the river's flow. Walking along the river bank, mortals were given the idea of *passages* and *lengths* of time. Indeed, it could be said that Chronos/Kronos bestowed upon mortals the idea of a strip or line along which lengths could be marked off and numbers affixed.

– With the image of the river in sight, the bank side observer was given the notion that time could be measured by the flow of a substance. And hence, time measuring instruments were devised which were based upon the flows of water, mercury or sand. The idea of measurable time flowed and mortals developed a passion, if not obsession, for perfecting those instruments that came to be known as clocks. In remembrance of the eternal time of Oceanos their faces my have been round, yet the development of clocks proceeded with a very definite linear conception of time. Clocks imposed their conception of time and under their influence some mortals came to believe that clock-wise time was the only time to tell.

– Time pursued an irreversible course and, influenced by the figure of Kronos, mortals became consumed by the idea of time as the great devourer. Kronos was a deadly figure, he ate his own children and reminded mortals of their mortality. With Kronos time took a negative turn; it became a monstrous consumer. In the end all is lost to time, all is eaten up and destroyed. Coming face to face with Kronos one could not avoid meeting death. Here was the face of the grim reaper, the figure who with sickle in hand harvests all.

– Kronos brought his image to bear upon the idea that time pursues an irreversible line, yet following this line mortals began wishing that they could immobilize time and win for themselves immortality and everlasting life.

– Adam and Eve ate apples and Kronos ate his offspring; in both instances there was a Fall from the paradise of heavenly eternal time. However, a great redeemer was to be born who would save mortals from the greed of an all devouring time.

– A son was born in Bethlehem, his name was Jesus. But this was no ordinary son; this was the son of a god who had a redeeming plan. In terms of this god's plan, time was still to pursue a linear course yet now there was a *telos:* linear history was to flow purposefully towards a meaningful end. Mortals will progress towards perfection and finally they will be delivered from linear time itself. The river of time will give up its dead and a new heavenly time will be created. In the end time will end and death will be no more.

– Jesus Christ was crucified upon the cross yet upon his remarkable return from death, mortals were given the promise of eternal light and everlasting life.

– The river of time carries me through to Christian historical time. Christianity has taken great trouble to make its historical time the one and only time, the universal story. The year is now 1687 *anno Domini* and for Sir Isaac Newton, who has just published *Principia Mathematica*, the flow of time continues to be absolute and universal. For this famous English scientist time flows, 'equably without relation to anything external'. He who observes time does not affect time and, moreover, whosoever seeks to measure it shall find time universally the same.

For Isaac Newton time is still of the order of an emanation from (a) God. However, for the emerging physics that was to be called 'Newtonian' the divine river of Oceanos belongs unmistakably to mythological times; and these times bear no relevance to modern times. Time may be conceived of as a flow, absolute and universal, yet here is a science which has the desire to completely straighten out time, to make mathematical progress and leave behind, for the poets to swim in, all the images and metaphors, all the mythologies of time. For this science a purely mathematical idea of time could be perfectly described by a geometrical line.

&

Accustomed as perhaps we have become to think of science as that which has no time for myths and fables, it is somewhat of a myth itself to think that truly scientific times do not involve mythological times. Yes, we may have become accustomed to thinking that the only time that scientific knowledge has for myths, illusions and fables is in order to discredit the fabulous, dispel the illusionary and demythologize the decidedly mythological. Yet, the very idea of science as fable-free is itself a fable.

Should we not always take care to listen to old wives tales?

&

The time of a season. The time when changes in the weather make us chat to a stranger. 'It's getting colder, summer is definitely over.' Another time. An autumn time. A turning time. Yet not exactly the same time returning again.

The colour green turns to rusty brown. A vibrant wind takes a turn with fallen leaves and a swirling dance proceeds. Pages of a book are turned and I read a popularized account of Albert Einstein's Theories of Special and General Relativity.

Leaves and wind and Relativity.

I listen to stories of how the Theories of Relativity had stirred up the conception of time as flowing universally the same. I hear that these theories had whirl-wind effects upon the Newtonian conception of time. The absolute and universal time which Isaac Newton wished to believe remained independent of space is completely turned around: with the Theories of Relativity both space and motion affect the telling of time.

Leafing through a book. Changes in the weather. Listening to a stranger chatting to me: 'The idea of a universal present is so important that it should be afforded the status of a myth. Deeply ingrained in western world views had been the concept of time flowing uniformly all over the universe.'[6]

&

It may well be said that it is a Western myth that time flows the same, universally. Yet would we agree that such a myth is purely innocent? I cannot help but ask if this myth, this deeply ingrained conception of time, has not been part of Western culture's drive to universalize itself, to make its world view the only world view. To make, that is, its conception of time the one and only time to the detriment of others.

&

In terms of the 'deeply ingrained' Western view of time flowing uniformly all over the universe, I am afforded the belief that I can snap my fingers and the diversity of the whole universe will share this very instance, this very same moment. Now, not all of the universe may be known to me as it changes from instance to instance, yet this conception of time does allow me to think of all the people and planets and everything else and envisage them doing whatever they may be doing at this moment i.e. *now*. At this present moment a planet is spinning, a sun is shining, a bee is humming, a bird is flying, whilst a worm is dying and a human sighing. *Snap:* I may not be able to photograph it all, but the idea of a universal present allows me, for a moment, to envisage the 'universe as a whole'.

Yet listen, I say to myself, have you not heard that the Theories of Relativity snapped this whole apart? Have you not heard that with these theories the universe as a whole has been separated into fragments that can never share a universal moment in time?

A plant spinning.

A bee humming.

A worm dying.

A human sighing.

I think of these lines and the individuality of their times and I ask myself: could it be that the Theories of Relativity took up with the question, *is time one or multiple?*

&

Humpty Dumpty may have taken a great fall, yet amid the clatter of all the kings horses, and all the kings men trying in vain to put the universal whole back together again, perhaps we shall hear chatter of times many and multifarious ...

For some time now I have been reading the novels of the French

writer Michel Tournier. How long this time has been I couldn't say; it feels like an indefinite time, a time not fixed by limit or line. Here are novels which for me can't be read once and then relegated to the book-shelf to gather dust and yellow with age. Sometimes it is a single word which beckons me to return to a particular passage; sometimes it is a smart metaphor which quickens me to return and hurry through pages; sometimes it is an astonishing image which having amazed me once, makes me want to look and listen again. For a host of reasons I find myself returning to these novels. They haunt me. They compel me.

On this particular day, a passage towards the end of the novel *Les Meteores* (translated as *Gemini*)[7] suddenly came to mind. Perhaps it was the spirit of an autumn wind dancing with the fallen rusty leaves outside my window which had stirred my thoughts. Perhaps it was the question – is time one or multiple? – which had quickened me, inexplicably at that moment, to return to those pages. A vague idea was in the air; its fragrance beckoned me. My thoughts began to dance and once again I found myself following a hunch, the outcome of which I knew not.

In astrology Gemini pertains to a heavenly constellation containing two bright stars, the twins. In Michel Tournier's novel *Gemini* I hear a tale of a twin who, having become 'dispaired' through losing his left limbs and twin brother, finds himself – his time – partaking of the varying times and individualities which pertain to the weather ' ... the wind blows as I breathe, a rainbow spans the heavens in the time it takes my heart to become reconciled to life.'[8] Ceasing to possess the 'health' of wholeness, this dispaired twin finds himself drifting, as a nomad, and discovering the multiplicity of meteorological times.

Let me tell you more.

Everyone knows stories about identical twins – one gets a cold in London, the other sneezes in Rome. Twins, we may conjecture, are the very stuff from which myths are made. Fascinated by myth *'a story that everybody already knows'*[9] and finding the twin theme an enormously fertile one, Michel Tournier launches us into a tale, a lengthy journey, which from the very first page is much influenced by the weather:

' ... on the twenty-fifth of September 1937, a depression moving from Newfoundland to the Baltic sent masses of warm, moist oceanic air into the corridor of the English Channel. At 5:19 P.M. a gust of wind from the west-southwest uncovered the petticoat of old Henriette Puysoux, who is picking potatoes in her field ... turned over eight pages of Aristotle's *Meterorologica*, which Michel Tournier was reading on the beach at Saint-Jacut ... started the wind pump racing at the Freme des Mottes; and snatched a handful of gilded leaves off the silver birches in the garden of La Cassine.'[10]

Let me tell you more.

As children the identical twins Jean and Paul are united as one. No one, not even their parents, can tell them apart. They are paired as one:

Jean-Paul. Having but one soul for two bodies their beings beat to the same tempo. Both are in tune with each other; at any one moment Jean's time is the same as Paul's time. Jean-Paul live concordantly and simultaneously: their childhood twinkles with 'twinned' time.

As adulthood severs the innocence of childhood, Jean departs from his twin. Jean elusively roams the world, in pursuit follows Paul. Driven by a desire which refuses to discover a world of difference, Paul seeks to restore his twinship to its original unity, to bring back Jean to the 'one and the same'. Yet this restoration is never to be.

In his quest to be reunited with this twin brother, Paul suffers a terrible injury which results in the amputation of his left limbs. Paul awakens to his dispaired state and his heart breaks with the realization that his twinship, his wholeness, is no more. Nothing will ever be the same again. Yet even as Paul suffers emotional and physical pain, a hope swells: Paul finds himself moving towards a certain *porosity*. With left limbs missing Paul discovers that his body is open to and permeated by the times of the weather. 'There is sickness still, yes, and great pain. Yet hope swells in my heart as I realize that I am in direct contact, plugged into the skies and to the pattern of the weather. I begin to perceive the birth of a barometric body, a pluviometric, anemometric, hydrometric body. A porous body through which all the winds of heaven breathe.'[11]

Through disablement and confusion of lost limbs with lost twin, Paul feels himself extending and moving out of his miserable obsession to bring all times under the control of the 'one and the same'. Feeling himself extending, Paul ventures to take up with the life and times of nomadism: 'I know it, this left side of mine which moves, wriggles and pushes out prodigious extensions into my room, into the garden and soon perhaps into the sky and sea. *It is Jean* ... Jean the Nomad, Jean the Inveterate Traveller.'[12]

The more one side of Paul becomes fixed and lives a sedentary life with a matchless intensity, the more, paradoxically, his other side, his left side, feels unhindered to wander and partake of, rather than vainly attempting to control, the time(s) which pertain to the mists, the snows, the frost, the dog days and the aurora borealis.

Reaching into the sky and the sea, Paul's left side moves out of the time controlled by clocks and regularized by straight lines. Times at sea and times in the air. Times that toss about in a roll that no military meteorologist can bring under control, predict and make march, rank and file, to the same incessant tempo.

Having become dispaired, having lost not only his same but also his other, Paul finally finds himself reconstituting. As a calm, clear flow of dry freezing wind makes itself felt, Paul discovers his participation within those multifarious times which, in the French language, constitute all weather – *les temps*.

In *Gemini* Michel Tournier plays with and upon the twin meanings of the word *temps*. In French, and other languages derived from Latin, time and weather are 'one and the same'. Time and weather are like identical twins. As Jean and Paul suffer a dispairing so do time and weather: both cease to partake of the 'one and the same'. There is a dispairing and the emergence of difference yet as Paul finds himself extending and reconstituting, a (re)merging occurs between time and weather. This (re)merging is not merely the restoration of an original unity, a return of the same identity but a reconstitution which brings with it a difference. Whilst time and weather merge, time no longer beats to the same tempo. With this reconstituting of the intimate relation between time and weather, *les temps* become as irregular and infinitely varying as the times of the weather. Here, then, are times which remain uncontrolled by and irreducible to the clock and its predictable, ordered and regularized time.

For Paul the dispaired twin who has lost 'the one and the same', time becomes as unpredictable and unruly as that dynamic non-linear system which we call the weather. In short, the linear conception of time becomes complicated by the nonlinear times of weather. Vortices, pockets of turbulence and perturbations. Clocks splattered with rain. As the science of complexity tells us, nonlinear systems are everywhere, in every puff of wind, every swirl of mist, every cloud which dampens the day, every spring that flows gushing from our hearts. Has not love always known of the turbulence of nonlinear times?

At last I come to the end of this particular tale.

We end (or is it begin) with infinitely varying times, a multiplicity of times which partake of the seasonal round but also abound with the individuality, the particularity, of a fog, a frost, a ray of sunshine that falls across and caresses the left cheek of a dispaired twin or a wind that suddenly picks up at 5:19 pm and turns over eight pages of a popularized account of Albert Einstein's Theories of Relativity.

Is time one or multiple? Perhaps the answer to this question is blowing in the wind.

&

The first frost of winter had arrived leaving its sparkling pattern upon ground, grass and window pane. As I reflected upon this scene, the idea that the photograph freezes time suddenly began to turn. Frost on the window pane and the photograph as a frozen moment: was I glimpsing here the knowledge that the photograph partakes of times which pertain to the weather? The very idea of the photograph freezing time may be said to be a myth, yet perhaps this myth recognizes, if only in a glimpsed manner, that the photograph has as many times as *les temps* of the weather.

It may be a still day without a breath of wind. Stillness may pre-

vail, yet even upon such a day the times of the still photographic image remain unfixed, indefinite.

Yes, we could say, *in the air*.

Perhaps it is a myth that time 'itself' flows and an illusion that the photograph freezes this flow. Whilst it may be our delight to dispute myths and illusions, let us not dream that our argument will not bring into play other myths, other illusions. Again I am reminded of the words of Michel Serres. 'Knowledge without illusion is an illusion through and through, in which everything is lost, including knowledge. A theorem of it might be sketched like this: *there is no myth more innocent than that of a knowledge innocent of myth.*'[13]

A cold, clear winter's night and the stars shine bright. The meteorologist predicts a frost and the astrologer observes the heavens at the hour of a birth and predicts the events of a life. Meteorological times and astrological times: as I listen to the weather forecast and read my 'stars', these times form part of my daily times.

Twinkle, twinkle, little star, how I wonder what you are.

Stars in the sky. Signs in the sky. Signs to be interpreted.

Celestial bodies affecting terrestrial bodies. Heavenly movements affecting lives and events on earth.

I was born on the 18th of December. I was born under the sign of Sagittarius. Here we have the image not only of a fabulous monster, half human and half horse, but also the Archer. In short, a monster who shoots arrows.

My life, horoscopically speaking, partakes of sagittarian time. A time which pertains to sagitta – an arrow.

The arrow of time. Come, let us see in which directions this image will take us.

&

A sagittarian shoots her arrow. As the arrow flies through the air we may *snap* our fingers and ask: At what point now is the arrow's time? However, in order to answer this question and secure the instance snapped, do we not have to convert the arrow's time into a line? Take a ruler. Draw a line. Then you can divide infinitely the arrow's time into a series of points or instances. No problem, you might say. Yet as we convert sagitta's time into a line are we not confronted with the paradox that perplexed Zeno from Elea many a year ago? If the arrow were at a certain point at every moment then, *snap*, wouldn't the arrow be immobilized at every instance? And then surely it would be immobilized for ever. The sagitta would never be air borne. As we convert the arrow's time into a line and make precise points or instances, do we not come to miss sagitta's time completely? Something happens, as it were, behind our backs.

In the early part of the twentieth century, the philosopher Henri Bergson was led to consider the idea of time; and there, as he said, 'a surprise awaited me'. Henri Bergson met with the idea that the mobility which pertains to time is irreducible to a series of 'instants' or 'points'.

Let me quote at length.

'Ever since my university days I had been aware that duration is measured by the trajectory of a body in motion and that mathematical time is a line; but I had not yet observed that this operation contrasts radically with all the other processes of measurement, for it is not carried out on an aspect or an effect representative of what one wished to measure, but on something which excludes it. The line one measures is immobile, time is mobility. The line is made, it is complete; time is what is happening, and more than that, it is what causes everything to happen. The measuring of time never deals with duration as duration; what is counted is only a certain number of extremities of intervals, or *moments*, in short virtual halts in time.'[14]

How can we come to understand 'time sagittaria' without 'converting it to a line and then dividing the line into mathematical points in time or instants.'[15]

The terms which designate time are borrowed from the language of space. When we reduce sagitha's time to a number of instants or moments we are spatializing time. That the arrow's time should appear, paradoxically, immobilized at every instant is an effect of the spatialization of time. *The moving arrow never is at a certain point.*

Time and space have been placed on the same level and treated as things of a kind. ' ... the procedure has been to study space, to determine its nature and function, and then to apply to time the conclusions reached.'[16] To pass from space to time one only has to change one word: replace juxtaposition with succession.

Space and time have become like counterparts. Yes, we could say that they become like identical twins where no difference can be told. Let us cease treating space and time as twins. For, when we do so, it is always space which speaks, always space which seeks to have the last word, always space which seeks to dominate and return the difference to the rule of the One and the Same.

'When we evoke time, it is space which answers our call.'

It is important, however, to specify what kind of space answers our call when we evoke time. Exactly what space is Henri Bergson referring to when he speaks of the *spatialization of time?*

The space in question is that of Euclidian geometry.

White lines drawn on blackboards. At school I was taught a geometry of flatness, worked out by a Greek mathematician named Euclid

over two thousand years ago. Against the plurality of different spaces and ways of representing space this geometry drew a univocal model of space. For Euclidian geometry there is only *one* space. No other space counts in the way that this geometrical space does. 1.2.3. Here is the one space where metric measure can apply its rules. Here is the one space which infinitely can be divided and measured.

Geometry. 'The measure of the world.' The spatialization of time pertains to the space which the measuring rules of Euclidian geometry invented.

Geometrical space = measurable space = homogeneous space. Indeed, we may ask: Have the rules of Euclidian geometry led us to believe that all space is the same? When a geometrical line is applied to the question of time is it any accident that we should come to maintain the idea of time as succession, and twined with this, the idea that time is homogeneous, the same throughout?

Let us think of time in terms otherwise than those borrowed from space.

<p style="text-align:center">&</p>

When we reduce time to a series of points or instants we are spatializing time. When we speak of the immobilization of time we are spatializing time. And for Henri Bergson the photograph provides the perfect example of such spatialization of time.

'Immobility is but a picture (in the photographic sense of the word) taken of reality (duration) by our mind ... ' ' ... But the moments of time ... are only snapshots which our understanding has taken of the continuity of duration.'[17]

Imagine that we 'shoot' in rapid succession a series of photographic shots of the sagitta's flight. We develop the film and from the negatives make a 'contact sheet'. As we look at this sheet we see strips of images. We see a series of distinct segments (frames) immediately adjacent to each other. Succession does become juxtaposition. Photographing sagitta appears to reduce the arrow's flight (time) to a number of immobile pictures or segments. But let us remember that for Henri Bergson the mobility which pertains to time is irreducible to immobile states. In short, the photograph never arrests or freezes time. The photograph doesn't immobilize time; it *spatializes* time.

We may come to the conclusion that photography is a spatialising machine par excellence. Yet, is this the only way to regard the photographic image? What if we extended to the snapshot, the photographic image, the invitation to think time in terms otherwise than those borrowed from geometrical space?

When we approach a photographic 'body' with a non-homogeneous concept of time who knows where the image of time as an arrow will take

us. Perhaps this image, this photographic shot, will carry us not only to heterogeneous time but also heterogeneous space?

&

It is almost mid-winter, only yesterday did it seem to be early summer. How time flies!

Time flies and a sagittarian asks herself: at what point in my life am I now? If this sagittarian were to follow Henri Bergson's argument perhaps she would reply that, like the moving arrow, the time or duration of her life never is at a certain point.

The time or duration of my life is 'forever incomplete, being always a *fait accomplissant* and never a *fait accompli;* in other words, it is a *continuous emergence of novelty* and can never be conceived as a mere rearrangement of permanent and pre-existing units. It never barely *is*; always becomes.'[18]

The moving arrow never is at a certain point. The time of my life never is, it is *continually becoming.*

Most certainly, a life time can be divided into points. Yes, one can always proceed in this manner. One can always go from point to point and determine from this procedure a succession of distinct segments. Chronology proceeds in this manner, as does often the writing of autobiographies, and the sequences of family snapshots albums.

My life is never at a certain point, and the photographic image is a body which is continually becoming. To speak of points or segments in time is to concede to the language of geometry and to spatialize time. Perhaps, in so doing, we come to miss the time of our lives.

Multiplicity, a sagittarian arrow, and

It is pouring with rain and I am rushing along the street seeking shelter. Quite unexpectedly I bump into an old acquaintance.

'My God, its been ages since I've seen you. What has become of you?' The philosopher Gilles Deleuze thinks that this question is particularity stupid for, 'as someone becomes what he is becoming changes as much as he does.'[1]

The continual becoming of a life isn't a matter of progressing (or regressing) through a series of 'states of being'. What she is becoming changes as much as she herself becomes. Needless to say, we persistently fix points, ascertain segments and spatialize the times of our lives.

Each year as we celebrate (or lament) a birthday we tell ourselves that we have passed from one point, segment or state of being to the next. As thirty nine years becomes forty years of age we are told that we have passed into the next segment of our lives. Now you are in the state of being a forty year old. Now you are entering middle age, and next there will be that state of being called old age.

The arrow of time flies and for this image the flight is irreversible yet even in so-called old age we are still becoming. We can enter into relations which make us young, as it were, novel and new.

Come, let us have the time of our lives.

&

Plato, ancient Greek Philosopher, is famous for drawing a distinction between Being and Becoming. For this philosopher the world of becoming (below the moon) 'is the object of opinion and irrational sensation coming to be and ceasing to be, but never fully real.'[2] Far superior is the world of being.

More often than not a life time is conceived of as journey to and from fixed points or states of being. In this sort of life becoming is subordinate to being. Becoming is merely the journey toward being. Becoming is secondary, 'never fully real'.

But there is another story which tells us that it is the journey which is 'real'.

'It is not the "states" ... that are real; on the contrary, it is flux, the continuity of transition, it is change itself that is real.'[3]

En route something new and unpredictable appears. With time comes heterogeneity, continuous variation; as with *les temps* of the weather, there never is just one time the same through out.

The weather is continually becoming and what endures is this becoming. Needless to say we often speak of the weather as if it will arrive at a state of being. We say it will be wet in the north and sunny in the south. Perhaps we speak accordingly only for convenience sake. We speak of states of being when we know only too well that it is transition which the weather is asking us to perceive. Even on those still days when a cloud hardly moves in the sky, or when a summer or winter appears to last forever, the weather is still becoming. For all the predictions and forecasts doesn't the meteorologist know only too well that the weather, like the moving arrow, never is a certain point.

Frosts and fogs and dog days and all the winds of heaven that blow through our bodies. Indeed, isn't the weather continually and unpredictably becoming? And doesn't this bring into play a multiplicity of times?

A multiplicity?

&

Has too little importance been attached to the use of the word 'multiplicity'?

The philosopher Gilles Deleuze thinks so. 'It is not,' he says, 'part of the traditional vocabulary at all – this is particularly not the case when denoting a *continuum*.'[4] Gilles Deleuze is keen that we take multiplicity as a noun. However, he acknowledges that it isn't so easy 'to reach a thought of the multiple as such, which has become noun ... '[5]

So, how are we to reach a thought of a multiplicity and, moreover, is there only one sort?

The spatialization of time offers us one way of reckoning a multiplicity of times. (And here reckoning is the operative word.) Let us think again of the image of time as an arrow. When the arrow's time is spatialized and converted into a line and then divided into points or instances, we

can indeed reckon a number of times. As we divide we can add a 3rd to 2, a 4th to 3 and so on, infinitely. As the number increases, as there becomes more rather than less, we can say that the arrow's flight contains a multiplicity of times. Each time or instance is distinct yet the difference between one time and another is only a matter of degree: it is the 20th time rather than the 3rd.

In ancient Greece Achilles enters a rather strange race with a tortoise who is given a head start. By way of spatializing time Achilles' (and the tortoise's) run can be divided into a number of steps or instances. In so doing we can obtain a run which contains a multiplicity of times. However, we also obtain another of Zeno's famous paradoxes. As with the moving arrow, the spatialization of time immobilizes each run at every step or instance: no matter how fast Achilles runs the tortoise will remain just that one step ahead.

The spatialization of time does afford us a way of reckoning a multiplicity yet this sort of multiplicity 'resolves itself into a definite number'.[6] Indeed, we may speak of 'an indefinitely divisible numerical multiplicity, all whose parts ... differ only in degree ...'[7]

In short, it is the amount which counts.

<center>&</center>

My head is swimming with numbers and then a little song breaks in and starts to sing: 'King Jesus hath a garden full of diverse flowers, where I go culling posies gay all times and hours.' Nowadays I am no longer sure about Jesus Christ being ranked as King, but what about those gay bunches of diverse flowers which I was taught at Sunday School, I can go picking all times and hours?

My childhood was spent in a village where each summer a Flower Show was held. Here was a highly competitive event where all manner of things vegetable and flowering were entered for prizes and praise. The category especially for children, which I entered annually, was that of the collection and display of a diversity of wild summer flowers. The flowers had to be wild and there had to be diversity. Now, when it came to the day, this diversity was judged according to number. Each bouquet, indeed each multiplicity, was judged upon a scale of the more and the less. To have entered but one flower and proclaimed this a diversity or multiplicity would have been judged a sorry failure, a bad joke or childish prank. No, the prizes of First, Second and Third were awarded strictly in accordance with the greatest number. In short, the diversity was judged quantitively.

It could well be thought that each collection of flowers constituted a *bouquet of times*. However, upon the prize giving day this bouquet was judged in the terms of a 'numerical multiplicity'. What was counted was a number of times, each of which were seen as separate and discontinuous. What the judging failed to take into account was the fragrance, the *bouquet*

of the bouquets. A multiplicity could be smelt in the air which defied enumeration. To be sure, the judges couldn't see it yet their noses couldn't deny it. This fragrance certainly comprised a multiplicity but, most importantly, it was non-discrete, as it were, continuous.

As I found myself sniffing out the idea of a continuous multiplicity, it was suggested to me that there are (at least) two types of multiplicities: numerical multiplicities which are discrete and discontinuous and continuous multiplicities which defy enumeration.[8]

<p style="text-align:center">&</p>

'In a multiplicity what counts are not the terms or the elements but what there is "between", the between, a set of relations which are not separable from each other.'[9]

I can always reckon a multiplicity as a collection of numerable elements or instances, but to take up with and explore the idea of a continuous multiplicity perhaps I need to turn my thoughts towards the relations between things: to cease thinking of discrete and definite things and, rather, to understand that any thing, any body, indeed any time, is never separable from its relations with the world.

Oh yes, easier said than done.

I can't deny that it is easier to think of a multiplicity as a number of elements or instances. I find myself doing so quite a lot of the time.

I think of my body. I think of a living organism. I think of this body comprising a number of elements. Blood and flesh and organs and bones and feet and fingers and head and gullet and gut. The analysis here will cut and divide and provide a numerical multiplicity. Perhaps, however, it is not so difficult to open myself to the idea that it is the relations entered into, both externally and internally, which make a body, which come to define a body.

A body, however it may be named, is continually in the making. An ongoing time which doesn't proceed from point to point, instance to instance, but ceaselessly 'bifurcates' or diverges from the path determined by the path determined by the rule of points. For Henri Bergson in the early part of the twentieth century (and for a thermodynamic of open systems in the latter part)[10] it is such divergence which continually brings into play an open future where something 'new' and thus unpredictable appears, as it were, all the time. Indeed, it is such divergence which brings into play heterogeneous times, times in transition, times that are continually becoming by way of the relations between things.

Taking up with the idea of a continuous multiplicity I may say my body becomes (and dies) in relation to a field of perpetual interaction and transition between 'all times and hours'.

And here the words of Michel Serres come to mind.

'The living organism ... is of all times. This does not at all mean

that it is eternal, but rather that it is an original complex, woven out of all the different times that our intellect subject to analysis or that our habits distinguish or that our spatial environment tolerates ... All the temporal vectors possessing a directional arrow are here, in this place, arranged in the shape of a star. What is an organism? A sheaf of times. What is a living system? A bouquet of times ... Perhaps it seemed difficult to intuit a multitemporality.'[11]

&

I didn't expect it but the image of the arrow of time has carried me to the idea of a continuous multiplicity. The arrow of time has taken me in directions that I hadn't expected. The moving arrow never is at a certain point: this idea has carried me to times which diverge from the line determined by the rule of points.

I had once seen the arrow of time as an image of an inexorable descent into decay and degeneration. Yet tonight a star burst is occurring. Venus is rising and the arrow of time is bursting into a multidirectional image.

A star.
A sheaf of times.
A bouquet of times.

&

Perhaps it seems difficult to think of a multitemporality. Ceasing to spatialize time, maybe our thoughts will sparkle with the idea that the times of a body – be this animal, child or photographic image – can never be located in one definite place. Like the particle of which the quantum physicist can never determine the exact position and momentum, the times of non-numerical multiplicities never are locatable at definite points in (geo)metric space. A body may appear to be nailed to the spot, fixed beyond belief, yet even in such circumstances there are still becomings.

The last chapter of Michel Tournier's novel *Gemini* is entitled 'The Extended Soul'. Towards the very end of this chapter Paul the dispaired twin is bedridden and lives a sedentary life with matchless intensity. Yet even as he is tied to the spot, Paul finds himself extending and becoming coexistent with the continuous becoming, the perpetual interaction of *les temps* of the weather. While Paul lies still in his bed and perceives his left side moving between the transitions of the weather, I cannot but think that he takes up with and explores the idea of a continuous multiplicity.

Come, let me quote again.

' ... I realize that I am in direct contact, plugged into the skies and to the pattern of the weather ... Then the great wrath of the storm thundered in my breast and my tears began streaming down the windows on the veranda. My grief, which has begun with the rumblings away on the

horizon, burst out a shattering clamour over the whole bay of Arguenon ...
My anger set the sky on fire and projected lightning images of anguish on
it ... While all this time my right side hardly moved, lying flat in bed, strick-
en with terror, my left side was shaking the earth and sky ... '[12]

<div align="center">&</div>

In the writings of Gilles Deleuze I read more than once that 'multiplicities
are made of becoming', that 'affects are becomings'. These lines may be
easy to read but they are not the most straight forward to follow.

What am I to make of these lines which, now I realize, invite me to
think of a (continuous) multiplicity which comprises of nothing but rela-
tions, nothing but affects.

Becomings? Indeed, what am I to make of the idea of a photograph
as a becoming?

Affects and becomings are something that happen between.

Something (I use the term imprecisely) affects another and in so
doing both enter into composition with each other; something *becomes*
between the two. It isn't that one term becomes like the other or that they
both become, like identical twins, the One and the Same: both enter into a
state of affairs where it ceases to be a matter of numerable terms.

For a sagittarian something happens between a horse and a human.
The horse affects the human and the human affects the horse. Between the
horse and the human something is becoming, something is 'in the making'
which is irreducible to either horse or human. To be sure, you can picture
a sagittarian as a half-breed: two states of being, two identities or 'territo-
ries', where each is halved and then recomposed as one (monstrous) being.
Or, you can think of something happening between these terms or territo-
ries such that both the horse state and the human state affect each other
and become, as Gilles Deleuze would say, 'deterritorialized'.

I can take this sagittarian tale further and say that a sagittarian
body or 'becoming' is nothing but the affects, the interactions, of a horse,
a human, a sheaf of arrows, a gallop ... some archery and a wind. What we
have here is an event, a set of co-functioning relations or times. Of course,
we can always divide this event into a number of separate elements or
instances. We can always turn this event into a numerical multiplicity, yet
in so doing something happens behind our backs. We miss what there is
between. We miss the times which are between a horse, a human, a sheaf
of arrows, a gallop, some archery and a wind.

Times which are in transition. Times which implicate each other.
Here things are not wrapped up in themselves. Here things are continual-
ly wrapped up with something else. One relation always involving another.
One relation always implicating another.

Multiplicities, I may say then, are made of becomings and bring with
them the work – indeed art – of implication. Folding. The difference between

things isn't so clear cut, the same and the other do not stand opposite each other.

<div align="center">&</div>

Continuous multiplicities are made of becomings and such becomings bring with them the work of implication.

What does this line of thought suggest to me? It suggests that continuous multiplicities are non-exclusive. In his book *Rome: The Book of Foundations*, Michel Serres speaks of a knowledge – 'although perhaps we should call it by some other name' – that demands implication. 'One that demands a fold.'[13]

To implicate is to include. Very often however, knowledge demands an explication which requires us to unfold in the manner of making clear cut, of cutting away. Here, 'in the last analysis', all the inessentials are to be excluded. We exclude and in so doing we believe that we can say what something is. A state of being is defined by stating and negating what it isn't. A=A=non-B. Either it is or isn't. Here we find the law of the excluded middle where everything is either A or non-A. We negate. We exclude. And then we pride ourselves on the clarity of knowledge.

We exclude. And then we believe that we have obtained true knowledge, complete knowledge. Exclude. Make a water-tight wall, a perfect boundary. Keep it out.

Dam. Dam. Dam.

We exclude and then we dare to speak of and boast about the unity of our thought.

Dam. Dam. Dam.

Everything is either A or non-A. Keep out the third. Keep out the middle. If you don't confusion will reign, will flood your thoughts, muddy the waters. However, there are some who believe that it is possible 'to think without excluding'.[14]

Continuous multiplicity, affects and becomings: are not these terms inviting me to think inclusively?

To think inclusively am I not invited to follow the principle of incertitude which makes walls porous?

<div align="center">&</div>

To think inclusively and suspend the logic of the excluded middle – oh yes, I can hear the argument against.

My dear you will talk nonsense. If you don't exclude the middle you will have no argument. You will never close your reasoning. You will never be understood. You will never conclude.

'In order for me to speak or think or write the third must be excluded. If it is not, I wander, unstable ... '[15]

For or against. Everything is either A or non-A. There is no other

way. Friend or foe? Choose. That is the threat. You have no choice. You must choose. For or against. You must reach a conclusion. The finishing point. The winning-post. The goal. That is the target of archery. My dear, either A or non-A, you must make a final judgment. This end must be your aim, your ambition.

Are you my friend or foe? Do you believe that it is possible to think without excluding?

&

It is a summer's day and a sagittarian is happily yet prudently shooting her arrows. Someone, friend or foe she doesn't know, walks up to her and asks: do you have a target in sight? What is your aim?

Now, for a stereotypical determinist the target pre-exists the act of archery. The arrow has a pre-arranged destiny.

By what name does such a determinist go? I hear the name Newtonian. This stereotypical determinist, this Newtonian, assumes that given all the data one can calculate and thus predict where a body will be later and also where it has been before.

Imagine the flight of a projectile. Imagine that one can take (freeze) any 'instance' of this projectile's flight and with the correct data plot and predict both its future and past. Imagine then that any one instance can provide all possible information about the universe. 'Frozen in that instance is the past and the future.'[16] All is preordained, down to the very last instance. Oh, just imagine.

But now I imagine those complex systems which comprise of many bodies. Now I imagine a star burst. A thousand arrows going in every which way. Now I imagine those vast weather systems where the slightest variation will lead to vastly different futures, putting paid once and for all to the deterministic dream.

Is this the argument which the sagittarian wants to make? To end the deterministic dream. Is this her goal? Is this her aim? Is this the conclusion she should seek?

The butterfly flaps its wings.

A sagittarian is shooting her arrows. Her spirits are high. Yes, its a fine summer's day. Butterflies are dancing and come to her to drink the tiny drops of moisture exuding from her body.

A sagittarian shoots her arrows. She takes aim, her words are shot. Yet as she partakes of this act she doesn't believe that her words, her arrows, have a pre-arranged destiny. She can't pretend to know in advance what their destination will be. To be sure she hopes. She hopes that some of her words will stick. Someone has approached her. Questions have been asked. And now she replies, not knowing if this someone is friend or foe.

The target doesn't exist before the act of archery. The target is made along with the act of archery. Stay a while, listen to these words.

'There is finality because life does not operate without directions; but there is no "goal", because these directions do not pre-exist ready-made, and are themselves created "along with" the act that runs through them.'[17]

Listen, continuous multiplicities are not events where 'anything goes'. They are not without inclinations. They are not lacking in direction. Continuous multiplicities *make* directions yet these do not pre-exist ready made.

&

Suddenly, in the middle of my thoughts, a question comes to mind.

Is a continuous multiplicity indivisible?

I take time to reflect.

I remind myself that a numerical multiplicity is divisible into a number of successive instances, elements, or times. One division is made after another. Cut after cut. In so doing a 4th is added to a 3rd and so on. With each division, each time is made distinct and separate. Ascertaining these different and discontinuous times, dividing and resolving the multiplicity into a definite number, subjects a multiplicity to analysis. If numerical multiplicities and continuous multiplicities were simply opposites then I might jump to the conclusion that, 'yes, a continuous multiplicity is indivisible.' If I jumped to this conclusion would I be mistaken?

Gilles Deleuze thinks so.

Reflecting upon Henri Bergson's idea of *durée*, Deleuze remarks that it would be a serious mistake to think that a continuous multiplicity is simply indivisible.

I want to hear more.

'It is not simply the indivisible, but that which has a very special kind of division; it is not simply succession but a very special coexistence, a simultaneity of fluxes.'[18]

How am I to envision this special style of division?

'It would ... be a serious mistake to think that duration was simply the indivisible, although for convenience, Bergson often expresses himself in this way. In reality, duration divides up and does so constantly: That is why it is a *multiplicity*. But it does not divide up without changing in kind, it changes in kind in the process of dividing up: This is why it is a nonnumerical multiplicity, where we speak of "indivisibles" at each stage of the division.'[19]

Yes, but how am I to envision this special style of division?

I take time to reflect.

Let me say that with a becoming, a continuous multiplicity, the *style* is that of involution. One thing (I use the word out of habit) involves another, one thing implicates another and another. There is implication, folding upon folding, and this brings with it (I imagine) a stretching. With a continuous multiplicity the relations involved are extensible. The human

and the horse and a sheaf of arrows and a gallop and a wind, and, and, and. But stop, does this implication never cease? Is there no division into beginning and end? *Again*: is a continuous multiplicity indivisible?

I know it would be a serious mistake to think that a continuous multiplicity is simply indivisible; it divides all of the time. Yet this division has a very special style, a logic which differs from the logic of analytic division, a logic which differs from the law of the excluded middle.

'Analysis cuts; the baker folds.'[20]

My father was a baker; but wait, I'll come to that story later.

&

A sagittarian shoots her arrows; she finds her words going in various directions. It may be thought that writing has only one direction in which to go yet, now as I reflect, I am beginning to fully realize that there is more than one direction to, more than one conception of, linear time.

I follow the convention of writing and reading from left to right. Is it this Western convention which makes us assume that linear time goes in only one direction? The past is to the left of us, the future to the right. However, in other cultures this convention is not always so. To go 'forward' may require a direction that goes from right to left. I think of Hebrew. I think of Chinese. Of course, it can always be argued that speech on earth proceeds in but one direction. A unidirectional arrow. Even if you speak backwards, the enunciation will still go successively forward.

Snowmen melt, statues crumble and china cups break. You can run the film backwards, you can run the tape-recorder backwards, but all this will never put Humpty Dumpty together again. But even as I speak, I become aware that straightforward linear time can produce the most unexpected nonlinear turns – another way of saying that the future is not uniquely fixed by the present or the past.

As I reflect I become aware that this writing has gone in various directions. Some arrows have come to rest; some are still flying; others have fallen into a river which is carrying them away to the turbulent waters in which Venus is rising. Writing and speech may proceed in a definite linear manner, nonetheless a metaphor can produce a turn, an implication or direction, never quite expected. But, even as I speak, let us not assume that literality and explanation has not this potential.

Through the nineteenth century steam engines huffed and puffed and for the stereotypical thermodynamicist, studying the steam and the movement of heat, the arrow of time had only one way to go. There was only one direction. There was only one arrow. There was only one interpretation of the Second Law of Thermodynamics: 'A universal tendency towards dissipation'. Decay, degeneration, death. This was the 'target' for the arrow of time.

Then one day the thermodynamicist took time off from studying the steam engines and watched the baker kneading dough. There amid the baker's transformation, fluctuations were seen. There amid the folds, the thousand little miracles of time were glimpsed.

The miracles of time, or perhaps I should speak of miraculous time.

Ah! Kronos turns in his grave: the sun shines on a bright and crisp winter's morning and we see the snowman melting into a continuous multiplicity.

&

Becomings? Continuous multiplicities? I am asked how I picture these events. I reply that there is no place where I can stand back, focus, snap and record or capture the whole thing. I could shoot a thousand photographic images and even then I could never attain the goal of picturing the whole thing.

To say this is not to suggest that becomings are devoid of images, or that in some sublime sense they are unimaginable. Are not becomings continually inviting us to use our imagination, to be imaginative? Images – be they visual, metaphorical, literal or abstract, actual or virtual – are always involved with something else, always combining with something else, always partaking of becomings. I say this to speak of the affectivity of images rather than to hark on about their failure to wholly represent or indeed re-present.

There is no outside from which I could photograph the whole thing, for becomings don't have clear cut frontiers where an inside and outside can be precisely demarcated. Continuous multiplicities don't have definite edges which we can trace; no precise outline can be produced. Rather than a box which has rigid edges, here is a fluid image. Extensible images. Stretching images.

Folding rather than cutting.

&

If we seek and do not find a precise edge then we may rush to the conclusion that multiplicities are messy events. If becomings are events around which one can't draw a neat boundary then are we not threatened with disorder?

Dis-order, the opposite of order. If there isn't order then there is disorder.

Ah! it doesn't take very long for a certain logic to step in and make this clear-cut conclusion. And what is this logic? Again I am returned to the logic of binary opposition. If there isn't order then there is disorder. Everything is either A or non-A. My dear, there is no middle way; it is too messy and muddling.

Binary opposition compels us to think dualistically. Ask yourself:

How often do I think dualistically? Ask yourself what dualistic thinking supposes. Michel Serres answers: 'The dualist supposes one space of error, illusion, and ignorance; and another, a open plateau soaked by the sun. Error and truth; the known and the unknown, the unsayable and the said. Knowledge and ideology, the conscious and the unconscious, science and poetry, heaven and hell. His simple world is made up of one black planet and one white; it makes it easy to judge.'[21]

It makes it easy to judge.

Binary opposition compels us to dichotomize, to cut in two. Divisions by two. In effect we are urged to draw a certain line. Then there is one side and its opposite, the other side.

A certain line?

'A certain line is a limit or frontier, separating spaces, defining ensembles, closing off cities, limiting ownership, designating the enemy.'[22]

That is precisely what binary logic is compelling me to do: to designate the enemy.

Ah! it is a neat logic, a very neat logic. The logic of binary opposition is against the messy and uncontainable, yet even this it manages to contain. If the attempt to draw a certain line or definite division is frustrated by a continuous multiplicity, whose style is such that it inclines not towards precise edges, we find that binary logic still manages to (re)draw its certain line.

Let me explain, if only for myself.

For binary logic a mess is the opposite of order. Simple. Binary logic (re)draws a certain line between order and disorder. The so-called messy multiplicity, the uncontainable, can then be placed on the other side. A division is made and a frontier is imposed and in effect the uncontainable is contained.

In effect multiplicity is captured.

It breaks my heart.

The logic of binary oppositions – it breaks my heart in two. Either you are or you are not. Here the principle of the excluded middle shines in all its unified glory. Here we find the principle of identity operating in all its logical sun-soaked glory. The One is and the Other isn't. The negative value of the other allows the One to affirm its oneness, its unity, its sameness, its identity in all its bloody glory.

The operation of this logic makes the so-called disordered mess of multiplicity come to affirm the identity of order. It is neat, so very neat ... 'the oldest merry-go-round in the world.'[23]

Stop! I want to get off.

Enough! the women shout. Enough of the logic of binary opposition. Enough of opposites, dualism, dichotomies and contraries.

Even the mountains moan: we have had enough of the opposition between the passive and the active.

And finally the dumb beasts speak. A brouhaha is heard in the animal world. A thousand enoughs!

Yet is this still enough?

The question remains of how to think of multiplicity, of brouhaha, such that it is not placed in opposition to the one voice.

The One, the Singular. At last I can say it: the question – is time one or multiple? – is badly posed.

The logic of binary opposition seeks to make clear-cut divisions but the baker folds. Stretches and folds.

A baker is kneading dough and a philosopher is carefully watching. The baker and the philosopher. And between the two something which is *becoming*: 'Love is not the reverse of hatred. Hatred is the whole of contraries.'[24]

Both the baker and the philosopher know that it isn't a matter of attempting to exclude or oppose the logic of binary opposition – it is a matter of enfolding it within the dough.

The baker's logic; I shall come to that tale very soon.

&

I had written a text called *The World is Fabulous Tale.*[25] Reflecting upon this text at a later time I had said that within this writing I wanted to make the logic of binary opposition surprise itself. In the very middle of this logic I wanted binary opposition to find itself breaching itself and there become exposed to multiplicity and the uncontainable. I had realised, like others besides me, that binary logic is a very neat logic. To oppose it is also to affirm its operation. Opposing this logic surprises it not one bit. The surprises happen when binary logic is made to *fold in* upon itself. One has to work in the middle of binary opposition – to turn in upon itself the law of the excluded middle such that *something else becomes involved*.

One has to practice an inclusive logic, a folding-in. One has to practice the 'baker's logic'.

The baker involutes; soon the philosopher will do likewise.

In *Rome* Michel Serres asks: 'What does a baker do when he kneads dough? ... The baker stretches it, spreads it out, then folds it over, then stretches it out and folds it over again. He does not stop folding the mass over on itself – an exemplary gesture.'[26]

What warm memories this exemplary gesture holds for me. Yes, it is true, my father was a baker. My father would rise early every morning to stoke the ovens; the fire glowed both summer and winter alike. To be sure there was mechanization, a machine for kneading dough, yet there were many occasions when by hand my father would knead dough. As a small child I would watch him and watch him, watch that exemplary gesture of stretching and folding. How the sound would make me chuckle, the warm

gaseous emissions, the soft burping and farting of the dough. And when my hands were big enough, I too would knead the dough.

For me the baker's logic is a very special kind of logic.

Michel Serres is in Rome; he watches another baker, a woman. 'The woman continues to fold, to stretch, to fold again '[27] My mother also kneaded dough; my parents were lovers who met in a bakery.

<div align="center">&</div>

What is special about the baker's logic is that it is a pliable logic; supple enough to bend freely; yielding readily to others; adjustable to varying conditions. For Michel Serres this pliable or enfolding logic can also be found in the 'strange' logic of sacks. A logic more flexible than the 'logic of boxes'.

Yes, I want to hear more.

'I will have to talk about the strange logic of sacks and the hard logic of boxes. A canvas sack folds easily into another, and it can, inversely, contain it as well; whereas if one wooden crate contains another, the latter cannot, inversely, contain the former ... The usual logic posits a space that is not deformable, like wooden crates, steel tanks, or marble boxes. But we must envision the case in which space is deformable. Here it is material, fabric, pliable or elastic ... '

'A canvas or jute sack does not contain only wheat, flour or cement. It can contain sacks as well. It is supple enough to be folded up in a sack with all the other folded sacks, even its former container. I believe that there is box-thought, the thought we call rigorous, like rigid inflexible boxes, and sack-thought, like systems of fabric.'[28]

Sack-thought and the baker's logic: both these occasions invite us to stretch our thought, to think inclusively and practice the art of implication.

The baker involutes. She doesn't attempt to antagonistically question the logic of binary opposition; she stretches and folds, stretches and folds. Practising the baker's logic she kneads binary opposition; she endeavours to make the two terms fold in such a way that it is shown that both sides implicate each other, and become as Jacques Derrida might say, 'both and neither/nor'. Both inside and outside, but also, neither inside nor outside: what we have here is a state of affairs where something else is involved, where something else is implied, where continually we find ourselves *between things*.

<div align="center">&</div>

Contemporary French philosopher Jacques Derrida has become famous for 'deconstruction'. Whether or not he welcomes this fame, I do not know. However, the more I reflect upon my understanding of this theory, this practice, the more I realize that 'deconstruction' offers an invitation to practise the baker's logic.

'Deconstruction' is a misleading term, I think Jacques Derrida would agree. Although the word implies a taking apart the practice of 'deconstruction' implicates, at least for me, the baker's logic. You may have read a 'deconstructive' text by Jacques Derrida and the perpetual enfolding, the folds upon folds, may have made you dismissive, perplexed or scornful. You may think 'heady stuff', but at last I can say it: Jacques Derrida has used his hands. Jacques Derrida has practised the baker's logic.

The baker stretches and folds and a theorist states that her understanding 'of what is most radical in deconstruction is precisely that it questions (the) basic logic of binary opposition, but not in a simple, binary, antagonistic way ... '

'Deconstruction shows, that there is *something else involved* that ceaselessly escapes the mastery of understanding and the logic of binary opposition by exhibiting some 'other' logic one can neither totally comprehend nor exclude.'[29]

&

She kneads. She involutes such that the two of binary difference become both one AND the other AND something else.

AND.

Is not AND more of a fold than a cut?

AND, AND, AND.

Involuting dualism and working in the middle: are not Gilles Deleuze and Claire Parnet also encouraging us to practise the baker's logic when they ask us to take up with the inclusive logic of AND: ... 'a multiplicity is not defined by the number of its terms. We can always add a 3rd to 2, a 4th to 3 etc., we do not escape dualism in this way, since the elements of any set whatever can be related to a succession of choices which are themselves binary. It is not the elements or sets which define multiplicity. What defines it is the AND, as something which has its place between the elements or between the sets. AND, AND, AND – stammering. And even if there are only two terms, there is an AND between the two, which is neither the one nor the other, nor the one which becomes the other, but which constitutes the multiplicity. This is why it is possible to undo dualisms from the inside, by tracing the line of flight which passes between the two terms or two sets, the narrow stream which belongs neither to the one nor to the other but draws both into ... a heterchronous becoming.'[30]

Heterchronous: time enters into the dough. Difference and time. The difference of a fold, rather than a cut. Although a clear explanation or whole picture remains elusive, hard to isolate, there amid the fluctuations of the dough she glimpses time's multiplicity. She glimpses times which know not the law of the excluded middle.

AND, AND, AND.

<center>&</center>

One doesn't have to be a famous philosopher to practise the baker's logic. One doesn't have to enter a prestigious institution to the learn the art of implication. The beauty of this logic is that it is flexible. One can practise it at home in the kitchen as well as in the philosophy department. One doesn't have to be designated a professional in order to practise this logic, this art, this science. One doesn't have to be a 'master baker'. There is no need for a certificate to prove that you can do it. For amateur and professional alike, the proof is in the rising, the expansion of the dough.

Practising the baker's logic one is not concerned to defend a specialism, to make an exclusive division, and defend a culture, a faculty. The Philosophy Department. The Art Department. The Science Department. Department, the word says it well: ' ... we often see discourses shaped with the unique purpose of showing the nonvalidity of the neighbouring discourse ... This speech is, alas, empty of speech; it reveals nothing more than the hatred nourished in one place for the neighbouring places. The space resounds with squabble or noise; nothing moves, because this is the most deeply rooted conservatism since the dawn of time; knowledge and novelty dissolve.'[31]

The baker and the philosopher; and between the two a becoming. When we practise the baker's logic theory knows no bounds; it becomes soft and flexible.

Air enters into the dough; things soon will expand. To get some air in your life, practise the baker's logic.

'Our multiplicities are like gases – they can expand ... The concepts that capture them are as fluid as they are; they imply each other reciprocally – what a scandal. Let us learn to negotiate soft logics. They are only crazy if we do not understand them. Let us finally laugh about those who called rigorous what was precisely their soft discourse. And let us no longer scorn what is soft – fluid ensembles.'[32]

<center>&</center>

Time enters the dough, and practising the baker's logic, kneading the logic of binary opposition, perhaps we would say: 'Time is not continuous, like this expanding dough, nor is it discontinuous like flaky pastry; it is one and the other, yes and no, black and white, shadow and light in a fine spectrum'[33]

Both continuous and discontinuous; the law of the excluded middle perhaps shudders at the thought.

Time enters the dough and now I am beginning to understand those multiplicities, the style of which is that of involution and inclusion. Now my thoughts are turning over. *Multiplicities are made of becomings and such becomings bring with them the work – the art, – of implication.*

Now I am beginning to understand those multiplicities which are made with the act of implication, of folding. Elastic bodies. Flexible bodies. Gilles Deleuze says it well: 'a flexible or an elastic body still has cohering parts that form a fold, such that they are not separated into parts but are rather divided to infinity in smaller and smaller folds that always retain a certain cohesion.'[34]

Now my thoughts are turning over: AND is a very special kind of division. 'Yes', the philosopher Leibniz might say, 'the division of a continuous multiplicity pertains to a fold.

'The division of the continuous must not be taken as of sand dividing into grains, but as that of a sheet of paper or of a tunic in folds, in such a way that an infinite number of folds can be produced, some smaller than others, but without the body ever dissolving into points or minima.'[35]

&

Today I can't stop the rush. The rush of thoughts amid the dough. The fluctuations of times amid the dough. And there I glimpse *les temps*, the sun and the wind and rain and snowman melting and the china cup breaking and the sagittarian arrow that is never at a certain point and the photograph which has ceased to be held up as a perfect example of the spatialization of time and the bouquet of times and the multiplicity smelt in the air and the flight of the busy bee and the crazy trajectory of the wasp watched by a small child in her father's bakery. And, finally, I glimpse another fold: I glimpse finality, those 'goals' which are made 'along with' the act that runs through them. In the dough: in the middle of a field of perpetual folding between the continuous and the discontinuous. Time's multiplicity but also a multiplicity of times.

Through involution and implication a becoming unfolds. No, I can't picture it. I can't photograph it. I can't make a time-lapse movie of it. Yet with each picture, each painting, each photograph, each movie, each word, there is always *something else involved*.

A fold, a wind and the event of ethics

The sky is blue and roses are red.

The philosopher Gilles Deleuze is amongst those who are keen that we substitute AND for IS. The sky and some blue and roses and red.

'Thinking *with* AND, instead of IS ... '[1] This is what Gilles Deleuze is asking me to do. Indeed, this is what the theory and practice of relations is asking me to do.

Include the AND.

'The AND is not a specific relation or conjunction, it is that which subtends all relations, the path of all relations, which make relations shoot outside their terms and outside the set of their terms, and outside everything which could be determined as Being, One or Whole.'[2]

AND instead of IS.

Is. What is ... ? What is the One? What is the Whole? What is its Being? Being, essentially that is.

What could be more essential to any sort of intelligent inquiry than to ask what something is, to know it as it is, in essence. What is time? What is photography? What is myth? What is woman? What is ... ? Western culture seems to insist upon the asking of this question. To ask what something is seems unavoidable.

The difficulty with questions lies not in finding the correct answer but in the questions themselves, in the assumptions they surreptitiously ask us to adopt, in the directions they take us unawares.

'What is ... ?'

Some would say that this question directs us towards the question of essence and being. Some would say that this is the philosophical question par excellence. Some would say that this question seeks that 'moment where the sun rises, where things appear for themselves ... Does one not say that the table is, that things are?'[3]

Yes, the question of being compels us to arrive at a place in the sun. Yes, the question of being compels us to arrive at that glorious point when all is said, when no more can be said, when knowledge speaks definitively. However, as glorious as it maybe, such knowledge, such *certainty*, suppresses, if not seeks to kill, the implication that even when all is said and done something else is involved.

Yes, the question of being seeks things as they are, *as no other*.

As no other, and no other. Oh yes, the question of being seeks to encompass a totality such that there ceases to be something else involved. One has to grasp and grip a Totality, a One. Yet as such grasping tightens its grip, the theory and practice of the AND is compressed.

<center>&</center>

Committed to the enterprise of Being, the logic of identity, we say A is-not B; we don't say A and B. In short, the AND is squashed. Negated. Killed off. So much thought, so much of a life time, has been dedicated to Being. To be or not to be? But there are some who ask: 'Should I be dedicated to being? By being, by persisting in being, do I not kill?'[4]

What is ... ? What is A? A is-not B. There are some who insist that being must actively negate in order to state its being. A is-not B. Here being is founded upon a negative logic. Indeed, here is a concept of difference founded upon negation. A is different from B: A is-not B. The being of A is founded upon the active negation of B.

To have a place in the sun. To be or not to be. No, we don't love our neighbour's discourse. In order to have being, we negate. A is-not B. Negate the relations. Negate the AND. We negate, and yes we even hate, so that we can pride ourselves upon having grasped Being.

'A certain grasp ... the metaphor should be taken literally ... (it) belongs to that unit of knowledge in which *Auffassen (understanding)* is also, and always has been, a *Fassen (gripping)*.'[5]

Doesn't the baker's wisdom lie in a non-grasping of the dough?

Gilles Deleuze feels that 'the history of philosophy is encumbered with the problem of being, IS'.[6] Philosophy may well be encumbered but so much of our lives is lumbered with the problem of being? Be a man! Be a woman! What is a woman? I can feel the pressure exerted upon me. I should ask ... what is a woman? what is time? what is photography? But I'm after something which is better than the 'what is ... ?' question. I'm after something which is better than being or non-being which is being's correlate, its

other, its twin. I'm not denying the existence of something. To be or not to be? – that is not the question.[7]

&

What does the baker's logic implicate? It implicates an event which involves neither Being nor Nothingness. Something else is involved. The baker seeks neither to grasp this something else, nor possess it. As I reflect upon the baker's gesture of kneading dough I begin to think of a gesture which seeks to caress rather than possess.

The baker caresses rather than grips

The art of folding, of implication, lies in a non-grasping of the dough. The baker doesn't seek to grasp all that which is involved and make a compressed round ball – a totality where the theory and practice of AND is effectively throttled. Practising the baker's logic leads elsewhere than towards the things we possess. The philosopher Emmanuel Levinas speaks of a 'slipping away', a movement quite different from the movement of knowledge conceived of as grasping.

' ... time is not the simple experience of duration, but a dynamism which leads elsewhere than towards the things we possess.'[8]

The baker's art of folding requires a caress rather than a grip. She seeks to caress but her caress doesn't know what it seeks. She doesn't seek to grasp time.

He doesn't know what his caress seeks. Emmanuel Levinas believes that this 'not knowing' is 'essential'. 'It is like a game with something slipping away, a game absolutely without project or plan, not with what can become ours or us, but something other, always other, always inaccessible and always to come. The caress is the anticipation of this pure future without content.'[9]

Michel Serres speaks of the baker involuting time. From this gesture I begin to think of a voluptuous time. My thoughts turn towards Emmanuel Levinas' words. 'My thesis, which consists in affirming voluptuousness as the very event of the future, the future purified of all content, the very mystery of the future, seeks to account for its exceptional place.'[10]

The baker stretches and folds and becomes involved with an event which is neither being nor non-being. Something else is involved. Something which is *otherwise than being*.

This event?

Emmanuel Levinas would perhaps reply: the event of ethics.

&

Once the theory and practice of the AND ceases to be suppressed or crushed by (the question of) being, indeed once the art – the logic – of implication is practiced then it seems to me that the question of ethics becomes unavoidable.

When I ventured to 'explore the fragrance of different times' I had no idea that I would come to the baker's logic. To be sure there had been the desire to find a logic which would surprise the logic of binary opposition, and I had an intimation of an inclusive movement, which later I would discover within the baker's logic. Now as I venture to unfold this logic, to explain its implications, I find it folding into many things.

So, should I find it surprising that the question of ethics becomes unavoidable? But also, should I find it surprising to hear the question raised: Just what is ethics?

What is ethics? What is time? What is art? What is photography?

Yes, we are back to the 'what is ... ?' question. The question of essence and being. However, let me repeat that I'm after something which is better than the 'what is ... ?' question.

Does ethics have an essence?

I pause. I leave the question hanging in the air.

You must have being, if you don't you are something less. Having being, having an identity – that is the priority. However, Emmanuel Levinas, an explicitly Jewish philosopher, takes care to question Western culture's prioritisation of being over ethics. For Emmanuel Levinas 'first philosophy is an ethics.'

In the introduction to the book, *Emmanuel Levinas: Ethics and Infinity,* Richard Cohen asks: 'In what way is the doggedness of the essential question a constraint, a viciousness? In what way is an attuned predisposition toward being and essence – what else could there be? – a flaw?' He goes on to say: 'The only way such questioning can be recognised as problematic is by introducing another sort of questioning, a questioning structured entirely otherwise ... Such is the ethical question. Rather than asking what ethics is ... one can ask if ethics is better than being.'[11]

He stresses that this sort of question is not an essential one.

We must take care to distinguish between two sorts of questions. Firstly the ethical question which, as Richard Cohen says, concerns itself with 'ought to be'. Secondly, the essential question which concerns itself with 'what is'. To ask what is ethics is to collapse the 'what ought to be' into 'what is'.

Yes ... let us hear more.

Richard Cohen goes on to say: ' ... ethics never *was* or *is* anything. Ethics does not have an essence, its "essence", so to speak, is precisely not to have an essence, to unsettle essences. Its "identity" is precisely not to have an identity, to undo identities. Its "being" is not to be but to be *better than being*. Ethics is precisely ethics by disturbing the complacency of being (or of non-being, being's correlate).'[12]

To ask if something (ethics) is better than being is to throw being and essence into question. It isn't that one knows in advance what *is* better. No, it isn't a matter of knowing what is better and then using this

knowledge, this vision, to form the superior standard against which to judge what is. With the ethical question we don't know what is better. If we did know then it would be a matter of swapping a better being for the being which is. One doesn't know in advance what is better. One questions without a preconceived criteria or model. For me this is the difference between morality and ethics – a difference which brings with it a different relation to and conception of time. Morality judges what 'is' in the light of a better being; it knows what 'ought to be' and seeks to impose this upon what 'is'. Indeed, it can be said that morality seeks to 'subordinate the present to what is (still) called the "future", since in these conditions the "future" will be completely predetermined and the present itself will cease being open to an uncertain and contingent "afterwards" ... what comes "after" the "now" will have to come "before" it.'[13]

In short, morality seeks to control time.

Ethics doesn't pretend to know what is better. It doesn't know in the sense that it never comes to rest upon an IS, a state of being. Ethics, we may say, is always becoming. It remains responsive to that 'something else involved'. Ethics works with time's multiplicity, it doesn't seek to grasp and grip and control time. In so doing, ethics stirs up the complacency of being's self-same time. Here, then, ethics requires the caress which seeks not to possess; the caress which anticipates a future without content.

&

Emmanuel Levinas perhaps would tell me, face to face, that I shouldn't be surprised to find the baker's logic folding into the question of ethics.

I shouldn't be surprised. However, this something else involved, this 'otherness', is what makes the question of time and ethics always surprising: 'time is not the achievement of an isolated and lone subject ... it is the subject's very relationship with the Other.'[14] And this otherness is what *surprises, astonishes, fills the subject with wonder (or apprehension).*

Once we face the implication that something else is always involved then we face an 'ethics of alterity', of otherness. Emmanuel Levinas is compelling us to practise an 'otherwise than being'. Rather than thinking 'being otherwise', which is still being, we are asked to think otherwise than being. To think otherwise. To think of our relations with others, the implication of another.

'Ethics is not a moment of being; it is otherwise and better than being ... '[15]

To seek a theme or principle for this 'better than' is to return ethics to the question of being. Ethics is precisely ethics because this 'better than' remains non-graspable, non-thematisable. Yes, this 'better than' is the non-thematisable charge of ethics. We may think of a wind. Yes, we may think of this 'better than' as something which remains in the air. An air which

haunts being. A wind which stirs up the leaves of the book of being. Oh yes, a wind-spirit which *'puts into the question* the proud independence of beings in their identity ... '[16]

Have you ever tried to grasp and grip a wind?

A wind. My thoughts dance with the idea of a photograph becoming a wind.

Airy fairy stuff you may well think. I want my two feet firmly on the ground. I want that stability. However, let me ask you: Is there only one way to walk? Can you imagine walking *otherwise* ? Can you imagine walking such that your being isn't founded upon the negation of another?

Let me spell it out. That something remains non-graspable doesn't mean that we have lost understanding or knowledge. On the contrary, what is demanded is a 'thinking otherwise'. A thinking which doesn't seek to grasp the essential and in so doing exclude the relations, the implication of another. A thinking which admits, without seeking to grasp, the unthought within thought. Indeed, what is demanded here is a knowledge – 'although perhaps we should call it by some other name' – that demands implication. As Michel Serres says, 'one that demands a fold'.

Gilles Deleuze suggests that the fold is inseparable from wind and my thoughts dance with the idea of photographs ventilating the proud independence of being.[17] Photographs becoming fans. Folds in the photograph and photographs becoming fans and folding ethics into the photograph.

<p style="text-align:center">&</p>

When all is said and done and being appears to be settled, the wind of ethics brings to this one the implication of another. It also brings a responsibility: being-for-the-other *before* being-for-myself. Enfolded within the ethical question is the demand to question those practices of the self or identity where one's being, one's territory or time, is taken as more important than, as having a priority over, relations with others.

The ethical relation pertains to that time when we no longer suppress or kill the AND. Here the wind of ethics touches us and obligates us to refuse totalization. Here ethics obligates us to become a 'porous body through which all the winds of heaven breathe'.[18] Here the ethical relation partakes of a time when time's multiplicity is no longer subordinated to a one time, to being's time. Yes, we can speak of an ethics of multiplicity – an ethics which demands an infinite responsibility towards relations.

The ethics of folding.

It may be said that the art of folding or implication ignores being. However: 'Such ignorance is not blind, it knows too much, more than it can comprehend, more than what can be comprehended – an infinite responsibility before others.'[19]

The ethics of folding works with the understanding – the obligation – that 'one is never quits with regard to the Other'.[20] It is this under-

standing, this obligation, which stretches (and folds) ethics to infinity. As Gilles Deleuze says: 'The problem is not how to finish a fold, but how to continue it, to have it go through the ceiling, how to bring it to infinity.'[21]

<p style="text-align:center">&</p>

The theory and practice of the AND requires that I listen.

In the middle of the hubbub or in solitude, listen. Lend an ear. Hear out the relations. Listen out for the implication of another.

' ... one speaks as a listener and not as an author.'[22]

Listening is at the very heart of my subjectivity. Indeed, is not my subjectivity constituted by and through my relations with others?

Listen to the folding. Listen literally. Listen metaphorically. Remaining responsive is the responsibility. Keep on listening, especially when all seems to have been said and done. This is the infinite responsibility. The ethics of folding demands responsibility in the strict sense of the term.

Responsiveness.

An open heart.

Heart and ears and eyes and feet and fingers. Becoming a porous body through which all winds of heaven blow. One doesn't know all that which is involved. Yes, one must be prudent rather than masterful.

'It is more prudent to let the forces of the forest cooperate rather than make them surrender and then risk their return in some form or other.'[23]

<p style="text-align:center">&</p>

What is a photograph?

'Nothing but relations, nothing but affects', we may reply.

I'm looking at a photographic image but I'm also listening. Suddenly I am astonished. I see a photograph stretching (and folding) to infinity. Suddenly I see the infamous window on the world not shattering but gently, gently folding. Suddenly I see the frost on the window pane of the frozen moment becoming an intricate pattern of unfolding and enfolding.

How to continue the fold, to have it go through the ceiling?

Here the photograph doesn't seek to suppress the implication that something else is always involved, always affected. Here an ethics of multiplicity unfolds and enfolds the photograph. The photograph and, and, and. Here then the photograph becomes an event; and finally that tiresome debate of 'reality or representation' becomes a matter of something else.

The event of ethics. Oh, it makes me wonder.

Ceasing to suppress the theory and practice of the AND, photography works with the infinite responsibility that one is never quits with regard to the other. Whether or not the photograph is made digitally or mechanically, whether or not 'appropriated' images are used, one is never quits

with regard to relations, to the other, to that something else involved. Digital images; analogical images; straight images; queer images; colour images; black and white images; single images; composite images; framed images; unbound images: one is never quits with regard to the other.

Making a photograph with the art of folding, indeed folding ethics into the photograph, one doesn't seek to capture, to possess. She asks: May I take your photograph? Yet now it is no longer a matter of 'taking' – the gesture of capturing and representing – but rather of the anticipation of something to come, always to come. Let me speak of the caress which doesn't seek to control time. Let me speak of the caress which anticipates a future without a preordained content.

And yes, here is the sagittarian prudently shooting her arrows 'not knowing' in advance what their destination will be, or where the arrow of time will take her. Not knowing but knowing too much, more than can be comprehended. Not knowing but knowing only too well that the target or goal is created along with the act that runs through them.

Let me put this another way.

As the photograph unfolds a content we also find it folding into a future that is without content. Unfolding and enfolding – both continuous and discontinuous. Being between these two folds is what makes a photograph astonishing for me.

The folds in the photograph demand that we remain responsive to and responsible for the photograph's otherness and the implication of (still) other relations.

The photograph may be still, as still as a mountain. But let us not forget that the picture of the mountain implicates the mountain's time of slow, slow folding.

A photograph may appear to be still or singular yet still it is a relation; it demands a response, a responsibility, from *both* the image maker and the image-viewer.

Being-for-others *before* being-for-myself.

Yes, Emmanuel Levinas, it is an exorbitant demand.

Act Two:
The Installation

Surprise

She breaks into a smile. And then she laughs. Today, however, she didn't want to theorize her laughter. She didn't want to theorize yet it was theory which was making her laugh, tickling her belly. She was tickled by the idea that there are more ways than one to theorize, to do theory.

Once my father asked me what in the world did I most want to do. I replied without hesitation: to sleep in the folds of a horse's belly.

My father looked surprised.

If you tickle a horse's belly with a piece of straw you will see a thousand little folds ripple. A sensuous sight.

The sensible. The experience of the five senses. We speak of the five senses yet perhaps, as with a continuous multiplicity, the senses defy enumeration.

'Empiricism', so says Gilles Deleuze, 'is often defined as the doctrine according to which the intelligible "comes" from the sensible, everything in the understanding comes from the senses. But that is the standpoint of the history of philosophy: they have the gift of stifling all life in seeking and in positing an abstract first principle. Whenever one believes in a great first principle, one can no longer produce anything but huge sterile dualisms.'[1]

What comes first – the sensible or the intelligible? What comes first – experience or thought? What comes first – sensations or ideas? Squabble and argument and rival discourses. The oldest merry-go-round in the world.

Whilst Gilles Deleuze speaks of empiricism in a way quite different from the standpoint of the history of philosophy, I am tickled by the thought of asking: if the intelligible "comes" from the sensible, then I wonder what the horse apprehends when being tickled by a single straw?

&

Theory tickling my belly, making me laugh. How can I deny that theory affects my belly? A body of theory affecting a belly. Bodies affecting each other. Where does one body end and another begin? Where would you like to draw the line? Would you like to draw a line between the intelligible and the sensible?

Some would argue that if no such line were to be drawn then one could never take up 'a critical distance from the data of first hand subjective knowledge'. Indeed, if no such line were drawn one would never have sound 'knowledge of experiences that would otherwise belong to the partial, perplexed and contradictory evidence of the senses'.

Sound knowledge. Knowledge which isn't diseased, injured or rotten. That is to say, knowledge which has transcended the messy mixture, which has risen above the smell of the senses.

To produce sound knowledge, well founded knowledge, take up a critical distance. If not, then there is the danger of being affected indeed, infected. Sound knowledge: here I have the image of clean theory. Theory which is always washing its hands.

Sound knowledge. Critical distance. Critique. 'To be taken in', that is the main worry of the Critique philosopher. The Critique philosopher fears infection, affection.

'The Critique work is that of a reduction of the world into two packs, a little one that is sure and certain, the immense rest which is simply believed and in dire need of being criticized, founded, reeducated, straightened up ... '[2]

Critique thinking seeks to find that certain point where an 'in depth' overview can be obtained. This is the point of a critical distance. From this vantage point the Critique assumes that it can remain outside of and untouched by that which is overviewed.

We arrive at the vantage point of critical distance. At this point a centre of unification has to be founded and a periphery created. This is the necessary foundation for a powerful 'in depth' critique: 'A powerful critique ... ties, like a bicycle wheel, every point of a periphery to one term of the centre ... At the end, holding the centre is tantamount to holding the world.'[3]

A powerful critique seeks to discover the underlying 'in depth' principles which provide the overviewed with order and sense. It is required that these principles or concepts are put at the centre so as to tie and unify every point of a periphery. The centre unifies, the centre holds sway.

Unified concepts and unifying principles: the 'overviewed' is ordered and unified from above. Indeed, let us not forget that the centre of unification which the Critique seeks to discover is conceived outside of, above and beyond, the overviewed.

Here I have the image of unifying categories and concepts laying upon a plane beyond the very things or circumstances to which they purportedly refer, or represent or capture. Here I have the image of a transcendental plane.

With this image in mind I begin to imagine the concepts or categories lying on this plane as plans. Plan in the sense of a model, a blue-print. I imagine a plane forming a plan which is then placed over the world. The world is overviewed by a transcendental plan.

This brings to mind the image of a net or grid.

A net is cast over the world: a grid into which the overviewed is made to fit. The plan is to make everything fit into the plan, to copy the model, to conform to the concept, the category or principle.

I can bring to mind the image of a net or grid, or I could return to the image of the bicycle wheel. Either way the plan is to make all revolve around one, a single category, at the centre. Indeed, holding the centre is tantamount to holding the world.

In *Rome* Michel Serres speaks of a star design. A bicycle wheel: isn't that a star design?

'The figure is the one I called a star, a relation between the single and the multiple.'

'The law is very simple; it follows the design of the star – the single becomes multiple and the multiple becomes unity ... We could even name this law the law of the empire.'[4]

What if things don't conform to the model or blue-print, the plan laid out on the transcendental plane? Indeed what if things don't fit into the star design, the bicycle wheel?

A certain logic comes into play. A closure excludes the unfitting, relegating it to that other, that difference, which has a negative status. It is an open and shut affair. Either it is in or it isn't.

An exclusive logic.

The law of the excluded middle.

The star design and the bicycle wheel. The single becomes multiple and the multiple becomes unity. The plan is to make the diversity, on every occasion, fit into the plan. To make all revolve around and constantly refer back (and forth) to a singular term, a one at the centre, above. In effect, diversity is totalised by the One. All in one. *Omnia un unum.*

Either something will be included in the 'all', or it will be excluded as the nothing. All or nothing. Either way amounts to the operation of an exclusive logic. Either way diversity is scuppered.

All or nothing. There is no third way. The middle is excluded.

It is a neat logic, a very neat logic.

However, as Michel Serres say, 'I am not sure of this *one* or this *in* ... We do not know what "all" really means.'[5]

The star concept shines with the glorious idea that it can grasp 'all' but yet ...

If we don't know what 'all' really means then surely this throws into question the very idea of the 'overview' which the Critique philosopher seeks to obtain.

I do not know what 'all' really means.

&

Is it a prerequisite of theoretical thinking that one must obtain critical distance? There are many who think not.

We can argue. We can always argue. The easiest thing in the world. Yes, we can always argue as to what comes first, what is primary and what is secondary. So much of a life-time is spent arguing. Are you my friend or foe? We can squabble until the cows come home as to which has the priority – thought or experience, the intelligible or the sensible, me or you? We may be dismayed by the reductive and totalising forces which the 'unity' of a transcendent, or star, concept imposes upon the world. Yet let us not rush to the conclusion that in order to combat this star concept we must return to the primacy of experience. The oldest merry-go-round on earth.

Are my hopes pinned upon the baker's logic? Tonight my thoughts embrace the idea that a concept is a body defined by the relations it is capable of entering into.

I am lying in the belly of a horse. The chaos of the straw scattered throughout the stable sends my thoughts in many directions. What can theory do? What can a concept do?

Tonight there is a horse and a human and between the two, a becoming.

Theory and, and, and.

A concept and, and, and.

&

She burns to write something and wonders what to do with her theories, 'all so pretty, so agile, and so theoretical'. However, something has taken her theories by surprise. They are surprised, yes, but not at all taken aback. Her theories have been enchanted, making them 'ready to be refuted and be converted, making no distinction between the abstract and concrete'.

Helen Cixious speaks of her beautiful theories and how they had gracefully taken up positions in her own starry night. There was an order, perhaps a celestial order, yet now she admits that her star-concepts 'no longer seem so proud and aggressive and stubborn'.

Helen Cixous: theoretician? writer of literature? philosopher? poet? professor? Helen Cixous: born 1937.

Helen Cixous' theories have been affected, enchanted: 'They are joyful; they make fun of each other ... They play with their own concepts, they toss them back and forth.'[6]

Helen Cixous says that her theories were 'no more than hypothesis and illusion'. However, she acknowledges that 'going from illusion to illusion, one also comes to understand the world.'

Is Helen Cixous a proper theoretician? She speaks of illusion. She speaks of enchantment. She speaks of joy. For some this is tantamount to the abolition of critical distance, the effect of which can only be disastrous.

Yes, some may speak of disaster; theory is suddenly without a star to follow. Dis-aster. Without star. Without star-concepts. Without proud and unified principles or categories. Without a star centred design to overview the world. However, Helen Cixous wants us to ask: can we theorize without assuming critical distance? Indeed, where does theoretical discourse begin and poetry end? Where does a concept begin and a metaphor end? What assumption do you hold concerning theory? What criteria do you employ to adjudicate on matters of the properly theoretical?

Helen Cixous doesn't duck the questions.

'What is a theory that is as light as a butterfly, carried away by the least fragrance (and does not even theorize its lightness, but flutters around with no regrets)?'[7]

What, in fact, is still theoretical about concepts that have ceased to take up a proud position in a starry night? When theories become affected by the least fragrance and illusion brings understanding of the world, we may well ask: What is still theoretical about theory?

Theory as a butterfly, affected by the least fragrance: What does this image suggest to me?

It suggests that theory and thought are susceptible to a process of continuous variation. What is this least fragrance which affects the butterfly if not the implication that another is always involved. And if thought, theory and concepts remain open to this implication then how can they not at times flutter?

Has theory ever made your heart flutter?

Fluttering thought.

&

When theory seeks to understand fluctuations then how can the theory involved not, at times, flutter?

Fluctuations, turbulence, fluid state physics and a poem by Lucretius. Michel Serres contends that Lucretius' poem *De Rerum Natura*, written in the century before the birth of Jesus Christ, offers a more accurate and far richer vocabulary to comprehend fluctuations, turbulence and

the physics of chaos. He claims that the whole text creates turbulence. The poem's text is nature itself, 'that of Venus'. He claims that the poem is a valid treatise in physics yet people laugh at the very idea.

People laughed at the theory. How could a poem be seen as constituting valid theory, indeed proper theory?

'So why could the poem not teach us something on our physics?

'If by physics you mean the tiny repertoire of solid and falling bodies started by Galilean physics, yes indeed, Lucretius is rather out of the way. If by physics you mean fluid state physics, how old is Lucretius' passionate description of it? It is still *tomorrow's* physics.'[8]

You may ask, well, what about Venus? Michel Serres speaks of Lucretius' poem not only as a valid treatise in physics but also as a hymn to Venus, a song of voluptuousness. He contends that Venus is not transcendent like the other gods but immanent in this world, 'the being of relation'.[9]

Venus, we may say, isn't the perfect model of a star-concept. She is immanent rather than transcendent.

Immanence; I'll come to this soon.

&

I am in a stable, a horse is sleeping and straw is scattered on the floor. As I become tickled by the idea of choosing a single straw my thoughts turn toward the words of Michel Serres.

'You can always find a needle in a haystack if you have time and patience, as well as nostalgia for the lost needle. In contrast, there is little chance that you will find a single straw in a stable full of hay. The hay is in disorder under the bellies of the oxen; which single straw would you like? Do you know? They are indiscernible, undecidable; how are you going to look for one straw in this pile of no interest?'[10]

Which single straw would I like?

Perhaps my immediate response would be: if I were to choose a single straw from the pile would I be privileging the One over the multiple?

I turn again to Michel Serres' *Rome: The Book of Foundations*.

Rome. The epitome of order. The paradigm of organised unity. How does Rome evolve out of 'multiplicities that teem with tumultuous variabiltites?' For some the answer is terrifying: 'at each historical layer of chaotic conditions, the steps taken to organise the entity called Rome are accomplished by excluding ... the "middle".'[11]

Either order or disorder. The middle is excluded and in effect multiplicity is crushed.

Multiplicity is continually threatened by the One, the Singular. Indeed, multiplicity is threatened by the order of binary logic, the law of the excluded middle. Michel Serres hopes that we shall insist upon the inclusion of the middle, the streaked multiplicity, the continuous spectrum of

black and white. He hopes yet he also laments: 'Our theories lack this fluctuating field, this moving ensemble, and most of all the multiple that moves or rushes there. It is always captured. The multiple is captured. Captured by the single, it is concept and synthesis ... The multiple rushes along, then is trapped by the single.'[12]

Which single straw would you like?

Here I could speak of an ethics of multiplicity which is concerned to prevent the capturing and negation of multiplicity. However, this ethics knows only too well that it isn't a matter of privileging multiplicity over the singular, of privileging difference over unity. Binary logic would have us believe that difference lacks unity. But if we celebrate this lack of unity, if we give priority to this conception of difference, then exclusionary systems will continue as surely as the sun rising tomorrow.

Michel Serres laments the singular which crushes multiplicity but his allegorical story of Diogenes is warning to those who wish to promote the 'other' of binary logic, of binary difference.

&

Diogenes is at peace. Diogenes is in direct contact with 'water, snow and sun'. The cynic doubts. He rejects all the models that impose themselves, that mediate the world. Without bowl or cup he drinks. Without clothing he feels the sun shining directly on his naked body. Nothing comes between him and his world. No bowl, cloth or shadow. Diogenes is at peace, and then the figure of Alexander the Great passes and imposes his long shadow. Diogenes cries: 'Remove yourself from my sun!' This cry, mobilized against Alexander, traps Diogenes once again. Once again the oldest merry-go-round turns.

Alexander. Singular figure. Alexander the Great. Unified concept. From above imposing his shadow. Alexander rules over all, including those who oppose him. To oppose Alexander is to affirm him.

'Win or lose, whoever plays loses. He loses for having obeyed the rules of the game or the redoubling of the stakes. He enters into the seductive space of squabbles and submits to it.'[13]

Which single straw would you like?

Are you asking me to cry out against the singular?

Cause

Gilles Deleuze's hopes are pinned upon 'a notion of multiplicity which saves us from thinking in terms of the "One and Multiple".'[1]

Which single straw would I like? Do I know?

Is it not time for me to reconsider singularity?

To reconsider, perhaps to discover another understanding of singularity, let me return to the story of multiplicity.

I am in a stable, around me straw is scattered and I ask myself: What are the conditions which make multiplicity possible?

Gilles Deleuze and Felix Guattari reply: '[A] multiplicity never has available a supplementary dimension over and above its number of lines ... All multiplicities are flat, in the sense that they fill or occupy all of their dimensions: we will therefore speak of a *plane of consistency* of multiplicities, even though the dimensions of this "plane" increase with the number of connections that are made on it.'[2]

Or, I could put it this way.

A body becomes by way of the relations it is capable of entering into. It is these relations which define, let's say cause, the composition of a body. What must be stressed here is that these 'causes' never occupy a dimension external to the body composed. This why it can be said that a multiplicity fills out and occupies all its dimensions. The causes which produce a body remain inhered within the production itself. Inhered – that is to say, immanent.

Yes, we could say that the condition which makes multiplicity possible is an immanent causality. Every multiplicity is flat because of this causality.

Or, to put this yet another way: the organization of multiplicity doesn't follow the putting into effect of an order or model planned upon a transcendental plane.

A multiplicity requires a 'flat' image yet this doesn't mean that multiplicity is without sparkle or freshness. Indeed, the immanent causality which founds multiplicity is a current, in all senses of the word.

'Against a transcendental foundation we find an immanent one ... '[3]

&

I am in a stable full of straw and I hear talk of a concept of singularity; suddenly my story is taken by surprise and a correlation causes me to smile:

– 'Singularity, in Deleuze, has nothing to do with individuality or particularity. It is, rather, the correlate of efficient causality ... '[4]

Singularity is the correlate of efficient causality – what can be meant by this? Indeed, what can be meant by efficient causality?

A correlation is a very close relation, a relation so close that one thing immediately implies another, and efficient causality, so I hear, is the inherence of causes within their effects. That is to say, where forces remain inseparable from their manifestations.

How can I not smile?

I had heard talk of a concept of multiplicity which involves an immanent causality and now, today, in a stable full of hay, I hear talk of concept of singularity which involves an efficient causality. This, so I hear, is the heart of the matter: *neither immanent nor efficient causality present causes which remain external to, or transcendent of, their effects.*

Both immanent causality and efficient causality speak of the same causality; both speak of, what can be called, an *internal causality.*

&

Which single straw would I like? Do I know?

I had heard of a concept of multiplicity where causes or forces remain internal to their productions and now I hear of a concept of singularity which also involves such a causality.

Singularity.

Come, let's hear more.

I am in a stable full of straw and hear talk of Spinoza's philosophy concerning the production and constitution of being. I hear that Gilles Deleuze has great affection for this seventeenth-century philosopher. Then, suddenly, I hear that singularity is what defines being.

Singularity is what defines being?

What is being said here?

To say that singularity is what defines being is to say that being is produced by an efficient or internal causality. To say that singularity is what defines being is to speak of a production which isn't caused or determined by anything outside itself. What defines being is an auto-production. Indeed, the seventeenth-century philosopher speaks of *causa sui*. Cause of self, in itself and through itself. Yes, this is what defines being.

Singularity speaks of *causa sui* and it is *causa sui* which makes being. Or, in other words, the production of being has no reference to or dependence upon an extra-dimension, above, below or beyond. Yes, the being of singularity doesn't involve external causality: singular being makes itself and is *always* in the making.

Singularity. Yes, it is a question of being.

The philosopher speaks of the constitution of an ontology.

Ontology.

Yes, it is, for the philosopher, a question of being.

&

In the stable full of straw I glimpse a being, an ontology as the philosopher would say, which is founded upon a moving force: to come into existence singularity has to make itself and in order to sustain itself singularity has to continually make itself. Yes, we could speak of a being which is continually *becoming*.

Singularity is a question of being *and* becoming.

A question of being. But wait. Has it not been asked whether I should be dedicated to being?

'By being, by persisting in being, do I not kill?'[5]

Have I not sought to practise an 'otherwise than being'? Indeed, have I not been alerted to the predilection of western culture to prioritize the question of being – ontology – over ethics?

Am I now to forget this and ignore the implications of the question of being?

To be sure, I want to ignore that being which is founded upon the negative logic of identity, yet I do not want to ignore the ethical implications of this 'negative ontology'.

As I sit amidst the straw scattered upon the stable floor and reflect upon the choosing of a single straw, I find it difficult to ignore Spinoza's conception of, and Gilles Deleuze's affection for, singularity.

Perhaps I will be taken by surprise.

Perhaps, as I choose a single straw, I will discover a (way of) being which doesn't follow the negative logic of identity.

Yes, tonight I have the feeling that something is in the air.

I don't know but I do know.

A correlation has made me smile; soon another will do likewise.

Soon, by way of singularity, I will discover a foundation which isn't set in stone but rather is founded with movement. Soon I will be tickled and folds will ripple as rippling water. Soon I will discover an ethics and an ontology which inhere in each other. Yes, soon I will discover a folding where ethics and ontology do not deny the immanence of one in the other, one in the middle of the other. In the middle – that is to say, without a great first principle.

Soon.

&

Here then is a proposition: a multiplicity becomes a singularity not when a star design, or bicycle wheel, imposes its model upon the world, when a One unifies – captures – the many, but rather when the being of *causa sui* comes into existence.

Let me spell it out: being = singularity = *causa sui* = efficient causality = immanent causality. Each term is the correlate of the other.

By way of these correlations, the question of multiplicity and singularity cease to be a matter of opposites; rather, the question becomes a matter of being.

A multiplicity becomes a singularity when an efficient or immanent causality comes into existence. It is this causality which makes multiplicity fill out and occupy all its dimensions. Yes, it is this causality which makes multiplicity limitless, impossible to overview.

This, so I hear, is the heart of the matter: to speak of singularity is to speak of a production, a producing, which has, by definition, no external causality. There is, as it were, no outside. An external causality, in effect, imposes a limit; it sets bounds. However, with singularity there is no such causality, there is no such limit. Quite simply, no outline can be drawn. There is no extra-dimension where one can stand and delimit an inside and an outside. There is nothing beyond. There is no transcendence. Singularity is limitless.

&

Causes which inhere in their effects and a single straw tickling a horse's belly and a thousand little folds rippling: against a transcendent causality I find an immanent one.

Immanent causality.

Yes, Gilles Deleuze, I want to hear more.

'A cause', he tells me, 'is immanent when its effect is "immanate" in the cause, rather than emanating from it.'

'What defines immanent cause is that its effect is in it – in it, of course, as in something else, but still being and remaining in it. The effect remains in its cause no less than the cause remains itself.'

Immanent causality involves no eminence, involves, that is, no positing of any principle beyond the forms that are themselves in the effect.

'Immanence', he tells me, 'is opposed to any eminence of cause ... any hierarchical conception of the world. With immanence all is affirmation.'[6]

Immanent causality refuses any hierarchy (of being) between the relations, the causes and effects, which come to make a body, a becoming. Immanence refuses any deep or hidden foundation of being; 'there is neither reserve nor excess.'[7]

Immanent causality: cause and effect have the same ontological status; their being is equal. A piece of straw causing a horse's belly to ripple: cause and effect have the same ontological status; their being is equal.

&

To be sure immanent causality can make me weep yet how can I not smile when I discover its folding logic?

Listen, come close.

With immanent causality causes remain implicated and involved in their effects – an enfolding. However, effects are also the explication, the expression, of causes – an unfolding. The implication of immanent causality doesn't deny explication.

To explicate is to evolve, to involve is to implicate yet, so I hear, the two terms are not opposites. They simply mark two aspects of expression. 'Expression in general involves and implicates what it expresses, while also explicating and evolving it.'[8]

Expression.

Here I discover that Spinoza folds a conception of expression into immanent causality.

Nothing is hidden; there is neither reserve nor excess.

Spinoza's concept of expression:

– 'What is expressed has no existence outside its expressions; each expression is, as it were, the existence of what is expressed.'[9]

A horse's belly is tickled by a single straw and I think of immanence and expression becoming folded into the baker's logic. Both implication and explication.

&

This sagittarian is tickled by the discovery of a conception of singularity which is founded upon a folding logic.

Let me spell it out.

Singularity is founded upon an immanent causality and this causality sets in motion, indeed expresses, a folding logic. Singularity only comes into being by producing itself, by expressing itself. And it is only by way of implication and immanence that such an explication can come into existence.

Expression, explication: here is a force, a power. A centrifugal force, a forcing out. Being comes into existence by the unfolding of this force. However, this force is equally a centripetal movement. Indeed, for a cen-

trifugal force to unfold there also has to be a centripetal force, an enfolding. This dynamic constitutes, for Spinoza, *causa sui*. Yes, this dynamic constitutes being.

There is no straightforward linearity in this mode of thinking, this mode of being, this dynamic where a folding relation emerges between cause and effect. As I begin to picture this dynamic, my thoughts turn inside out and outside in. No longer can I draw a straightforward line between an inside and an outside. Binary logic fails to insert its concept of difference. A swirling image comes to mind. My thought swirls yet in the middle of this 'dynamical nonlinearity', as the science of chaos would perhaps say, I begin to glimpse an ethical project.

Ethics taking a turn with ontology.

An autumn wind taking a turn with fallen leaves and producing a swirling dance.

Soon, but not quite yet.

Soon it will become autumn.

<p style="text-align:center">&</p>

I cannot see the future straight ahead of me yet with immanent causality I glimpse a nonlinear causality. Sun light dancing on water. A wasp that darts here and there. This causes me to smile; for, here I find a causality which doesn't seek to control time, which doesn't make all unroll according to a predetermined plan or march along the direct path.

I am in a stable and scattered straw is beckoning my attention, and then, suddenly, I am turned toward the image of a thousand arrows.

The moving arrow of time never is at a certain point.

A sagittarian shoots her arrows; a sagittarian expresses herself.

The time of my life never is a certain point.

A sagittarian shoots her arrows; a sagittarian expresses herself.

The time of my life isn't the unfolding – the expressing – of an essence which remains 'before' and 'behind' the acts of expression.

A sagittarian expresses herself, yet the expressed has no existence outside its expression.

A sagittarian shoots her arrows yet these arrows, these expressions, are not as rays emanating from a star design.

A sagittarian and Spinoza's concept of expression.

Did Spinoza ever tickle a horse's belly?

I do not know, I haven't heard so, but I have heard that Spinoza's concept of expression refused to model itself upon a star design; refused, that is, any notion of emanation, emanative causality or emanative expressionism.

'The emanative cause produces through what it gives ... : so that an effect comes out of its cause, exists only in coming out, and is only determined in its existence through turning back toward the cause from which it has come.'[10]

Yes, Gilles Deleuze, a star design..

Yes, it can be said that 'emanation serves as the principle of a universe rendered hierarchical.'[11]

In short, a cause or expressing agent rises above and remains external to its effect or expression. However, this morning Spinoza's concept of expression has tickled this sagittarian's belly.

The image makes me chuckle.

The rippling folds of immanence rather than rays issued from emanation.

Immanence rather than emanation.

To what extent has photography modelled itself upon a star centred design? To what extent has the photographic image endorsed emanative causality, emanative expressionism?

Come, let us choose a straw and tickle photography ...

A horse's belly is tickled and I begin to think of immanent causality folding into the photographic image.

A photographic image: the expressed has no existence outside its expression; each expression is, as it were, the existence of what is expressed.

&

How do I know which single straw to choose?

The making of singularity which is made with an efficient, immanent, causality – my question is quite straightforward; will this bring me joy?

I do know but I don't know.

What do I know of singularity?

Thinking on one's feet means you never quite know the outcome in advance. Is this not how being proceeds when making itself in terms of singularity? In advance of its creation there is no preconstituted order.

What do I know of singularity?

Singularity is cause of itself, in itself and through itself. To define (a) being in terms of singularity – *causa sui* – is to recognise its difference without recourse to any other. The constitution and production of singularity involves no other ... How can I not wonder what the outcome of these lines are when the art, indeed ethics, of implication has asked for, in advance, the continual consideration and inclusion of others? ... 'Nothing but relations, nothing but affects; a body is never separable from its relations with the world.' Has not the theory and practice of relations asked me to think *with* AND instead of IS? Include the AND. The photograph and, and, and. Theory and, and, and. Have I not hoped for a practice which suspends the law of the excluded middle? Have I not hoped for a practice which includes the middle, the mixture, the multiplicity where no one can tell with certainty where one thing ends and another begins? Has not the venture been to find a non-exclusive way of thinking, of being? Have I not

hoped for a practice where one doesn't negate or oppose in order to affirm one's position?

Thinking on one's feet means that one's thinking is always on the move, negotiating the circumstances, negotiating the unexpected, rather than rushing to conclusions, predetermined goals; and it would be a stupid mistake to rush to the conclusion that the making of singularity which involves immanent causality is based upon an exclusive logic, an exclusive way of being. My thoughts rush yet I have the feeling that it would be a mistake to rush to the conclusion that cause-of-itself is an exclusive production. The constitution and production of singularity involves no other; however, this is not to say that the production of singularity is opposed to others, to another.

Let me say it quickly.

The production of singularity made with immanent causality has nothing whatsoever to do with opposition to, or exclusion of, others.

This is the very heart of the matter.

What happens to difference in this story of immanent causality which ceases to place singularity and multiplicity as opposites? This is the question which tickles my belly.

&

Which single straw would I like?

Singular being, so I hear, is not different from 'anything outside being, and neither is it indifferent or abstract'.[12]

What am I to make of this as I seek to choose a single straw?

Here, I find myself returning to the logic of identity:

A is different from B. A is-not B. B is placed opposite to A. In short, the difference between A and B is founded upon an negation. The one is and the other is-not. Here difference means non-identity. Here difference is put into opposition. The opposite other has conferred upon it a minus value; however, this minus allows A to affirm a positive identity. 'A phantom affirmation' – yes, this is what we need to remember: the identity of A is founded upon and affirmed by the negative value of the other's difference. The other is excluded from A's identity yet it is this non-identity which causes A's identity. A's identity is, as it were, *externally* caused. In this case, cause and effect cease to be immanent to each other. And for Spinoza this brings neither joy nor being to A or B.

If singularity were to be produced by way of the negation of an other then singularity would be dependent upon an external causality.

This is the heart of the matter.

The production of singularity doesn't adhere to the following line: the existence of something is the active negation of something else. Singularity doesn't define itself against something else, if it did this would make singularity have recourse to external factors. Indeed, there is

no negation or exclusion of an other so as to include all that which is the same.

The star concept shines with the glorious idea that it grasps the same and always shines the same. However, the concept of singularity doesn't twinkle with the idea that concepts must shine as guiding stars or they must be, as Plato insisted, self-identical and in every instance opposed to contraries. The concept of singularity doesn't twinkle with the logic of identity.

Gilles Deleuze and Felix Guattari contend that concepts are singularities. Concepts are not waiting for us ready made, like heavenly bodies. Concepts must be invented, fabricated, created.

'Every creation', they say, 'is singular, and the concept as a specifically philosophical creation is always a singularity.

'The concept ... is to be created. It is not formed but posits itself in itself – it is self-positing. Creation and self-positing mutually imply each other because what is truly created, from the living being to the work of art, thereby enjoys a self-positing of itself, or an autopoetic characteristic by which it is recognised.'[13]

Let us not beat about the bush: cause-of-self in no way means self identical.

The production and producing of singularity involves no extra dimension, no supplementary dimension. I repeat, singularity knows no limit. The predisposition towards finding an inside and an outside becomes frustrated. There is no other to singularity; neither is there a transcendent Great Other to which it is beholden; nor is there another sort of other which has to be negated, relegated to an is-not, for singularity to come proudly into being.

Yes, let us not beat about the bush: the founding of singularity in no way practices the logic of identity. The immanent causality which founds singularity *and* multiplicity simply ignores the merry-go-round of the 'same and the other'.

'The dignity of being is precisely its power, its internal production – that is, the efficient causal genealogy that rises from within, the positive difference that marks its singularity.'[14]

There are some who may laugh and ridicule yet I cannot but smile when a being comes into existence without opposition to, or negation of, another. Singularity doesn't twinkle with an individuality which seeks to be 'different from' something else.

In the middle of singularity I glimpse a difference which is taken out of opposition.

&

My venture to explore 'the fragrance of different times': has this not been the adventure to find a difference which isn't based upon negation?

A difference which has been taken out of opposition, dualism, dichotomy.

There are some who may laugh and ridicule. Yes, there may be some who rush to the conclusion that I am seeking the beautiful soul ' ... we are different, but not opposed ... ' Yet, there may be others here who ask: where does this concern to find a different difference, a non-exclusive logic, come from?

To this I would reply: from the gut. It is a gut feeling, rather than the beautiful soul, that moves me to find a difference which isn't based upon negation. And to say that it comes from the gut is to say that, as with a belly laugh, it comes from the middle. It comes from the middle of my life. I have to say it: the question of a non-oppositional difference is a force which moves me. A belly laugh and a gut feeling but also, thinking on my feet.

I speak of a gut feeling. I could speak of how exclusionary systems hit you in the gut when they attempt to knock out the middle.

Yes, Gilles Deleuze, I agree with you: 'It is not difference which pre-supposes opposition but opposition which presupposes difference, and far from resolving difference by tracing it back to a foundation, opposition betrays and distorts it.'[15]

I speak of a gut feeling but I could also speak of a sympathy with what Luce Irigaray proposes: the question of difference, explicitly sexual difference, is one of the major philosophical issues, if not the issue, of our age. Luce Irigaray agrees with the philosopher Heidegger that each age has one issue to think through. Sexual difference 'is probably the issue in our time which could be our "salvation" if we thought it through.' Luce Irigaray hopes for a non-oppositional difference. She hopes for a thinking through of difference which will lead to the creation of a new poetics. I hope for a new logic which could be an old logic. I hope for a folding logic. I hope for the art of folding rather than the cut of cutting. Yes, that is the poetics I hope for.

The thinking through of a non-oppositional difference calls for a certain amount of guts. The theory may be as light as a butterfly, carried away by the least fragrance, yet who amongst us can say that this little creature who lives by the wind doesn't have guts, doesn't have tenacity? And yes, I have the feeling that it is a difference taken out of opposition which truly has the guts, the power of endurance.

I do know but I don't know.

Luce Irigaray speaks of sexual difference but she knows only too well that the question of difference is wrapped up with many things. I quote at length:

'But, whether I turn to philosophy, to science, or to religion, I find this underlying issue still cries out in vain for attention. Think of it as an approach that would allow us to check the many forms that destruction

takes in our world, to counteract a nihilism that merely affirms the reversal or the repetitive proliferation of the status quo values – whether you call them consumer society, the circularity of discourse, the more or less cancerous diseases of our age, the unreliability of words, the end of philosophy, religious despair or regression to religiosity, scientistic or technical imperialism that fails to consider the living subject.'[16]

She hopes but she is no fool. She hopes but she is acutely aware of the resistance to be faced.

&

Which single straw would you like? Do you know?

There are some who would perhaps say that with the concept of singularity, founded upon *causa sui*, I am merely clutching at straws in a desperate attempt to flee the negative logic of identity. However, clutching at straws, choosing a straw, just may turn out to be a very plucky act.

There are some who insist until they are blue in the face that for being to demonstrate its being, show itself, it must gain determinacy.

Welcome to determinate being!

All determination is negation!

Welcome to the power of negation!

For being to show itself it must gain determinacy and in order to gain this it must, first and foremost, negate. If there was only being in its simple immediacy then this being would have no real character; it wouldn't stand out against all that which it is not. First and foremost you must stand by the negative movement of being: the existence of something is the active negation of something else. It is the power of negation which determines being.

Omnis determinatio est negatio.

'Determination is negative; if you are a king, here and now, you are not an ox or a shepard or a hero.'[17] Determinate being creates (the concept) of the other in order to distinguish itself and extinguish the other.

If you want determinate being then you must applaud the power of the negative, the work of the negative. However, there are some who believe that this power only serves the military: 'The philosophy of war, of struggle, and of the negative-at-work served only the soldier, the military, the militant who submits to death to accomplice the work of history.'[18]

Amid the applause a voice is heard: *It is not the negative – the destructive work that seems to advance things.* No, it is never the work of the negative that transforms things. However, others have overheard, for immediately I hear the cry: without the power of negation, without the negative at work, without that sort of opposition, there would be no history, no innovation! Yes, it rouses with all the force of a battle cry calling us into action. And all action, it is exclaimed, is opposition to an adversary. 'Since no innovation in the world can take place without an action to introduce

it, and since all action is opposition it follows that opposition (negation, contradiction) is responsible for introducing the new into old.'[19]

The power of negation, we must applaud, for without this power there would be no history, indeed no freedom. However, there are some who have the guts to say that the work of history is done behind the backs of those who believe that history and the negative-at-work go hand in hand.

Yes, Michel Serres they may laugh at you. But today I want to applaud those who stick in there and insist upon a non-oppositional difference. Yes, I want to applaud those who quietly persevere with the art of folding. Michel Serres believes that it is possible to think without excluding. He believes the knot and the fold are inclusive; and equally so, 'the absence of negation'.[20]

'All determination is negation; it is the power of negation which determines being.' Yes, the power of negation constitutes the movement of a negative ontology. However, I would run as fast as my legs would carry me if I thought ontology was this and only this. But I can make a choice. A singular choice. I can choose a single straw without this entailing the active negation of all the other straws in the stable where my beautiful horse lies.

All determination is negation.

However, there are some who have the guts to say: 'The being that must seek an external support for its difference, the being that must look to negation for its foundation, is no being at all.'[21]

All determination is negation, however, the being of singularity doesn't look to negation for its foundation; its existence doesn't entail the active negation of something else. Indeed, the existence of singular being doesn't entail a power which first and foremost negates; rather, it entails a power which first and foremost produces, produces itself. This is what the philosopher means by *causa sui*.

For the philosopher the creation of singular being is an ethical act.

Move

Questions have been asked of me.

How does singularity express its non-oppositional difference? Indeed, how do you picture the non-oppositional difference which cause-of-self puts into effect?

I had been thinking of photography. A photographic image and a concept of expression: the expressed has no existence outside its expression; each expression is, as it were, the existence of what is expressed. Perhaps it is here, with this photographic image, that I shall find the expression of a non-oppositional difference. Moreover, perhaps it is upon this very concept of expression which the non-oppositional difference of singularity turns.

Turn. Turning. Or, in other words trope. Or, in other words, a figure of speech. So far I have discovered the trope of folding. The turning of folding rather than the cut of cutting. Perhaps I shall discover other tropes to express non-oppositional difference.

Let me here turn to the word trope itself.

Trope. The word is Greek for turning and turning to the dictionary I read: a figure of speech, properly one in which a word or expression is used other than in its literal sense – metaphor, metonymy, synecdoche, irony. Traditionally the trope is defined as an opposite to or a deviation from the literal. As such, the trope is seen as a *turning away*. The trope turns away and becomes, so the logic goes, the minus of the literal. A is-not B. Here we find the logic of identity quickly returning. The literal becomes affirmed by

way of the turning away of the figurative. The literal determines itself by way of the difference of the figurative founded upon negation.

It was some time ago, more than ten years ago, that I wrote the following words; then, as now, my venture was to question, and find an alternative to, oppositional difference.

Come, let me quote:

'For long enough she had heard it said that with the figurative the literal deviated from its proper path ... How would the literal remain so literal, how would it remain the same, if it didn't contrive its disappearance with the appearance of metaphor? ... What rhetorical games the literal plays; what double-edged games. How the literal will hide itself, appear to go missing, so that it can return the same. Is it any wonder that the literal frames the metaphorical as the turning away of things from their proper path; for, turn, trope, trick, such turnings are already re-turnings. It is said that the metaphorical is a deviation from the literal. A turning away. A detour. But I say: that de-tour is a return tour guided by the light of the same. I say: the absence which is said to be found with the appearance of metaphor but re-turns to and so affirms the literal's presence.'

Here we are on the merry-go-round of the same and the other. The binary merry-go-round.

The turning is returning, going around and around, and then, quite unexpectedly, a single blade gleams in a stable full of straw and turns my attention to an alternative 'logic of tropes'.

Come, let me say more.

By way of the writings of Michel Serres I find a logic of tropes which doesn't follow the logic of identity where the figurative is seen as the turning away from, the minus of, the literal.

He doesn't believe that a trope hides a literal meaning. Nothing is hidden and neither is there deviation.

Come, let me say more.

Michel Serres wants so much to escape oppositional difference, the 'hell' of dualistic thinking. He has had enough of the dualism order/disorder. He prefers to speak of 'noise' rather than disorder, the opposite of order. For Michel Serres, noise indicates chaos, and it is towards chaos that he wishes us to turn. He believes that the word noise has vectorial power: rather than stating chaos, noise *turns* our attention towards chaos. Here the word does not function as a sign or name, 'but as a vector, a directional motion that is manifest as a turn, since the target toward which it turns remains unknown.'

'In other words, the sign has become a trope ... '[1]

By indicating and pointing to something, noise is a trope.

With Michel Serres' tropology, the trope expresses vectorial power. Not a turning away from the literal, rather a directional motion. Yes, a force. An arrow in flight. Indicating. Pointing. Yet not stating.

Come, let me say more.

To speak figuratively, by way of tropes, it is said that one speaks indirectly. One implies rather than explains. Indeed, the trope implies and very quickly we assume that something isn't stated directly. Now, we can believe that the trope is a turning away from the directly stated and thus conclude that tropes are deviant; or, we can turn to an alternative logic, as Michel Serres does. Figurative language speaks indirectly for it knows only too well that there isn't in existence a 'stated' – a standing still – to which we can go directly. The trope is a vector, a directional motion, however the target isn't in place, standing still. The target remains undefined not because it remains hidden or turned away from, but rather because the trope turns to a world that is coming into being. The trope points us to a world which is itself already turning, a world that is in the process of making itself, a world that is emerging, dissolving – that is, in motion. The target doesn't exist before the act of archery. The trope turns indirectly, for how can there be a direct path to that which isn't already stated, which is, as it were, in motion.

To explicate is to unfold and to implicate is to enfold. By speaking indirectly the trope turns and implies, implicates and enfolds, a world in motion, a world in the making. It is the implicative and vectorial power of the trope which enables a world in motion to become expressed in language. Here, then, the relation between language and the material world becomes, figuratively speaking, one of folding. The double movement of enfolding and unfolding.

Time and time again Michel Serres speaks indirectly. Time and time again his figurative speech stresses the implicative and vectorial power of the trope, *and the world*.

'That's it,' Michel Serres tells me, 'I think vectorially.

'Vector: vehicle, sense, direction, the trajectory of time, the index of movement or transformation.'[2]

His vectorial thinking expresses the materiality of the world; his vectorial world *includes* language and figures of speech.

&

Nothing is hidden, and neither is there negation. Michel Serres doesn't believe that the trope is a turning away from the proper literal path.

What do the oxen know of the literal path, the direct path? He tells me that the oxen only deviate once they have been harnessed to the plow:

' ... the oxen grazing in thick grass go everywhere. They don't go diligently, as if subjugated to the plow, from left to right and then back, as in morals or politics; they divagate, that's all, moving all over the space, their tracks leaving a graph that is crazily complex. Fairly quickly this design must fill up the whole plain, the whole of its surface as well as the little local details.'

The path made by the oxen is always and everywhere turning, going in all directions: 'each brute beast, drawn by the turf, the odour of flowers, or bothered, driven, teased by flies, dazed by a shadow, or going to lick another's neck, wanders without knowing where or why.'[3]

They wander, they stray, they divagate yet such acts of continual turning only become deviations once the path of oppositional difference becomes cut and built upon foundations of stone. Beneath this foundation, however, we can discover another sort of foundation, one that is founded upon movement: 'The oxen straying in sweet grass leave a complex curve under their hooves, all folded in on itself, like a protein – implicated, duplicated, traversed, crushed, streaked, variegated, tiger-striped, zebra striped, damasked, watered ... This is the streaked multiplicity ... the de-differentiated.'[4]

Today, on the plain where the oxen turns to lick another's neck, I discover a tropology, a logic of tropes, which ceases to involve a negation, a turning away, a deviation. On this plain, the trope ceases to figure oppositional difference; the literal and the figurative do not stand opposite each other.

On the tropographical plain something is emerging, something is dissolving, something is turning: non-oppositional difference is on the move.

The earth moves beneath my feet.

The letters of the literal may be carved in stone yet, today, the literal can no longer pretend that a mountain is a solid immovable rock wherein it can hide to evade the act of turning, the trope of folding.

Today I have discovered the trope which can move mountains.

The mountain, slowly, slowly folding.

How can I not laugh?

&

The figures Venus and Mars are, for Michel Serres, two tropes for two definitions of the trope. Mars, the allegorical figure who battles to secure literal invincibility, who wants to make the figurative a turning away; and Venus, the trope which is a vector, a directional motion, a turning towards. Two tropes: one that carries martial power and one that carries vectorial power.

Which way do you want to turn?

– Which single straw would you like?

Two tropes but, also, two times. The time of Mars and the time of Venus. Michel Serres prefers to turn toward Venus, the trope which turns towards, and upon, a world that is continually emerging, dissolving, in motion. A world, a time, which turns without an outcome, a future, known in advance. The time of vectorial power: the time of Venus turning. Venus turns and what matters is the act of turning, the verb turning. V is for Vector. V is for Verb. V is Venus. V is It. Venus turning in the ocean, the

oxen turning to lick another's neck, the mountain slowly, slowly folding – this, rather than the battlefield of Mars.[5]

The trope which figures oppositional difference and the trope which figures a difference where the materiality of the world is pure poetry in motion.

Yes, this is the poetics I hope for.

He is accused of confusing poetry and science. How can a poem by Lucretius be a valid treatise in physics? He is accused of not speaking in plain language.

– Why can't you say in plain language what you have to say?

– What I have to say is that plain language has to be turned as a baker kneads dough for something to be said.

– What I have to say is that plain language is already turning. Plain language is already the tropographical plain where the oxen is turning, drawn by the odour of sweet grass, bothered by a fly, or going to lick another's neck.

– What I have to say is that language has to turn for there to be a saying of something, a coming into existence of something.

– Which is to say, yet again, that the expressed has no existence outside its expression; each expression is, as it were, the existence of what is said. For the expressed to come into existence there has to be a turning.

As for the questions asked of me.

Have I deviated from the path?

Turn

Questions have been asked of me.

– How do you picture the non-oppositional difference which singularity brings into existence, which *causa sui* puts into effect?

The philosopher speaks of *causa sui* as founding an ontology, however for this ontology there isn't a once and for all. On the contrary, this being is continually founding itself. Yes, I could say that the founding of singularity is *current*. Singularity doesn't seek a condition of homeostasis; the same standing still, always the same. This would be a sad death for singularity. To become a once and for all finished entity, what some would call a 'closed system', would not bring joy to singularity.

– So, there is nothing statuesque about singularity but what about its non-oppositional difference?

I will come to statues a little later, but let me say here that singularity doesn't seek a condition of standing still, even if, like a mountain, it never appears to move from the spot; rather, singularity seeks a condition of folding. Yes, the continual turning of folding. The difference which singularity brings into existence turns upon this folding; indeed, it is this movement which constitutes the *current* of singularity. Yes, the philosopher may well speak of an ontology which is founded upon movement.

– The philosopher may well speak of an ontology founded upon movement but how do you picture the non-oppositional difference which singularity produces?

If we are talking about singularity as a force or power which only comes into existence by expressing itself, by producing a manifestation or effect, and if this power in no way remains external to or transcendent of its productions, its expressions or effects, then it seems to me that in producing itself singularity *turns* and immediately differs with itself. A difference is produced which is an affirmation of the power of singularity to produce and express itself. A difference is produced which is immediately positive, affirmative, sparkling. Do I make myself clear?

– Say a little more.

The non-oppositional difference which lies at the heart of singularity is all to do with the turning of explication and implication, expression and immanence. There has already been much talk about unfolding and enfolding.

What follows is my story.

To come into existence singularity has to immediately turn and produce an unfolding, an expression or effect. This turning causes singularity, first and foremost, to differ with itself; yet, singularity doesn't turn in only one way, there is, concurrently, the turning of enfolding, of immanence where causes remain inhered within their effects, where forces remain involved in their manifestations. Singularity differs with itself; it produces a difference yet this difference isn't founded upon negation or opposition. Singularity doesn't negate in order to have being and neither does it do everything in its power to return identically the same. Picturing this non-oppositional difference I am still, quite honestly, drawn toward the *trope* of folding.

Come, let me say just a little more.

Singularity *turns* upon both unfolding and enfolding. However, this turning doesn't figure an oppositional difference in so far as this trope isn't a 'turning away from', as it were, the negative of the literal. The difference which singularity brings into existence isn't a turning away which involves a negation, rather it is a *turning into*.

When dough is kneaded one fold is continually turning into another fold. The production of a new fold doesn't entail the negation of a previous fold. Something is carried over yet in being carried over it doesn't remain the same.

– Oh yes, the baker's transformation.

When dough is kneaded there is unfolding turning into enfolding and vice versa. So far I have spoken of the trope of folding but I could also speak of the trope of a spiral. The turning of a spiral. A helix comes to mind.

&

In the middle of singularity I discover, figuratively speaking, the trope of Venus. Singularity has no time for Mars, god of war. In the middle of sin-

gularity I find a trope which turns in the direction of a world which is continually emerging, dissolving, that is to say, in motion, immersed in time.

The trope of Venus but also the trope of an oxen drawn by the turf or going to lick another's neck. The trope of Venus but also the trope of folding dough.

Am I making the picture of non-oppositional difference too complicated, to complex?

But, quite simply, non-oppositional difference makes a world which is remarkably complex. In one respect the image of folding dough is simple, however this image brings with it all the complication of a world of non-oppositional difference.

Michel Serres asks: What does a baker do when he kneads dough?

He replies: 'At the beginning there is an amorphous mass, let's say a square ... each fold, each loop, each folding over changes the ensemble of the beginning into a complex ensemble. The same square is conserved, and yet it is not the same square ... '[1]

Singular being is conserved yet it is not the same being.

What defines immanent cause is that its effect is in it – in it, of course, as in something else, but still being and remaining in it.[2]

&

Which single straw would you like?

Do you know?

In producing itself singular being first and foremost differs with itself. Determinate being, however, differs with itself because, 'first and foremost it differs with all that it is not.'[3] The difference of singular being is 'internally' produced. The difference of determinate being is 'externally' produced.

I hear that the philosopher Hegel, champion of determinate being, was most irritated by Spinoza's conception of singularity. If being is not held in opposition to its opposite – nothingness – then it will dissolve into nothingness. Hegel may laugh, he may scorn, he may believe that the difference of singular being produces indifference, dissolution, no difference at all.

I wonder.

Did Hegel have a sense of humour? Was his belly ever tickled by a single straw?

&

In order to express itself and come into effect, the being founded upon *causa sui* must immediately differ with itself and continue to turn and differ. It is this differing, this turning, which sustains and founds singular being. At the vector of this turning a difference comes into existence which is 'tropological', which is to say vectorial, rather than oppositional. The difference

which I discover at the heart of singularity is a difference which isn't caused by anything outside itself.

Yes, Gilles Deleuze, I agree with you: with singularity we find 'difference in itself'. It is this difference which makes singularity sparkle, not as a star design but rather as a tropographical plane. This plane, where we find the streaked multiplicity of the complex path of wandering oxen, we may refer to as a 'plane of immanence'.

&

Multiplicity is that which flows by the continual turning and folding of *causa sui*. From the heart of singularity 'flows the real multiplicity of the world'.[4] Yes, multiplicity is the *current* of singularity. It is only now that I am beginning to realise exactly how multiplicity and singularity explicate and implicate each other. Both unfolding and enfolding; a double movement rather than either one or the other.

&

When we take multiplicity as a noun this isn't the naming of a number of elements but rather the naming of a vector, the directional motion of the act of turning. Taken as a trope, the word multiplicity directs our attention toward a world that emerges between the folds of singularity. Multiplicity: the word does not function as a sign or a name ... but as a vector, a directional motion that is manifest only as a turn.

As tropes of Venus rather than Mars, the words difference and multiplicity carry with them vectorial power. And those who populate this vector know only too well that they are not names but acts. To take multiplicity as a noun is to understand that at heart it is a verb. To understand nouns as verbs.

When you say mountain think of this as a verb.

No, a mountain never stands still, is never absolutely at rest.

Everything in the world is in motion. The heavens are in motion. The waters are in motion. The weather is in motion. Nothing is absolutely at rest.

A worm folds into an exquisite knot and sleeps sound beneath the ground. Yet even here the rest is relative.

The Greek philosopher Aristotle believed that the natural god-given state of a body was to be at rest and thus have a fixed position. All motion is caused by an external force and when this force stops so does the motion. For Aristotle the world is at rest in the centre of the universe: everything and everybody has its appropriate place in space. A fixed system. However, in a mobile system everything is in motion and even sleeping worms can never attain an absolute state of rest. Especially so when young girls have the desire to dig them up and hold them in their hands to see the beautiful knots they have made in their sleep.

Have you ever seen a sleeping worm?
Dig one up, hold it gently in your hand.
Folds and knots and a worm's difference.

&

No, a mountain never stands still. When you say mountain think of this as
a verb. Yes, understand time not as a noun but as a verb.

Time.

Yes, we can say that time is also a trope. And, today, how can I not
say the following: *causa sui* is a trope for time.

This is my story:

– Time becomes by way of a continual act of folding and turning.
This is what gives time existence, a life of continuous multiplicity. However,
it is also time 'itself' which causes the act of turning. Yes, today, how can
I not say this: time is *causa sui*. Cause of self, through itself, and in itself.
As time causes itself it turns and so immediately differs with itself. A pho-
tographic image is nothing but this difference. The expressed has no exis-
tence outside its expression; each expression is, as it were, the existence of
what is expressed. What is being expressed here is difference in itself. A
photographic image is nothing but difference in itself.

The photographic image is nothing but a turning. A turning between
the folds of enfolding and unfolding.

Time's multiplicity and a multiplicity of times; the time of each fold
and the time of continuous folding. The weather is continually becoming
and what endures is this becoming. An ongoing time which only continues
by way of a tropological difference.

Soon I will come to death.

Soon, but not quite yet.

&

In advance I had never expected the outcome: it is the ontological practice
of singularity, of *causa sui*, which gives multiplicity the guts to persevere
in its continual becoming and it is multiplicity which gives singularity the
guts of its being. It is a difference taken out of opposition which makes all
the freshness and the materiality of the world.

There is nothing exclusive about the immanent causality which
founds both singularity and multiplicity; both turn upon a non-exclusive logic.
For me, it is a difference taken out of opposition which truly produces a belly
laugh. How can I not laugh when I discover that 'unity' and 'difference' have
ceased to be placed in opposition to each other? How can I not laugh when
I discover the unity of folding? How can I not laugh when I discover the dif-
ference of folding? A belly laugh. A belly folding with laughter. A belly unfold-
ing and enfolding. Yes, how can I not laugh when I discover a unity which
isn't modelled on the exclusive designs of the 'star' and the 'bicycle wheel'.

A belly is laughing and soon the ontological practice of cause-of-self which makes singularity and multiplicity concurrent, will turn immediately into an ethical practice.

Do you have the stomach for such a practice?

Soon; but it is already happening. Concurrently.

<div align="center">&</div>

How can I not be enchanted by the double movement of unfolding and enfolding? How can I not smile and feel my belly move as a laugh begins to rise up? Have we forgotten how to laugh? To fold up with laughter. Mountains of laughter. Have we become deaf to laughing mountains? Perhaps the mountains have become too slow for us; we have come to believe they are standing still, always the same.

Please, stop rushing to conclusions.

Efficient causality; immanence; ontology – you may perhaps rush to the conclusion that these words are of the vocabulary of philosophy. You may think that these words sound very technical, part of the technique of philosophy. For me, however, these words turn on the plain language of folding. That is their poetry. Their poetry in motion.

Please, stop rushing to conclusions.

Run with an idea, see where it takes you, see what you can make of it. Yes, in advance I never thought I would run with *causa sui* – and yes, something quite unexpected has happened.

Oh yes, my belly has been tickled. How can I not want to leap? A leaping horse but also a fish taking to water. Tickling a fish's belly. They leap like horses. Horses in the water. Taking to 'immanent causality' as a fish takes to water. Both thinking on my feet and swimming. For me, immanent causality founds both multiplicity and singularity on movement. The trope has turned to folding, the turn of a fold. However, the current upon which singularity is founded, quickly, quietly, almost imperceptibly, turns the trope to water. From singular being *flows* the real multiplicity of the world. The trope flows. Quickly, the trope turns to liquid. 'What is liquid is neither cut nor broken ... '[5]

For Michel Serres a good foundation is one which is built on what moves. He tells me that we can only found on what flows: we can only found on time 'Time always takes revenge on what is made without it ... liquid is not liquid, it is the most solid, most resistant, most permanent of beings in the world. We must found on liquid, not on solid; we must found on time ... The foundation is the theory and practice of movement. Of fusion and melange. Of the multiplicity of time. Indeed, all foundation is, in the original sense, current.'[6]

So often, far too often, we think that for things to be founded there most be a solid ground. We rush to the conclusion that a good foundation is one which is built on rock, with rock. We rush to the conclusion that

mountains don't move. So often, far too often, we turn to a rock to found being. The trope quickly turns to stone. We think that without rock or solid ground, being will dissolve. For being to have being it most be founded upon a rock: is this the logic around which the principle of identity turns? Quickly, far too quickly, the trope turns to stone. The Christian church founds being on a rock. As solid as rock. Peter is the trope that turns to rock. Peter the rock. And, of course, you can always throw rocks and cast down an opponent.

Ontology turns to seek that which founds being. Yes, I had rushed to the conclusion that ontology seeks a solid ground. Yet now I have been surprised. I have been moved. I have heard a mountain laughing.

An ontology founded upon liquid: are we petrified of this? Do we think that such a way of being can only bring disorder to the world?

Which single straw would you like?

Do you know?

&

On the plane of immanent causality which knows no limit, we find no hierarchy of being. We do not find a god dishing out portions of a limited being, the conferring upon each thing an exclusive identity. There is, on this plane of immanence, always an ontological equality between cause and effect, between, that is to say, differences. Here there is no ranking of the turns produced by singularity.

The ontology founded with immanent causality posits being, as it were, everywhere. The oxen going to lick another's neck and a photographic image and a thought and a worm asleep in my hand. Gilles Deleuze tells me that immanent causality requires an equality of being, or the positing of equal being. He tells me that not only is being equal in itself, but it is seen to be equally present in all things. Indeed, immanent causality cannot be sustained unless it is accompanied by a thorough going conception of univocity.[7]

Univocity?

Where ever being speaks it speaks the same voice.

Univocity. Let us not rush to the conclusion that this makes all being identical. When I first heard of Gilles Deleuze's admiration for Spinoza's 'ontological principle of the univocity of being' my stomach sank. I was, quite simply, rushing to a conclusion and confusing univocity with the identical. But my belly has been tickled and with this act I realize that the essential equality of immanence 'demands a univocal being'. If there was no such demand then difference would continue to be relegated to a negative phenomenon.

No, univocity isn't a reduction of everything to the same. It isn't modelled on a star design; it doesn't have an empire. No, it doesn't have anything whatsoever to do with making everything identical. Far from it.

For Gilles Deleuze there has only ever been one ontology, the one which gives being a single voice.

'There has,' he says, 'only ever been one ontological proposition: Being is univocal.' Being, even if it is absolutely common, always speaks in a single voice.'

He adds that being, this common designated, 'is said in turn in a *single and same sense* of all (...) being.'[8]

In turn: it is univocity which affords difference in itself. Yes, it is univocity which affords a difference to come existence, augmented rather than diminished by the weight of negation.

Come, listen, but see for yourself:

'In effect, the essential in univocity is not that Being is said in a single and same sense, but that it is said, in a single and same sense, *of* all its individuating differences or intrinsic modalities ... It is 'equal' for all, but they themselves are not equal. It is said of all in a single sense, but they themselves do not have the same sense ... Being is said in a single and same sense of everything of which it is said, but of which it is said differs: it is said of difference itself.'[9]

&

On the plane of immanent causality where the productions of singularity turn, we find the expanse of a 'univocal and undivided being'. Perhaps Gilles Deleuze would describe this expanse as 'smooth space'.[10] Smooth. That is to say, unlimited, unapportioned, undivided.

Undivided, or perhaps I should say, operating with a special kind of division. Of the fold. We could describe the expanse of univocal being as smooth space yet this space, this expanse, is absolutely wrinkled. It wrinkles with difference in itself. And for those who populate this expanse, the wrinkles on their brow speaks in the same sense of being as the ripples of water or sand.

On the plane of immanent causality – the expanse of univocal being – Gilles Deleuze comes to the trope of the nomad. The nomad spreads itself over a land without dividing it among individuals, each member takes what she can, and touches a limit only at the point where he can expand no further. The nomad doesn't command the mountain to stand still and there build for herself a home for being. He doesn't build on a solid foundation. The nomad founds being on movement.

Leap

For Michel Serres it is the allegorical figure of Mars who is driven by a loathing of fluidity. Mars will not accept the nature of flows, where nothing is of invincible solidity. It is Mars who commands the mountain to stand still.

Mars wants to be literally invincible. He wants to bolt the stable door so the horses won't bolt.

Mars believes that stability comes by closing the door, by shutting out movement, by containing it. He believes that stability comes by making a closed system. For Mars, movement and flow turn towards dissipation. He is petrified that his being will dissolve.

Mars believes the arrow of time only goes in one way. He fears what he calls disorder. This is the end result of what flows. This he wants to stop. To freeze, to immobilize. No! mountain thou shalt not move. Stay still.

Mars wants so much, far too much, to evade death. He battles to do so. He shuts the stable door. He battles to win immortality. He erects statues believing that this will win for him a stable being, a rock being, a being founded with stone. He battles; he throws stones. His opponent; all that which flows.

Shut the stable door, keep the horses in, I need them for war!

Mars, god of war, opposes that which flows. God of war: god of opposition. Mars cuts. Mars carves out of stone. He builds dykes and in so doing institutes oppositional difference. He creates an opposition between solid

and liquid, order and disorder. God of binarism. God of dichotomy. God of opposition. God of negation. How can I ever fight you? To fight violence with violence?

In an attempt to prolong his reign and gain solid stability, Mars seeks to stop fluidity and the chaos of bolting horses. However, the attempt is futility itself. He shuts the stable door, but this God can never evade *les temps* which erodes statues yet keeps the mountain turning. The statue becomes worn out by the 'kisses of the faithful'.[1] The statue loses its atoms little by little in the downstream flow. In wanting to stop this flow, Mars becomes deaf to the mountain's song:

... the world is unstable, in a state of disequilibrium ...

And it is precisely this world that I will discover in the stable.

In the stable where at last I choose a single straw.

&

Choosing a single straw from a stable full of straw. What can this choice possibly mean?

Come, let me return finally to Michel Serres' little allegorical tale. So little, but a few lines, that it could be passed over unnoticed.[2]

In the stable straw is in disorder under the bellies of the oxen. Here a trope turns and scattered straw beckons my attention. Yes, you could say that my attention is turned towards that which is not of one piece.

My attention is turned and then I am asked to choose but one straw from this indiscernible pile before me, beside me, under my belly. I am urged: go on then, choose one from this pile.

'Which single straw would you like?'

'Do you know?'

'How are you going to look for one straw in this pile of no interest?'

All his hopes are invested in this straw; this he tells me. All his hopes are invested in that act of choosing a single straw. Again I ask: what can this choice, this act, possibly mean?

He tells me that he knows no other image of hope than the straw that gleams alone in the pile of no interest. He tells me that his hope is rare, as rare as common straw. His hope lies not in the direct path that leads us monotonously on. No, his hope lies in the short-cut, the indirect path, the crazy trajectory of a wasp. His hope lies in the unexpected.

I am urged: go on then, choose but one from the pile.

How can I predict which straw will be chosen? There is no guiding star which will lead me to the chosen one.

The oxen are lying peacefully. We could say that they are quite stable, yet around them, beneath them, lies disorder. Elsewhere he tells me how he hopes so very much that one day we will abandon this so negative label of disorder. How can it not imply a thinking only in terms of order?

The scattered straw goes in every which direction.

I'm still looking. Still looking.

I look but the trajectory of my looking goes crazily in every direction. He bids me look at the crazy trajectory of a wasp and, equally, a sea of fluctuations: he wants me to look at unpredictability and instability in the stable. Or, perhaps, I should put this the other way round: the scattered straw in the stable bids me see, first and foremost, instability at the very heart of the stable. To start with chaos, to start with instability rather than seeing this as the end result of a broken down order: this is what Michel Serres is bidding me do.

Order is born from chaos and we may call this birthing time. Elsewhere he tells me that time is chaos, 'at first, it is first of all a disorder.' He tells me that time is still and always chaos, a noise and a disorder. 'The present, now, is this indiscernible jumble. This chaos is not merely the primitive state, it accompanies my every step, we frequently forget it ... It makes up the great masses of time, its ocean as it were.'[3]

The scattered straw in the stable: am I looking at an image of time?

I'm looking, I'm looking. I'm still looking to choose a single blade from the indiscernible jumble.

In the stable the chaotic straw goes in every which direction, far from an image of a straightforward linear time. However, am I to say that such chaos is a deviation from the rule of order?

The scattered straw turns my attention toward instability. A turn. A trope. Yes, the scattered straw in the stable is a trope for unpredictability and instability; however, this trope isn't a deviation from a straightforward (literal) path. This trope, this turning, and indeed the instability which it bids me see, isn't a turning away, a deviation, from the 'rule of order'. A deviation – no, that is not how Michel Serres wishes his trope to turn.

I'm still looking at the discernible jumble; however, my thoughts are turning. Yes, I think to myself, in the stable full of straw a host of tropes are turning:

– The scattered straw is a trope for a thousand directional arrows going in every which way, a network or sea of fluctuations immersed in time.

– The scattered straw is a trope for the 'noise' which Michel Serres wishes his vectorial trope to turn towards.

– The scattered straw is a trope for the turbulent waters from which Venus, traditional emblem of flux and dissolution, is born.

Dissolution. Dissipation. Some would speak of irreversible processes which bring only death and decline. Yet there are some who see not only death but also life emerging from the instability of dissolution and irreversible processes: 'Where ... trajectories become unstable, the world of the irreversible begins, the open world in which, through fluctuation and bifurcation, things are born, grow, and die.'[4]

In the stable full of straw tropes are turning. Yes, we could say the stable is *in* a process of *turning*, irrevocably so. *In* (en) *turning* (trope). Yes, some would say that *entropy* is on the move, changing all that which is most stable, turning it toward death and decline. Yet there are some who glimpse amidst this entropic scene, this turning of the stable, the birthing of a turbulence which heralds the beginning of a new direction for the world, the beginning of a new organization,

It's time for me to choose a single straw. It's time for me to jump, to take a leap. I close my eyes and imagine the scattered straw as a sea of fluctuations ...

The straw is going in all directions, a sea of fluctuations, and then, quite unexpectedly, one fluctuation turns and swerves such that a collision ensues. And then turbulence. And then a swirling vortex. The vortex turns and swirls and forms a pocket wherein a coming together organizes itself.

A sudden swerve, a sudden turning which inclines towards a new composition of the world.

At last a single straw has been chosen.

At last I can say it: choosing a single blade in a stable full of straw is a trope for the *clinamen*, the 'swerve', which Michel Serres discovers at the very heart of the physics of Lucretius' poem *De Rerum Natura*. The *clinamen* which makes Lucretius' poem tomorrow's physics. The fluid physics of creative chaos, as some would say.

The *clinamen*; or, in other words, the smallest possible condition, the minimum angle, that initiates turbulence.

A single straw is chosen, a fluctuation swells and Venus is born amid the swirls of a spiral. Yes, the figure of Venus is also a trope for the *clinamen*.

The trope turns towards the *clinamen* and this swerve, this act of turning, becomes a model for Michel Serres' tropology. The swerve turns and expresses vectorial power.

&

The *clinamen*, the 'swerve' – oh yes, there were some who mocked the very idea and laughed at Lucretius' poem. Yes, there were some who scorned the sudden and stochastic turning of the *clinamen* because no external causality could be found. Indeed, they mocked Lucretius' understanding of turbulent atomic collision where atoms suddenly incline to make a new organization of the world. Why mock when no external causality can be found? Why mock when an internal causality stares you in the face?

Michel Serres says it is bad laughter. He says that the production of the *clinamen* 'needs no other referent than the intrinsic one of flow'.[5]

He tells me that the 'swerve' brings time into existence. This I must ask: does it also bring into existence non-oppositional difference?

<center>&</center>

A swirl. A whirlpool and the formation of a pocket in which a process of inclination occurs. The atoms incline towards each other; sand and straw mix with water and a composition emerges, as it were, a pocket of stability.

A pocket of stability emerges which enables Venus to come to stand. Her two feet on the ground. But first and foremost, Michel Serres tells me, Venus is that very process of inclination where a coming together organizes itself and makes a new composition. He believes that physics is the science of relations, of general links between atoms of different kinds: 'Conformities, conventions, congeries, coitions ... Venus assembles the atoms, like the compounds ... She inspires inclination; she is inclination.'[6]

Tonight Venus is born in the stable wherein lies the oxen and above which we find no guiding transcendental star. Venus is not like the other gods, she is immanent in the world. Venus is born in the stable; she is born from the instability within the stable. He bids me not to forget this. Order and stability are born from chaos, from the irreversible processes of time, from the stable *in* a process of *turning*. The stable is never quite so stable, if it were there would only be, so he says, laws of fate, that is to say, chains of order. 'The new is born of the old; the new is only the repetition of the old. But the angle interrupts the stoic chain, breaks the *foedera fati*, the endless series of causes and reasons. It disturbs, in fact, the laws of nature. And from it, the arrival of life, of everything that breathes; and the leaping of horses.'[7]

<center>&</center>

The little tale has suddenly got larger than the few lines which mark its beginning and end upon the page ...

A pocket of stability has collected. Sand has collected, straw has collected and an island has emerged. Michel Serres never hides his love for Lucretius' poem: 'The first inclination around which atoms, grains of sand or wheat are fixed. Banks of sand or knots of straw, an island is born from that, a real island, a fragment of the world. Lucretius founds objects in the fluvial diffusion of atoms, in the white cataract whirling with turbulent stops, in the banks of sand and the knots of straw.'[8]

An island emerges upon which Venus comes to stand. *Comes to stand* – this, so I hear, is the rudimentary beginning of the word statue.

The figure of Venus comes to stand yet this figure, this statue, doesn't come to stand for the immutability and permanence of stone. On the contrary, this statue and stone stands and testifies to the dissolution and erosion of the world, the irreversible processes where humpty dumpty can never be put back together again. The statue of Venus stands for the time of wear and tear which brings entropic degradation yet also, and moreover, turns the world anew.

Please listen to the mountain's song: the statue of Venus testifies to the irreversible processes of the world where humpty dumpty falls down but where, because of this falling down, this 'declination', this entropic degradation, something miraculous happens – the swerving of the *clinamen* and the birthing of leaping horses, leaping fishes and leaping hearts.

The statue of Venus comes to stand for the impermanence of the world. Indeed, the statue of Venus comes to stand as a monument to instability, movement and unpredictability. Yet, this we so quickly forget as Mars, god of war, comes to make statue and stone stand for (his) invincibility, (his) solidity. We forget to listen to the mountain's song.

A pocket of stability emerges and quickly Mars makes his stand: this stability is mine! He foolishly believes that the founding of this stable order is the result of his winning battle against disorder. Mars cuts an opposition between solid and fluid and then proclaims to the world that the coming to stand of the statue is a monument to his victory over disorder.

Mars exclaims that disorder destroys order. He seeks to exclude chaos and those irreversible processes that bring death and decline to the world. He seeks, ultimately, to destroy disorder. Ironically, Mars kills in order to overcome death; he kills in order to win invincibility. Death to disorder! However, as Mars seeks to destroy disorder he also negates the very processes, as irreversible as they may be, where *en route* something miraculous happens. Death by Mars negates the swerving of the *clinamen* and birthing of a new direction of the world. By a tragic irony Mars delivers himself over to death at the very moment when he thinks he has won immortality.

The statue of Mars stands proud and proclaims victory over Venus and vectorial power, yet quickly, and persistently, through the statue of stone the words of Lucretius flow: *here is nothing in existence that does not have a porous existence.*

Through the statue the time of wear and tear percolates. *Les temps* flows through the statue and it becomes filled with the fluctuations of flows; indeed, the statue and the stable, becomes filled with instability.

The statue of Mars declines; it crumbles and there ensues the process of falling down. The atoms fall. A down turning, a declination. In the statue and in the stable entropy turns, Venus turns. And as the trope turns so also does the *clinamen*. Declination. However, the process of decline is the herald of a new vortex, a new inclination. Venus is a trope which turns towards *both* declination and inclination. 'Venus inclining is the declination itself.'[9]

Both, rather than either, or.

Michel Serres, let me ask you: Is Venus a figure for the inclusion of the middle?

&

Time makes poor old humpty dumpty fall down, never to be put back

together again. Indeed, time makes me old. Yet, in this irreversible process of decline there is the unpredictable turning of the *clinamen*. The turning which makes for me, and the world, a new direction, a new fold. The turning which brings multiplicity fresh to the world. All the freshness and materiality of the world.

Come, let us have the time of our lives.

The folds of my belly are both old and young, both declination and inclination.

He is old and young and he tells me that time alone can make co-possible contradictory things. 'Only my life, its time or its duration, can make these two propositions coherent between themselves. Hegel's error was in reversing this logical evidence and in claiming that contradiction produces time whereas only the opposite is true: time makes contradiction possible.'[10]

The *clinamen*, the 'swerve' and the turning of Venus: no, not a deviation from the straightforward path of order, rather a path which invents itself. A self-constituting path.

Dare I speak of *causa sui*?

Act Three:
The Experience

Practising

A power

In a stable full of straw a sagittarian hears of an ethical project: the creation of singularity. A sagittarian hears of an ethical mandate: become being.

Easier said than done.

The sagittarian's question is simple: How can it be done? This, the sagittarian stresses, is a practical question.

But wait. Before daring to approach this question there is another question which this sagittarian is dying to ask: How can a being which is founded upon an internal causality enter into composition with a body that maintains that one thing always implicates another and another, and, and, and?

Yes, how can there be a relation between the production of singularity, which is cause-of-self, and the idea that an animal, thing or body is never separable from its relations with the world?

The question haunts the sagittarian; it clings. It will not go away. But the sagittarian doesn't want it to go away; rather, there is the hope of finding a way through the question. And seeking to find a way, this sagittarian returns to the question: How can I become being, become singularity?

I pause. I take a breath. And there again is that wind, causing vibration, causing me to voice what I know of the being of singularity. And what

I know of this, is that the being of singularity is voiced by its power to cause itself. The voice constitutes itself in the act of speaking.

Again I take a breath. No, the question won't go away. It rushes like a great wind. Going straight to the heart. Yes, I'll say it as clearly as I can: cause of self is nothing but power. At heart, a constituent power.

To be able to exist is to have a power, a force.

It is a practical matter.

Yes, the singular being which is defined by cause-of-self is, at heart, a constituent power: a power to act, exist and produce.

Come, listen.

The power of being constitutes itself by way of an act of making, and this production is, in itself, an expression and affirmation of the constituent power of being. Indeed, this power can only manifest itself by producing; or, in other words, this power is expressive.

Come, listen.

In order to be, the power of being has to continually express itself; however, the expressed has no existence outside its expression. Or, to put this another way: the power in no way remains external to or transcendent of its manifestations. Nothing is held in reserve. The power is always active and actual. This practice (and theory) of power is otherwise than the power of negation. There is no seeking of an opposition in order to make a manifestation and an affirmation; first and foremost, there is a making.

The being of singularity is always constituted, in practice, by what it can do. There is no predetermined being. No, not even for sagittarian babe born in the month of December.

What can a sagittarian do? What can a thought do? What can a horse do? What can a concept do? What can a fish do? What can an oxen do? What can a mountain do?

What can a body do?

A sagittarian becomes defined in practice, and in practice it is always exercising its power to act, exist and produce. Nothing is held in reserve. A sagittarian, as with a fish, thought or mountain, has no power that is not active and actual. It is, at any given moment, all that it can be.

A warm wind blows and brings with it the odour of grass. The horse turns towards the sweet, sweet grass and is, at this moment, all that it can be. The sagittarian turns. The fish leaps. The worm curls up in a knot to sleep. The oxen goes to lick another's neck. The bodies turn and exercise, even if sleeping, their power to act, exist and produce. Yes, the power of being is always an act, even if this is the act of sleeping, or standing still. But come, there is another sense to the power of being which the odour of sweet grass brings to me. The sagittarian is *affected* by the odour of grass. It is moved.

Yes, the power of being involves a *power to act* and, also, a *power to be affected*.

The receptivity of a body is not a passivity but involves a power to be affected, *a capacity for being* moved. What matters, for the constitution of being, is not just a power to exist; what matters, equally, is affectivity, a power to be affected.

For the philosopher, affectivity is inextricably bound up with (a) being's force of existing. However, affectivity is much more than the movement of so-called (human) emotions.

Take an animal, or indeed human, and then ask: What is this animal affected by in the infinite world, what moves it or is moved by it?

The philosopher tells me, time and time again, that an animal is defined less by the 'abstract' notions of genus and species than by its capacity for being affected. When attempting to explicate the power to be affected, Gilles Deleuze is fond of citing the blood-sucking tick.

Come, he says.

Listen.

What a tick can do is inextricably bound up with its power to be affected, its capacity for being moved. There are three processes of 'affection', three 'affects', which come to make the tick. The first has to do with light: the tick is affected by light and hoists itself up to the tip of a branch. The second has to do with smell: upon the tip of the branch the ticks waits to be moved by the smell of a warm-blooded mammal as it passes beneath. The third has to do with heat: the tick leaps to the mammal below as it is affected by the heat given off by the least hairy spot where with ease it can dig into flesh and suck the warm sweet mammal's blood. The tick has a power to be affected by a light, a smell and a heat and corresponding to this there is a leaping of its power to exist, act and produce. The rest of the time it sleeps, sometimes for years on end, indifferent to all that goes on in the immense forest.

What can a horse do? What can a fish do? What can a sagittarian do?

'A horse, a fish, or even two men compared one with other, do not have the same capacity to be affected by the same things in the same way: they are not affected by the same things, or not affected by the same things in the same way.'[1]

A correspondence

The question hasn't gone away, and the sagittarian doesn't want it to go away.

An 'existing mode', let's say a sagittarian, is always exercising its power to act, its 'force of existing'. The sagittarian's power to exist is realized at every moment; its power is always 'in action'. However, what matters, for the ethical creation of being, is the conditions under which this action is realized. Given that nothing is held in reserve, a sagittarian has,

at every moment, as much power of action as it can have, but what it does have corresponds to how its power to be affected is exercised. What matters is how its power to be affected is caused to be moved. The causality matters for the ethical creation of singular being.

The power of being comprises a power to act and a power to be affected; however, exactly how the power to be affected is caused to be moved has consequences for the power to act; it can come to increase the power to act or diminish it.

Come, the sagittarian wants to hear more.

When the power to be affected becomes a reaction to being acted upon, then, corresponding to this, hurdles are put up for the power of action; hurdles which hinder a sagittarian leaping into the production of cause-of-self.

When the power to be affected is exercised as a reaction to being acted upon, it is caused, by external factors, to become a 'force of suffering'. A reaction is caused by something beyond me and when all that I can do is to react then I suffer the effects of an external causality. Suffering requires a force, however, exercising my power to be affected as a force of suffering effectively diminishes the production of singular being which is, by definition, 'internally' caused.

Yes, the difference between an external cause and an internal, or immanent, cause matters for the ethical creation of singular being.

Ask yourself: How many times am I merely reacting to an external force acting upon me?

Ask yourself. Ask yourself. Ask yourself.

What does a force of suffering affirm?

It affirms nothing.

It affirms nothing because it involves only your impotence. The more your power to be affected is filled with reaction, with suffering, the more you become separated from what your power of action can do. What matters is for your power to be affected to be answerable not to an external cause but your power of action, to be inseparable from that power.

Rather than reaction, action: for the philosopher this is joy.

Only joy is worthwhile.

An affection

The power to be affected – the philosopher wants to say more.

The philosopher Spinoza is exercising his power to be affected. This produces a moving – an affection – of his body, and I dare say, his mind. With this process of affection comes the production of a sensation, a sensibility, a feeling – an affect.

Gilles Deleuze encounters Spinoza's *Ethics* and says: 'From ... an affection there necessarily flows "affects" or feelings (*affectus*).'[2]

The philosopher speaks of sad affects and joyful affects.

'By affect', Spinoza says, 'I understand the affecting of the body by which the body's power of acting is increased or diminished ... '[3]

Let me conjecture that Spinoza is exercising his power to be affected as a 'force of suffering'. During this time he feels a diminishment of his power of action. Hurdles prevent him from experiencing the 'bliss' of leaping. These times, for Spinoza, produce sad affects. However, there are other times when Spinoza's power to be affected is moved such that he experiences an increase of his power to act. When an affection produces this affect, Spinoza speaks of joy.

Joy is the experience of an affection that increases our power to act. Yes, joy is the affect of an increased power to act yet this affect is also a spark which sets in motion the movement of being. The turning and folding of cause-of-self.

The production of joy; it is with this production that the ethical project is concerned.

An ethics of joy.

A distinction

How can I become being? The question hasn't gone away. The question won't go away. It has moved a sagittarian; it has affected her.

A sagittarian has been affected. With this process of affection she pictures rippling folds. However, there is an important distinction to be made: is this process externally or internally caused?

Gilles Deleuze isn't scared to make distinctions. He tells me, in fact, that it is very important that a distinction is made between two sorts of processes of affection: those which are produced by an internal (immanent) causality and those which are caused by factors external to the affected body. Yes, the philosopher is keen that I make a distinction between *active affections* and *passive affection*. Spinoza speaks of the latter as 'passions'.

Active affections and passive affection – yes, the sagittarian wants to hear more.

Let's say that your power to be affected is merely reacting to external forces. Here your power to be affected is being moved by an external cause, and the affection which is being produced is passive. In short, external causes passive affections.

So, how do active affections differ?

An active affection comes into being when the cause of the process of affection become both enfolded and unfolded within the very process itself. This folding is moved by, and equally a movement of, the power of action itself.

Let's not beat about the bush: an active affection envelops and expresses its cause. Active affections voice immanent causality.

The production of active affections – can you picture this?

In the immense forest a tick is exercising its power to be affected. A ray of light is falling and a process of affection is being caused to come into action. A tick is hoisting itself to the tip of a branch whilst the cause of this action is becoming enfolded within its belly; it is making an odour a cause of its own actions. There is an envelopment of a cause, yet there is equally an unfolding of this cause. Yes, a leap.

Let's not beat about the bush: active affections create, and are the creation of, self-positing being. That is to say, singularity. Active affections are the movement of being itself. Being taking a turn, taking a leap.

An adequate action

In the immense forest a cause is leaping into, rather than remaining detached from, its effects. Being is on the move. Leaping horses, leaping fish and leaping hearts. Yes, in the immense forest active affections are being produced, yet there is something else being produced, what the philosopher calls, an adequate action.

The tick takes a ray of sunshine into its belly, it hoists itself and, at that moment, posits itself. The philosopher doesn't beat about the bush: an adequate action is that action which is produced by self-positing being. An adequate action is that which causes being to move; indeed, such action is the movement of being itself. Being taking a turn and producing difference in itself.

Time, and time again.

Let me spell it out: adequate actions are the productions of active affections. Yes, the adequate comes into being when an action, or indeed idea, envelops and expresses its cause. When, for instance, a sagittarian leaps over the hurdle of external causality.

For the philosopher it is a good day when adequate actions are produced. Yes, it is a good day when active affections make their own causes. A good day, for on this day there is the production of singularity.

However, there are bad days. Perhaps far too many. Bad days are when the power to be affected becomes a force of suffering. On bad days a body endures external causes and the production of singularity is seriously weakened. On bad days the becoming of being can be fatally weakened.

Bad days, for the philosopher, are sad days.

No, the philosopher isn't scared to make a distinction between good days and bad days.

For the sagittarian there begins to emerge a practical answer to the questions which won't go away: start by denouncing those who take pleasure in making others suffer bad sad days.

There are some who may find the example of the tick attaining active affections and adequate actions a laughable image.

Is this bad laughter which I am hearing?

Who is laughing so mockingly?

Is it one who would rather hear of the inadequacy of others?

Would you prefer to hear of the sadness which can be produced by external causes which diminish an other's power of action? Are you happier mocking those who suffer being acted upon by external forces greater than their own?

Ask yourself. Ask yourself. Ask yourself.

Is this bad laughter which I am hearing?

Ask yourself: How can I produce adequate actions?

A (great) question

The question won't go away and I don't want it to go away. I don't want to shy away from making distinctions.

I pause. I take a breath. And there is that wind again. A vibration in my throat but also a wind up my tail. Oh yes, I much prefer this than having the wind taken out of me. Having the wind taken out of me? Doesn't this produce passive, rather than active, affections?

'The great question that presents itself in relation to existing modes is thus: Can they attain to active affections, and if so, how?'[4]

Yes, it is a great question.

The philosopher says this is the "ethical" question, properly so called.

It is a great question for so often, far too often, this sagittarian feels that her capacity to be affected is moved by passions, that is to say, passive affections. Yes, most of the time this sagittarian feels that she is merely reacting to forces acting upon her. Overpowering forces. Forces greater than her own. Yes, what matters is the creation of active affections.

Suppose that a finite mode manages to produce active affections. While it exists will it have the power to eliminate, for all times, all the passions which are the result of external causes? A finite mode cannot eliminate all its passion; at best, a finite mode can bring it about that passive affections only occupy a small part of itself.[5]

It may be disheartening to hear that the majority of the time finite modes experience passive affections. Yet, hearing this, the sagittarian gets wind of something ...

As I begin to take on board the extent to which I experience passive affections, I get an intimation of the activity of making another distinction. Yes, I get an intimation of the activity of distinguishing *sad passive affections* from *joyful passive affections*.

An encounter

The questions won't go away and the sagittarian doesn't want them to go away:

- How can I produce singularity?
- How can this finite mode do all that she can to further the production of, and the productions made by, an immanent causality?
- How can I strengthen the production of cause-of-self?
- How can I make active affections?
- How can I make adequate actions?
- How can I make actions and affections which unfold and enfold their cause?

Oh yes, the sagittarian has the wind up her tail. She has been stirred to make a distinction between active affections and passive affections, and now she is stirred to make another distinction between *sad passive affections* and *joyful passive affections*.

You could say that the sagittarian is driven but you could also say that the sagittarian has 'encountered' a wind and that both are running together ...

Yes, the philosopher turns our attention toward an encounter in order to speak of the importance of making a distinction between those passive affections which are joyful and those which are sad.

Everything in the universe is encounters ...

You could say that a sagittarian has been produced by an encounter between a human and a horse. Now, you may think it important to ask if this was a heavenly encounter pertaining only to celestial bodies; or, you may think it far more worthwhile to ask: *Was the encounter organized or did it come about by chance?*

Everything in the universe may well be encounters but not all encounters are the same ...

Again it is pouring with rain and a driving wind is forcing me to seek shelter. I am rushing along and then, by chance, I encounter another who is seeking shelter. In the pouring rain and driving wind two 'bodies' encounter each other. However, these two bodies are not fixed units with static structures, rather, they are themselves, like the weather, a dynamical composition of relationships. You could say, nothing but a compound of affects. As these two bodies encounter each other will they, in some way or another, enter into composition with each other? Will they make a new composition of relationships or will they 'decompose' each other? In short, what sort of affections will be produced?

'When a body "encounters" another body, or an idea another idea, it happens that the two relations sometimes combine to form a more powerful whole, and sometimes one decomposes the other, destroying the cohesion of its parts.'[6]

Let us remember that a body can be anything; 'it can be an animal, a body of sound, a mind or an idea; it can be a linguistic corpus, a social body, a collectivity.'[7]

As for the encounter which is taking place, again she asks: What sort of affections are being made?

A driving wind and a pouring rain. To be sure, we could say that both bodies are being acted upon by the weather and this has forced each body's power to be affected to become a force of suffering. Yes, we could say that both bodies are enduring an external force acting upon them and thus experience passive affections. However, rather than blaming everything on the weather, let us ask what affections the two bodies themselves are making for each other.

Everything in the universe may well be encounters but this sagittarian is compelled to distinguish between two sorts. *The first sort occurs when I meet a body whose relation combines with my own.*[8]

Let's imagine a chance meeting between two bodies whose dynamic composition can combine. That the two bodies can combine necessarily involves an active moving of each body's power to be affected; as such, the process of affection sets in motion the power to act which brings with it, what can only be called, joy. As the two bodies enter into composition with each other they come to produce a more intense power to act; indeed, as the two bodies enter into composition their relations compound and produce a new dynamic of relations, as it were, a new body which has enfolded within it a more intense power to act. With this sort of encounter each body comes to move and augment the other's power to act; it produces joyful passive affections.

Meeting an 'external' body whose composition can combine with my own increases my power to act. Yes, this is a good day, even though it is pouring with rain. With the encounter just made the power to act is increased, however, it is not increased such that there is the production of active affections and the leaping of an adequate action. The philosopher doesn't beat about the bush: 'Our passive joy is and must remain a passion: it is not "explained" by our power of action. but it "involves" a higher degree of this power.'[9] To be sure, there is the joyful affect which an increased power to act brings; however, the cause of this affect lies, for each of the bodies concerned, with the other. As such, it lies outside. And it is such an external causality which defines passive affections. Nonetheless, such an encounter is good.

However, there is a second sort of encounter which isn't so good.

As I seek shelter from the wind and rain I may well meet, by chance, a body whose dynamical composition of relations does not, and will not, enter into composition with my own.

' ... it is as if the power of that body opposed our power, bringing about a subtraction or a fixation; when this occurs, it may be said that our power of acting is diminished or blocked ... '[10]

Yes, as I seek shelter I may well encounter a body which blocks my power of action, which decomposes the composition of my relations, destroying them, just as poison decomposes and destroys blood. Such an encounter produces nothing but impotence. Nothing but sad passive affections, sad passions.

A sad encounter. A bad day.

The philosopher doesn't beat about the bush: sad passions are the result of an encounter between finite modes where one body has the effect of making the other body suffer a diminishment of its power to act. Having my power to be affected filled by sad passions produces only impotency.

You may well laugh at another's sadness. You may well mock. But, let me ask you, is this mockery the result of your own bad sad days turned to hate and cruelty?

The philosopher traces a dreadful concatenation; first, sadness itself, then hatred, mockery, fear, disdain, envy, shame, regret, anger, vengeance and cruelty.

Dreadful, yes. But let us not forget that just as there are those who, through their own impotency and sadness, mock others, there are also those who seek to break and belittle the potency of joyful spirits.

Those who know how to break the production of being, rather than strengthen it, are 'burdensome both to themselves and to others'.[11]

No, the question won't go away and the sagittarian doesn't want it to go away. And here is another question which the sagittarian can't dismiss lightly: To what extent does the principle of identity, operating in all its sun-soaked logical glory, produce the affect of sadness?

Ask yourself.

In seeking to reproduce itself, the principle of identity inflicts upon another a lack of identity. In short, the principle of identity produces non-identity. The one is and the other is-not. The principle of identity, let us remember, creates the other as it negates the other, the non-identity, in its effort to have identity affirmed. As the principle of identity creates and inflicts non-identity should we not ask: To what extent does this produce sad passions?

Everything in the universe may be encounters but not all encounters are the same.

I may well prefer to organize encounters with external bodies that increase my power of action but here I must ask myself: 'How can a being take another being into its world, but while preserving or respecting the other's own relations and world?'[12]

Or, in other words, how can I make an encounter with another without subsuming this other? Indeed, how can I actively engage in a non-subsumptive relation to another's being?

For the philosopher Emmanuel Levinas, this is the ethical question. A non-subsumptive encounter with another is the event of the ethical.

The question remains: *How can I become being?*

I encounter an external body – let's say a photographic image. From this encounter there is the production of affections. Sometimes joyful passions. Sometimes sad passions. Sometimes, even, active affections.

Sometimes. Sometimes. Sometimes.

A photographic 'body' in its encounters may come to affect another such that there is a diminishment of the power to act. On this occasion the photographic image produces sad passions and causes an ever lower degree of the power of action. However, there are other times when a photographic image encourages an increase of the power of action. And there are yet other times when a photographic encounter produces, for all the relations involved, active affections. That is to say, there are times when a photographic body is involved in the production of singularity. That is to say, a practice of immanent causality. That is to say, being.

Do you find it laughable that a photographic body can become being?

Is this bad laughter which I am hearing?

The philosopher compels me to investigate the affects of which I am capable. What can I do?

What I can do corresponds to my power to be affected and investigating the affects of which I am capable, is equally an investigation of the relations I am capable of entering, making.

The philosopher also proposes a critique of sadness, a 'devaluation of sad passions and a denunciation of those who cultivate and depend on them'.[13] This, the philosopher believes, is the practical task of philosophy.

The sagittarian has the wind up her tail; she is running but she doesn't want to run away from either a critique of sadness or an investigation of affects. She wants to investigate the affects of which she is capable yet she also wants to ask: Of what affects is a photographic image capable?

Is not a photographic body, like a tick, a compound of affects?

Is not a photographic body, like a tick, affected and moved by light? Do you find it laughable that photographic bodies have a power to be affected?

A photographic image is nothing but a dynamical composition of relations. A photograph is nothing but affections. An image is nothing but affects. It is not so absurd to say: a horse, a fish, or even two photographic bodies compared with each other, do not have the same capacity to be affected by the same things in the same ways.

What can a photograph do? What relationships is a photographic body capable of entering? Will a photographic body compose relationships which increase the power to act? For the philosopher seeking to produce a

philosophy of immanence, this is an ethical question and has nothing what-soever to do with the question of representation.

Rather than look at a photograph as a representation involve your-self with it as an affective body. Sad affects. Joyful affects. However, let us not make the mistake of thinking that a joyful encounter only comes from happy smiling images. Indeed, we may find that such smiling pictures pro-duce sad passions and diminish our power to act.

A photographic body is not a fixed unit with a static structure. A photographic body, like the weather, is always on the move, even if it appears perfectly mountain still. A photographic body is continually enter-ing into relations, composing relations and decomposing relations.

Are you to deny the affectivity of the photographic image?

A photographic body can affect and be affected in many ways. Indeed, doesn't the production of a photographic image afford us a rich understanding of processes of affection and interaction among bodies? Isn't a photographic body continually exposing itself to a process of affection?

Yes, acknowledge those times when, in photographic productions, causes become enveloped and developed in processes of affection. Yes, be aware of those times when a photographic body practices immanent causal-ity. The photographic image: the expressed has no existence outside its expression; each expression is, as it were, the existence of what is expressed. When a photographic body practises immanent causality, it folds the eth-ical into its production.

The sagittarian has the wind up her tail.

She is running with the wind. A driving wind and driving thoughts. Can I keep up?

And then the sagittarian cries out: Are you to exclude photograph-ic bodies from becoming being?

Are you to exclude photographic bodies from the production of sin-gular being which in its continual turning produces univocal being and dif-ference in itself? Are you to exclude photographic bodies from the *expanse of a univocal and undivided being?*

The philosopher cries out: there has only ever been one ontology – being is univocal!

Another fold

The philosopher says that the ethical question falls into two parts: *How can I turn joyful passions into active passions?* But, first of all: *How can I ex-perience a maximum of joyful passions?*

And still there are those other questions which won't go away.

– How can a being which is founded upon an internal causality enter into composition with a body that maintains that one thing always impli-cates another and another, and, and, and?

– How can there be a relation between the production of singularity, which is cause-of-self, and the idea that an animal, thing or body is never separable from its relation with the world?

The sagittarian begins to suspect that the question of causality is what matters.

The sagittarian is aware that a photographic body, as with a linguistic corpus, idea or social body, can partake of the ethical creation of singularity. Indeed, when a body is not beholden to or subsumed by an external or transcendent causality it can become both singularity and multiplicity.

Oh yes, the sagittarian is aware that all sorts of bodies can turn toward the ethical creation of being, yet the sagittarian is also aware of another 'ethical' turn. Yes, the sagittarian is equally aware of the ethical turn of practising non-subsumptive relationships with others. One thing always implicates another: yes, how can the sagittarian forget the non-subsumptive practice of relations with which the art, and theory, of implication and the baker's logic seek to actively engage ?

Non-subsumptive: when a practice, and a theory, seek to neither grasp and include 'all', nor exclude, negate, and indeed create, 'the other' in order to affirm the glory (of the logic of) identity.

Non-subsumptive: when you are not subjected to an external force, or transcendent causality, which overpowers and belittles you.

Non-subsumptive: when no supreme principle rules; when no blueprint imposes its *a priori* plan or order upon the movement and immanent organisation of relations of the world.

Yes, rather than the bicycle wheel or the star centered design, the non-subsumptive looks to folding as the trope for its practice. The trope which brings non-oppositional difference to the world.

The trope of folding.

But, she says quietly, there are many ways to fold.

'No two things are folded in the same way.'

No two rocks, no two souls, no two mountains, no two brains, no two loaves of bread, no two thoughts.

' ... there's no general rule saying the same thing will always fold the same.'[14]

With the art of implication and its practice of non-subsumptive relationships we could speak of an ethical fold; a practice of, and a continual experimentation with, an ethics of folding. And now, there is yet another fold: the folding of immanent causality; the double movement of expression and immanence which brings to the world the ethical creation of singularity.

How can I not smile when I find a photographic body, or come to that, a linguistic corpus, moving between these two folds?

'There's nothing more unsettling than the continual movement of something that seems fixed.'[15]

Between two folds.

For some, however, this makes a pudding of ethics.

A chuckle and then a belly laugh and then a mountain roar: *But will the pudding's digestion turn joyful passions into active affections?*

That's the great question.

Common notions

How do you know in advance of what affects you are capable ?

Whilst you may seek to avoid sad encounters and favour joyful encounters, you still don't know what a body can do; each encounter is, as it were, an experimentation in the art of composing relations. Knowing the affects you are capable of is 'a long affair of experimentation, requiring lasting prudence'.[16]

There is no general rule saying the same thing will always fold the same way.

You may well seek to avoid sad passions and favour the production of joyful passions. However, it is not enough to think that an accumulation of joyful passions will come one day, in their adding up, to produce the experience of active affections, adequate actions.

Whilst the sagittarian finds joyful passions desirable, it is even more desirable that she find the means to turn joyful passive affections into active passions. A sum of passions do not make an action; it is a matter of an ethical turn, and this turning is a matter of continual experimentation.[17]

The ethical turn: How to turn joyful passions into active affections where the power to be affected and the power to act fold immediately together and produce adequate actions? Yes, how to turn joyful passions into adequate actions which, by enveloping and expressing their cause, make being and affirm being in the moment of its practical constitution.

Yes, how are joyful passive affections to be turned into active affections? Again the philosopher prompts me: 'from every passive joy there may arise an active joy, distinguished from it only by its cause.'[18]

Again it is a question of causality.

Again: *How can this sagittarian become being?*

I pause. I take breath and there again is that wind ...

In the making of a sagittarian a horse and a human enter into composition with each other. Neither the horse nor the human are fixed units with static structures; rather, they are both, in themselves, a dynamic composite of relations and processes of affection.

Two bodies have encountered each other and it is found that their relations are 'composable'. It must be said, however, that this composability has nothing whatsoever to do with copulating couples, although, it must be also said, that the question of the production of joyful passion is totally relevant to copulating couples, no matter what their sexual combination may be.

Two bodies have entered into composition with each other, the relations have compounded and increased the power to act. With the act of compounding comes the production of a new composition of relations which are irreducible to either horse or human. This new composition is not a subsumption of one by the other; and neither should we make the stupid mistake of naming the newly composed sagittarian a half-breed (there are no half-breeds in this world); rather, what we have here is the production of a new fold. A new fold produced between two folds. In short, a new body of relations and affects which has folded into it an increased power to act. A new body, but also a more powerful body.

Now the human and the horse can only enter into composition (and make this new body) because between them they have discovered a concurrency. Something in their make up, as it were, agrees. In short, the human and the horse have discovered, between their relations, a commonality. This commonality, and its discovery, is the cause of the composition of relations between the human and the horse. For the so-called sagittarian composition to happen, the bodies involved have to discover the cause of the composition 'from the inside' of the process of composition itself. Indeed, the bodies involved have to discover between themselves the logic of their compatibility. What has to be discovered is an internal logic, what the philosopher calls a *common notion*. However, this discovery is more than just a discovery; it is an active making. Without the active making of this internal logic there would be no sagittarian body. Indeed, by way of their commonality, the two bodies make an internal logic yet, moreover, they produce an *internal causality*.

Let me spell it out: *common notions* are the discovery of the internal logic which causes the composability of two (or more) bodies. *Common notions* are made when two bodies make a composition which both envelops and expresses it cause. Here, neither horse nor human, and the encounter between them, are beholden to, or 'explained' by, an external or transcendent causality. With the active discovery of *common notions* neither of the bodies involved are taken in by something greater. The discovery of commonality does not amount to subsumption. No, no, not subsumption for between the bodies something is 'in the making', something is becoming.

Two bodies have encountered each other, they have affected each other and joyful passions have been produced. In the process of affection a new dynamical composition has been produced; yet something else has happened: in the process the two bodies have discovered the internal logic and the internal causality of their encounter. Yes, an external causality has been turned into an internal – immanent – causality.

A sagittarian composition can only come into existence because the common set of relationships, which are its cause, have been enfolded, and also unfolded, in the composition itself. Yes, joyful passions have been turned to active affections.

Yes, joyful passions have taken an ethical turn: the composition of the sagittarian is the leap of an adequate action. An adequate action because the cause has been enveloped and expressed in the actual making of the composition itself. It is a practical matter: with the production of *common notions* being takes a 'leap'.[19]

Yes, a *common notion* produces the adequate, 'it envelops and explains its cause.'[20] Yes, *common notions* produce the active affections which make a new constitution of being. There is, as the philosopher would say, a new becoming of being. Another becoming; another production of difference.

Time, and time again.

The sagittarian begins to attain a practical answer to her practical question: to become being, to become singularity, seek to *produce common notions*.

Yes, to have the ethical and the ontological turning together, make *common notions*.

'When we encounter a body that agrees with our own, when we experience a joyful passions, we are induced to form an idea of what is common to that body and our own.'[21]

An idea, a notion, a *common notion*..

The philosopher says a *common notion* is precisely the idea of a composition of relations between several things. However, this idea isn't merely an idea.

In the sphere of the composition of relations, it is not merely a notion that intervenes, 'it is not merely reason that intervenes.' but all the material resources of bodies. Whilst I am reminded that *common notions* refer principally to a physics of bodies and not a logic of thought, this in no way excludes a body of thought from producing common notions and using all its material resources, its physics, to do so. The production of *common notions* involve all the material resources of bodies, which includes thought in as much as it includes, what the philosopher calls, 'physico-chemical or biological Ideas'.[22]

In the sphere of the composition of relations there may well be the production of abstract bodies, but the abstract does not mean unreal or ideal. An abstract body, or bodies composed in part or whole of abstract relations, have as much life as a corporal body. A non-organic life, yet still a life.

The philosopher says it clearly: 'The idea of non-organic life is constant in *Mille Plateaux*, since it is the life of the concept.'[23]

Are you to deny that abstract bodies have a power to be affected?

Are you to deny that abstract bodies have affects?

An abstract body. A concept perhaps. A sagittarian perhaps. Or, perhaps, an encounter between abstract relations and a corporeal sagittarian body which upon producing a *common notion,* enter into composition with

each other and produce for the world a new sort of being, a new mode of existence.

In the sphere of the composition of bodies which founds and is founded upon an immanent or efficient causality, there is no distinction to be found between 'natural' bodies and 'artificial' bodies. The real distinction is between those encounters which produce sad passions, and thus have no inclination to produce *common notions*, and those encounters which turn joyful passions into active passions – those encounters which produce *common notions*.

Making this distinction and partaking of the ethical turn is, for the philosopher (and perhaps the artist too), an Art:

'The common notions are an Art, the art of [Spinoza's] *Ethics* itself: organising good encounters, composing actual relations, forming powers, experimenting.'[24]

To cup (it)

As the horse and the human encounter each other, discover an internal logic and produce an internal causality, a sagittarian body is made which has nothing whatsoever to do with a star designed causality.

A chuckle, then a belly laugh, and then a mountain roar:

– Common notions are the discovery of the internal logic which causes the composability of two bodies. For the two bodies to become composed it is necessary that they cup the causes which make them composable.

– The process of cupping causes produces a new composition, a new arrangement of relations.

– We can speak of a process of cupping but we can also stress that a common notion is the production of a folding logic. (The baker smiles.)

– The composition of the new affective body is an enfolding and unfolding of its cause: the cause is *inhered* in the composition itself yet the very existence of the new composition is an *expression of the cause*. The new body is an expression of the expressed which has no existence outside its expression.

– The new body, the sagittarian body, is a production which cups its own 'producibility'. The new assemblage of relations is not a chance composition; it is an ontological constitution because the process which makes the new body, envelops and expresses its cause in the new body itself.

– The new composition is, in its fullest sense, cause-of-self. In itself and through itself.

Suddenly cause-of-self has taken on a new practical meaning. Suddenly cause-of-self has political implications.

In the moment of its practical constitution, the new composition of relations affirms being itself. This practical constitution affirms the power

of being to produce itself, that is to say, to act, effect and exist. (No, there is no need to negate another in order to come into existence.) Such affirmation constitutes a joyful practice. Active joy.

The newly composed sagittarian is a singularity.

The newly composed sagittarian composition is also a multiplicity.

With this composition there is the production of difference in itself.

A new composition has been individuated, yet this individuation far exceeds the narrow boundaries (im)posed by a selfish individualism. The singularity and multiplicity composed has no little or big subject, absent or present, at its centre.

The philosopher cries out:

'There is no longer a subject but only individuating affective states of an anonymous force.'[25]

There is no subject, or perhaps we should say that the subject has turned to become, is becoming, is always becoming, the interaction of a field of immanent forces. Here we find no subject and object relation, just affective states.

The subject is now found on the plane of immanence. An oxen turns to lick another's neck and subjectivity becomes inseparable from affectivity.

A common notion both enfolds and unfolds the cause of a joyful encounter, this makes an adequate action which 'in itself' is the making of a new constitution of being. A new fold in the wrinkled surface.

The conception of being here is mobile. All sorts of creations can be made. A sagittarian has become being but 'being' has taken a turn quite different from determinate being, the being of the logic of identity. Yes, there is nothing fixed as regards Gilles Deleuze's being. Yes, he turns being into 'a hybrid structure constituted through joyful practice'.[26]

Being is on the move. Indeed, it has to move, it has to turn and differ with itself. Yes, the mountain is belly laughing but it is also roaring: *Yes, the problem is not how to finish the fold but how to continue it.*

And

Common notions have given the sagittarian an answer.

At last I am beginning to realize that a singularity is never separable from its relations with the world. At last I am beginning to realize that cause-of-self *is* a relation with the world.

A non-subsumptive relation and an immanent relation.

At last I realize that a self, or indeed a world, is a field of immanent forces. Singularity understands its relation with the world, with another, and another, and another, by way of an internal logic, an immanent logic, a folding logic. If singularity becomes separated then these relations become external factors which, by definition and effect, diminish the production of singularity.

It is the immanent causality of the production of *common notions* which gives me an answer to my 'other' question. It is the immanent causality of singularity which produces the non-oppositional difference of indivisible continuous multiplicity.

Perhaps it is time itself.

I don't know but I do know that I can't cup it all. Yet to cup something is not the same as to grasp. Is it?

Indivisible; but we should remind ourselves that there is the special division of the fold.

Yes, how to continue the fold, given that there is no general rule saying the same thing will always fold the same way.

An art

A singularity has been produced but this is not the end of the story; it is never the end of the story. It is just a beginning. The process, indeed *art*, of organizing encounters and producing *common notions* must be indefatigably pursued.

The 'art of organising encounters' is truly an art.[27]

Perhaps, she says, the only art worth pursuing.

Yes, the composition of relations, the making of *common notions* and immanent causality, the folding of singularity and multiplicity, is an art for it has to be continually done anew. This is the experimentation; it is, also, the practice of joy.

What is an art work? Nothing but affects, nothing but relations. A continual process of the composition and decomposition of relations.

What is an art? The production of cause-of-self, be this of a concept, a social group, or an oxen going to lick another's neck, or a photographic body that has entered into composition with a linguistic body, or perhaps a landscape, or a swan, or a laughing face, or a body of flesh and bone that is turning and running.

A practice of cupping and, equally, a practice of folding. But also, a practice of the trope of Venus.

The art of organizing encounters and producing *common notions* may take place between artists; it may take place between doctors and artists; it may take place between bodies that seem, by external perception, the most unlikely to combine.

A singularity has been produced yet, for the sagittarian, this is not the end of the story. The sagittarian doesn't want to shy away from the art of organizing encounters, the art of *common notions*.

Encounters and compositions may be made that produce art assemblages. Encounters and compositions may be made between artists; between the painter and the film maker; between the photographer and the poet; between, that is, all the material resources that these bodies involve.

For what is an artist?

She says, loudly, nothing but a temporary individuated affective state.

What is an art-composition?

She says, equally loudly, nothing but a temporary individuated affective state.

And what is an encounter with an art-composition?

Nothing but a field of immanent forces.

In this field the most exquisite flowers can grow. Flowers yet unthought.

The art of *common notions* is not the exclusive domain of any given social group. Encounters can be organized between all sorts of bodies, be they abstract or concrete, be they natural or artificial, be they linguistic or musical, be they visual or verbal, be they of flesh and bone or mountains folding. All sorts of bodies can be composed. Bodies yet unthought, bodies yet to come. That indeed is the experiment. That is the art.

With the production of common notions one is always becoming-other than what you are: the art of organizing encounters is always the pursuit of an increased power to act, the pursuit of a practice of joy.

Assembling bodies, making encounters and composing new bodies, is the production of an internal logic, an immanent causality; and this production, necessarily, proceeds by way of an open logic of organization. Organization rather than order. For this experimentation there can be no blue-print, no prior plan, no predetermined order, no *a priori* knowledge. Such a plan would block the movement of immanence. Of course, for some, this is exactly the plan: to destroy immanence and secure an external transcendent space.

She says it loudly: a predetermined order blocks the production of immanent causality which becomes, which is always becoming, in the making of a *common notion* and the production of being.

&

At last she realizes that ethics is an art, as is, equally, the production of being.

The baker does indeed smile as the ethical and the ontological are seen folding together.

The philosophy of immanence becomes an art, a way of life.

A joyful practice is the movement and expression of being.

This is the becoming.

The becoming-other of what you are.

This is the becoming of being.

Common notions afford us the time of our lives.

Come, let us make that time.

The sagittarian looks back to the very beginning of this linguistic body; that she has arrived at where she is now is truly surprising.

She smiles.

Yes, she smiles as she thinks of the adventure she has had, and the adventure yet to come. Her smile is two fold, for as she looks back she finally realizes that sagittarians come to learn things, as it were, ass backwards.

Notes Chapter Four

... And Words in the Middle

1. Hannah Arendt, *The Human Condition*, University of Chicago Press, 1968, p 198.

2. See this volume, Yve Lomax, 'Future Politics/The Line in the Middle', p 39.

3. Hannah Arendt, *The Human Condition,* p.199.

4. Ibid., p 198.

5. For an expansion of this argument see my 'How to Dress for an Exhibition' in *Stopping the Process*, Maretta Jaukkum and Mikka Hannula, (eds.), NIFCA, 1998.

6. Giorgio Agamben, *The Coming Community*, Minnesota University Press, 1993, pp 1–2.

7. See this volume, Yve Lomax, 'Sometime(s)', p 77.

8. Giorgio Agamben, 'Outside', *The Coming Community*, p 67.

9. Jean-Luc Nancy, 'Myth Interrupted', *The Inoperative Community*, University of Minnesota Press, 1998, p 44.

10. Ibid., p 50.

11. Ibid., p 53.

12. Ibid., footnote no.23, p 161.

13. See this volume, Yve Lomax, 'Future Politics/The Line in the Middle', p 39.

14. Jean-Luc Nancy, *The Inoperative Community*, p 52.

Serious Words
Act One
The photograph and *les temps*

1. Gilles Deleuze, *Spinoza: A Practical Philosophy*, translated by Robert Hurley, City Light Books, San Franciso, 1988, p 125.

2. Michel Serres, 'The Origin of Language: Biology, Information

Theory and Thermodynamics', *Hermes: Literature, Science, Philosophy*, Josué V. Harari and David F. Bell (eds), The John Hopkins University Press, Baltimore and London, 1983, p 75.

3. Roland Barthes, *Camera Lucida*, translated by Richard Howard, Hill and Wang, New York, 1981, p 91.

4. See this volume, Yve Lomax, 'Sometime(s)', p 77.

5. Gilles Deleuze and Felix Guattari, *A Thousand Plateaus: Capitalism and Schzophrenia*, translated by Brian Massumi, The Athlone Press, London, 1988.

6. Alan J. Friedman and Carol C. Donley, *Einstein as myth and muse*, Cambridge University Press, Cambridge, New York, Melbourne, p 59.

7. Michel Tournier, *Gemini*, translated by Anne Carter, Minerva, London, 1989.

8. Ibid., p 450.

9. Michel Tournier, *The Wind Spirit: An autobiography*, translated by Arthur Goldhammer, Collins, London, 1989, p 157.

10. Michel Tournier, *Gemini*, p 9.

11. Ibid., pp 441–2.

12. Ibid., p 447.

13. Michel Serres, quoted from Vincent Descombes, translated by L. Scott-Fox and J. M. Harding, *Modern French Philosophy*, Cambridge University Press, Cambridge, New York, Melbourne, 1985, pp 91–92.

14. See Henri Bergson, *The Creative Mind*, translated by Mabelle L. Andison, Citadel Press/The Wisdom Library, New York, 1946, p 12.

15. Alan J. Friedman and Carol C. Donley, *Einstein as myth and muse*, p 124.

16. Henri Bergson, *The Creative Mind*, p 14.

17. Henri Bergson, published in *Écrits et paroles*, R. M. Mosse-Bastide, (ed.) Presses Universitaires de France, 3 vols, 1957–59; and Henri Bergson, *The Creative Mind*, p 16.

18. Henri Bergson, quoted from Friedman and Donley, *Einstein as myth and muse*, p 124.

Multiplicity, a sagittarian arrow, and

1. Gilles Deleuze and Claire Parnet, *Dialogues*, translated by Hugh Tomlinson and Barbara Habberjam, Columbia University Press, New York, 1987, p 2.

2. Plato, *Timaeus*, translated by Desmond Lee, Penguin Books, London, 1977, p 40.

3. Henri Bergson, *The Creative Mind*, translated by Mabelle L. Andison, Citadel Press/The Wisdom Library, New York, 1946, p 16.

4. Gilles Deleuze, *Bergsonism*, translated by Hugh Tomlinson and Barbara Habberjam, Zone Books, New York, 1988, p 38.

5. Gilles Deleuze and Claire Parnet, *Dialogues*, p ix.

6. Henri Bergson, *The Creative Mind*, p 26.

7. Gilles Deleuze, *Bergsonism,* p 47.

8. In *Bergsonism* Deleuze writes that Bergson never gives up the idea that duration, that is to say time, is 'essentially multiplicity'. However, it is important that we ask: 'What type of multiplicity?' (p 79) Deleuze asks us to remember that Bergson's theories make a distinction between two types of multiplicities, and he goes on to say: 'This is perhaps one of the least appreciated aspects of his thought – the constitution of the logic of multiplicities.' (p 117) Following this logic we would say that there are two major types of multiplicities: the one discrete and discontinuous, the other continuous; the one spacial and the other temporal; the one numerical and quantative, the other non-numerical and qualitive. Deleuze says: 'It is clear that in Bergson's terminology, Einstein's Time belongs to the first category. Bergson criticizes Einstein for having confused the two types of multiplicity and for having, as a result, revived the confusion of time with space. The discussion only apparently deals with the question: Is time one or multiple? The true problem is "What is the multiplicity peculiar to time?"' (p 80)

9. Gilles and Deleuze and Claire Parnet, *Dialogues*, p viii.

10. For example, the work and collaborations of Ilya Prigogine.

11. Michel Serres, 'The Origin of Language: Biology, Information Theory and Thermodynamics', *Hermes: Literature, Science, Philosophy*, Josué V. Harari and David F. Bell (eds), The John Hopkins University Press, Baltimore and London, 1983, p 75.

12. Michel Tournier, *Gemini*, translated by Anne Carter, Minerva, London, 1989, p 441 and pp 449–50.

13. Michel Serres, *Rome: The Book of Foundations,* translated by Felicia McCarren, Stanford University Press, California, 1991, p 78.

14. Ibid., p 80.

15. Ibid., p 168.

16. See Peter Coveney and Roger Highfield, *The Arrow of Time*, Flamingo, London, 1991, p 29.

17. Gilles Deleuze, *Bergsonism*, p 106.

18. Ibid., p 81.

19. Ibid., p 42.

20. Michel Serres, *Rome,* p 81.

21. Ibid., p 72.

22. Ibid., p 188.

23. Michel Serres, *Detachment,* translated by Geneviève James and Raymond Federman, Ohio University Press, Athens, 1989, p 91.

24. Ibid., p 83.

25. See this volume, Yve Lomax, 'The World is a Fabulous Tale'.

26. Michel Serres, *Rome,* p 80.

27. Ibid., p 82.

28. Ibid., p 178 and p 236.

29. See Barbara Johnson, *A World of Difference*, John Hopkins University Press, Baltimore and London, 1987, pp 12–13.

30. Gilles Deleuze and Claire Parnet, *Dialogues*, pp 34–5.

31. Michel Serres, *Rome*, p 252.

32. Ibid., p 236.

33. Ibid., p 83.

34. Gilles Deleuze, *The Fold: Leibniz and the Baroque*, translated by Tom Conley, Athlone Press, London, 1993, p 6.

35. Leibniz, quoted from ibid., p 6.

A fold, a wind and the event of ethics

1. Gilles Deleuze and Claire Parnet, *Dialogues*, translated by Hugh Tomlinson and Barbara Habberjam, Columbia University Press, New York, 1987, p 57.

2. Ibid., p 57.

3. Emmanuel Levinas, *Ethics and Infinity, Conversations with Philippe Nemo,* translated by Richard A.Cohen, Duquesne University Press, Pittsburgh, 1985, p 51.

4. Ibid., p 120.

5. Emmanuel Levinas, 'Ethics as First Philosophy', quoted from *The Levinas Reader*, Sean Hand (ed.), Basil Blackwell, Oxford, 1989, p 76.

6. Gilles Deleuze and Claire Parnet, *Dialogues*, p 56.

7. See Emmanuel Levinas, 'Ethics as First Philosophy'.

8. Emmanuel Levinas, *Ethics and Infinity*, p 61.

9. Emmanuel Levinas, 'Time and the Other', *The Levinas Reader*, p 51.

10. Ibid., p 51

11. Richard A. Cohen, introduction to *Ethics and Infinity*, pp 7–8.

12. Ibid., p 10

13. Jean-François Lyotard, 'Time Today', *The Oxford Literary Review*, ii/1–2, 1989, p 10.

14. Levinas, *Ethics and Infinity*, p 57.

15. Levinas, 'God and Philosophy', *The Levinas Reader*, p 179.

16. Levinas, *Ethics and Infinity*, p 116.

17. See Gilles Deleuze, *The Fold: Leibniz and the Baroque*, translated by Tom Conley, The Athlone Press, London, 1993, p 31.

18. Michel Tournier, *Gemini*, translated by Anne Carter, Minerva, London, 1989, pp 441–2.

19. Richard A. Cohen, *Ethics and Infinity*, p 15.

20. Levinas, *Ethics and Infinity*, p 105.

21. Gilles Deleuze, *The Fold*, p 34.

22. Jean-François Lyotard and Jean-Loup Thébaud, *Just Gaming*, translated by Wlad Godzich, Manchester University Press, Manchester, 1985, p 72.

23. Ibid., p 41.

Act Two
Surprise

1. Gilles Deleuze and Claire Parnet, *Dialogues*, translated by Hugh Tomlinson and Barbara Habberjam, Columbia University Press, New York, 1987, p 54.

2. Bruno Latour, 'The Enlightement without the Critique: A Word on Michel Serres', *Contemporary French Philosophers*, A. Phillips Griffiths (ed.), Cambridge University Press, Cambridge, New York, Melbourne, 1987, p 85.

3. Ibid., p 90.

4. Michel Serres, *Rome: The Book of Foundations*, translated by Felicia McCarren, Stanford University Press, California, 1991, p 246 and p 118.

5. Ibid., pp 254–8.

6. Helen Cixious, *The Book of Prometha*, translated by Betsy Wing, University of Nebraska Press, Lincoln and London, 1991, p 7.

7. Ibid., p 7.

8. Bruno Latour, 'A Word on Michel Serres', p 87.

9. See Michel Serres, 'Lucretius: Science and Religion', *Hermes: Literature, Science, Philosophy*, Josué V.Harari and David F. Bell (eds), The John Hopkins University Press, Baltimore and London, 1982.

10. Michel Serres, *Rome*, p 84.

11. Maria L. Assad, 'Michel Serres: In Search of a Tropography', *Chaos and Order: Complex Dynamics in Literature and Science,* N. Katherine Hayles (ed.), The University of Chicago Press, Chicago and London, 1991, p 287.

12. Michel Serres, *Rome*, pp 236–7.

13. Michel Serres, *Detachment*, Ohio University Press, translated Geneviève James and Raymond Federman, Athens, 1989, p 83.

Cause

1. Gilles Deleuze, *Bergsonism*, translated by Hugh Tomlinson and Barbara Habberjam, Zone Books, New York, 1988, p 43.

2. Gilles Deleuze and Felix Guattari, 'Rhizome', *A Thousand Plateaus: Capitalism and Schizophrenia*, translated by Brian Massumi, The Athlone Press, London, 1988, p 9.

3. See Michael Hardt, *An Apprenticeship in Philosophy: Gilles Deleuze*, UCL Press, London, 1993, p xv.

4. Ibid., p 63.

5. Emmanuel Levinas, *Ethics and Infinity, Conversation with Philippe Nemo*, translated by Richard A. Cohen, Duquensne University Press, Pittsburgh, 1985, p 120.

6. Gilles Deleuze, *Expression in Philosophy: Spinoza*, translated by Martin Joughin, Zone Books, New York, 1990, pp 172–3.

7. See Michael Hardt, *Gilles Deleuze*, p 64.

8. Gilles Deleuze, *Expressionism*, p 16.

9. Ibid., p 42.

10. Ibid., p 172.

11. Ibid., p 173.

12. See Michael Hardt, *Gilles Deleuze,* p 67.

13. See Gilles and Felix Guattari, *What is Philosophy?*, translated by Graham Burchell and Hugh Tomlinson, Verso, London and New York, 1994, p 7 and p 11.

14. Michael Hardt, *Gilles Deleuze*, p 114.

15. Gilles Deleuze, *Difference and Repetition*, translated by Paul Patton, The Athlone Press, London, 1994, p 51.

16. Luce Irigaray, *An Ethics of Sexual Difference*, translated by Carolyn Burke and Gillian C. Gill, The Athlone Press, London, p 5.

17. Michel Serres, *Rome: The Book of Foundations*, translated by Felicia McCarren, Stanford University Press, California, 1991, p 36.

18. Ibid., p 20.

19. See Vincent Descombes, *Modern French Philosophy*, translated by L. Scott-Fox and J. M. Harding, Cambridge University Press, Cambridge, New York, Melbourne, 1980, p 32.

20. Michel Serres, *Rome*, p 80.

21. Michael Hardt, *Gilles Deleuze*, p 114.

Move

1. See Note 2 in Maria L. Assad, 'Michel Serres: In Search of a Tropography', *Chaos and Order: Complex Dynamics in Literature and Science*, N. Katherine Hayles (ed.), The University of Chicago Press, Chicago and London, 1991, p 294. 'This definition of the trope is borrowed from Paul de Man's essay "Pascal's Allegory of Persuasion" ... Breaking with traditional definitions of the figurative as a *deviation* from the norm or an *opposite* to the literal, de Man's understanding of Pascal's trope is instead based on a *substitutive relationship*, a *turning toward* something that remains, however, undefined.'

2. Michel Serres with Bruno Latour, *Conversations on Science, Culture and Time,* translated by Roxanne Lapidus, The University of Michigan Press, 1995, p 104.

3. Michel Serres, *Rome: The Book of Foundations*, translated by

Felicia McCarren, Stanford University Press, California, 1991, p 22.

4. Ibid., pp 36–37.

5. See Michel Serres, 'Lucretius: Science and Religion', *Hermes: Literature, Science, Philosophy*, Josué V. Harari and David F. Bell (eds), The John Hopkins University Press, Baltimore and London, 1982.

Turn

1. Michel Serres, *Rome: The Book of Foundations*, translated by Felicia McCarren, Stanford University Press, California, 1991, p 80.

2. Gilles Deleuze, *Expressionism in Philosophy: Spinoza*, translated by Martin Joughin, Zone Books, New York, 1990, p 172.

3. See Michael Hardt, *An Apprenticeship in Philosophy: Gilles Deleuze*, UCL Press, London, 1993, pp 3–10.

4. Ibid., p 114.

5. Michel Serres, *Rome*, p 245.

6. Ibid., p 275.

7. See Gilles Deleuze, *Expressionism*, p 178.

8. Gilles Deleuze, *Difference and Repetition*, translated by Paul Patton, The Athlone Press, London, 1994, p 35.

9. Ibid., p 36.

10. See for example, Gilles Deleuze and Felix Guattari, '1277: Treatise on Nomadology', '1440: The Smooth and the Straited', *A Thousand Plateaus: Capitalism and Schizophrenia,* translated by Brian Massumi, The Athlone Press, London, 1988.

Leap

1. Michel Serres, 'Lucretius: Science and Religion', *Hermes: Literature, Science, Philosophy,* Josué V. Harari and David F. Bell (eds), The John Hopkins University Press, Baltimore and London, 1982, p 118.

2. See Michel Serres, *Rome: The Book of Foundations,* translated by Felicia McCarren, Stanford University Press, California, 1991, pp 84–5.

3. Michel Serres, *Genesis,* translated by Geneviève James and James Nielson, The University of Michigan Press, 1995, p 97.

4. Ilya Prigogine and Isabelle Stengers, Postface, *Hermes,* p 152.

5. Michel Serres, *Hermes*, p 120.

6. Ibid., p 114.

7. Ibid., p 99.

8. Michel Serres, *Rome*, p 267.

9. Michel Serres, *Hermes,* p 114.

10. Michel Serres and Bruno Latour, *Conversations on Science, Culture and Time*, translated by Roxanne Lapidus, The University of Michigan Press, 1985, p 49.

Act Three

1. Gilles Deleuze, *Expressionism in Philosophy: Spinoza*, translated by Martin Joughin, Zone Books, New York, 1990, p 217.

2. Ibid., p 220.

3. Benedict de Spinoza, *A Spinoza Reader: The* Ethics *and other works,* translated by Edwin Curley, Princeton University Press, New Jersey and Chichester, 1994, p 154.

4. Gilles Deleuze, *Expressionism*, p 219.

5. Ibid., p 219.

6. Gilles Deleuze, *Spinoza: Practical Philosophy*, translated by Robert Hurley, City Lights Books, San Franciso, 1988, p 19.

7. Ibid., pp 127.

8. Gilles Deleuze, *Expressionism*, p 239.

9. Ibid., p 240.

10. Gilles Deleuze, *Spinoza*, p 27.

11. Benedict de Spinoza, *The* Ethics, p 241.

12. Gilles Deleuze, *Spinoza*, p 126.

13. Gilles Deleuze, *Expressionism*, p 270.

14. Gilles Deleuze, *Negotiations*, translated by Martin Joughin, Columbia University Press, New York, 1995, p 156.

15. Ibid., p 157.

16. Gilles Deleuze, *Spinoza*, p 125.

17. See Gilles Deleuze, *Expressionsim*, p 274.

18. Ibid., p 275.

19. Ibid., p 283.

20. See Michael Hardt, *An Apprenticeship in Philosophy: Gilles Deleuze*, UCL Press, London, 1993, p 97.

21. Gilles Deleuze, *Expressionism*, p 282.

22. See Gilles Deleuze, *Spinoza*, pp 114–15.

23. See Gilles Deleuze and Felix Guattari, *A Thousand Plateaus: Capitalism and Schizophrenia*, translated by Brian Massumi, The Athlone Press, London, 1988.

24. Gilles Deleuze, *Spinoza*, p 119.

25. Ibid., p 128.

26. Michael Hardt, *Gilles Deleuze*, p 119.

27. Gilles Deleuze, *Expressionsim*, p 262.

Afterword

At the beginning, the book is implored to open its pages to the presence of the sun, yet quickly, very quickly, the pages turn to the question of difference. More and no more difference is the cry.(p.11)

Now, as the book turns towards its closing pages, I can see she has a twinkle in her eye. I can tell she wants to ask me a question.

– 'Reflecting upon the endeavours of this book, what would you say opens up for you at this present moment?'

With little hesitation I reply: a concept of difference founded *with* time.

For far too long I have been told to 'see' difference in a space which compares and contrasts but, nowadays, when I think of difference I can no longer ignore the question of time. A temporal approach to the question of difference – yes, this is what is now opening up for me.

I speak of a concept of difference, yet I must stress that I do not take this to be an immobile or inflexible concept. Indeed, I do not conceive of this concept as a Big Idea which is, at every instance, self-identical and opposed to contraries. To found with time, as Michel Serres has said, is to found on what moves.(p.192) A mobile concept is one that is flexible, always open to being refolded. Yes, a temporal concept of difference is a pliable concept.

Again I can see she has a twinkle in her eye.

– 'Time does not always develop in a linear manner; it 'moves' in

an extraordinarily complicated and unexpected way. Some would say that time is highly paradoxical. Does it not twist and fold as the dancing movement of flames?'

The flames may merrily dance yet so very often the time of our lives is subjected to the miserable obsession of controlling time, of subordinating time to the hands of the clock and the rule of the chronological line.

Let me add that the temporal conception of difference which is opening up for me is, at heart, a matter of an ethics of time – an ethics which seeks to open up the joy of active affections and the becoming of being. Coming to the closing pages of this book, I would say that an ethics of time and an ethics of joy have become inseparable. And, simply put, it has been an immanent causality which has afforded me this opening.

Immanent causality is not directly spoken of until the question of singularity becomes a pressing concern.(p.170) Indeed, the words may not be spoken earlier yet if you take care to listen you will hear immanence implying itself. Yes, it is implied when the question of representation falls 'flat', spreads out and becomes a question of the horizontal movement and assemblage of parts.(p.26) Yes, it is implied with the movement of partial lines. Or, in other words, when images and concepts cease to be representations of the world and become part of the world and its extraordinary complex materiality.(p.13, p.43) It is also implied when we find ourselves in a *milieu* where things turn out to be inter-connections between things which are, in turn, inter-connections between other things; that is to say, inter-connections where no one thing can be said to play the determining part.(p.62, p.81) Moreover, it is forcefully implied with the ramifications of the figure of the rhizome which Gilles Deleuze and Felix Guattari so aptly employ.(p.65: n.11 and n.13) For me, immanent causality has opened up (a) future politics; however, it would be a mistake to think that immanence offers itself as a guiding star which a future politics can follow. Immanence does not constitute a Big Idea which from above seeks to impose its model upon the world.

Yes, the folding of immanence, along with the trope of folding, the turning of which ceases to maintain a separation of mind and word from the matter of a world in motion (p.182), has opened up a fresh approach to the question of time, power and, moreover, the image.

Let it also be added that I cannot grasp the 'present moment'. I do not, however, say this in a glib manner. That the present can never be grasped has to do with time as a highly paradoxical event. A little later I will speak more of this event.

For some, the question of difference has ceased to be a 'trendy' issue. Trendy thinking, however, can quickly become suckered by chronological time.

Chronological time adheres to the idea of a straight line along which moves a succession of moments or present points which separate what comes

before from what follows after. A point is made, then you move along to another. Something stops and then something starts.

Chronological time spends all its time making a stopping point in order to start; it is believed that it is the making of this point which forwards movement. With chronological time you can never just go for a walk; on the contrary, you have to stop before you start. Yes, chronological time is always halting you in your steps. In order to move you have to step from one stopping point to another; the steps are marked yet, in so doing, we miss the walk, we come to miss what happens in the between.

With chronological time one present is successively replaced by another, and for those who adhere to this time, the past is forever outstripped by the up-to-date. Partaking of time as the 'highest paradox', the past is never out-of-date, rather it is made anew at every moment.

Considering the present, I find that it is continually splitting in two directions, one of which is the present-becoming-past and the other, the present-becoming-future. The *having already happened* paradoxically coexists with the *still to come*. Or, to put this another way, the past is not constituted after the present that it once was but, rather, contemporaneously. The continual splitting of the present into the *having already happened* and the *still to come* means that it is always too soon or too late to be grasped. Try as I may, I can never quite take possession and control of the present.

I can never master the present in as much as I cannot self-master the present of myself. Yes, the present cannot be grasped; it has to continually differ with itself in order to be present, in order to endure. Simply put, time is what continually differs with itself (p.188). It is, as Gilles Deleuze perhaps would say, difference in itself.(p.190)

Time 'itself' divides yet time also divides in us, making us become other than what we are. However, let us not forget that this is a very special kind of division, one that pertains to a fold ... analysis cuts; the baker folds.(p.44)

The paradoxical event of time's division testifies that the self is essentially open to a recurrent becoming-other. That I can never grasp the present does not mean something is lacking in my life such that I am haunted by a 'missing term'.(p.39) Far from it, this non-possession is that which positively makes a life and affirms our power of transformation. Subjectivity is constituted by the dividual – that is to say, folding – movement of time; there is no self-identical subject because we think, live and love in time.

The present of myself can never persist in itself with out losing its identity as a state of now. To open ourselves to time's paradoxical event is to remain open to new modes of existence, new ways of being. Becoming other than what we are is not the exchange of one identity for another; rather than a numerical multiplicity, it involves a continuous multiplicity.(p

158) It is, as the philosopher Henri Bergson would say, a 'creative evolution'.

Time as the highest paradox is what produces time's inventiveness; it produces the possibility of a past and, at the same time, the possibility of the new and the unforeseen; moreover, it renews these possibilities at each and every moment.

With time's paradoxical event something happens that reason has *not yet* known. Without seeking to grasp this *not yet*, reason opens itself to the unthought within thought, that is to say, a process of thinking which is a thinking not already thought. Call it nonsense if you wish, but thought has no life without this process.

Again there is a twinkle in her eye.

– 'Are you to deny that the writings collected in this book adhere to chronological time?'

With little doubt my in mind, I reply: it would be naive to deny that time which develops according to the chronological line. Becoming a baker, however, you can always fold the line.(p.148) The chronological line marks its time by number, yet between the dates you can hear the making of a fold.

Listen.

This book of collected writings is involved with more than one time. Listen carefully and you will hear this book making itself, as it were, between two folds. The chronological line may develop yet, at the same time, there is the envelopment of a series of folds.

Listen. And keep on listening, especially so when all appears to be said and done.(p.58) And listening, perhaps you will open your ears to the question which is crying out to be heard – the question of a temporal conception of difference.

The concept of difference founded with time is a mobile concept which asks us to open ourselves to the movement of time; what is more, it asks us to reconsider our understanding of movement in the spatial sense.

A temporal conception of difference asks us to distinguish movement in time from movement in space.

Again I return to the photographic image. I return because I remain bothered by a number of unresolved questions. There is something about the still photographic image that appears to present itself as an obstacle to thought when it comes to the question of time and movement. An obstacle can be like banging your head against a brick wall, or it can be where thought is pitched into movement by an unresolved question.

My thought has been continually set in motion by the photographic image; however, why does my thinking feel it has hit a brick wall when it is said that, unlike cinema, the photographic image 'drains' movement from its object?

If we see the photograph in terms of movement in the spatial sense

then, to be sure, we can say that it reduces a walk to a series of immobile steps. But, if we approach the photographic image with a temporal conception of difference, which asks us to reconsider our definition of movement, perhaps we will cease seeing the 'still' as the opposite of the 'moving'.

Again there is that twinkle.

– 'How are we to regard the still photographic image in terms of time's paradoxical event? With a photographic image how can there be, at the same time, the *already happened* and the *still to come*?'

Listen, I reply. It remains an unresolved question, one that demands the making of some new folds, which may involve some very old and 'untrendy' folds; perhaps, it also demands taking hearing as a model of understanding.

– 'Look, but first of all listen ...?'

Previous versions of texts published in:

'A Metaphorical Journey', *Feminist Review*, no.32, 1984.
'More and No More Difference', *Screen*, xxviii/1, Winter, 1987.
'Re-Visions', catalogue essay for *Re-Visions*, group exhibition, Cambridge Darkrooms Gallery, 1985.
'Future Politics/The Line in the Middle', limited edition publication for exhibition, *Next Tomorrow*, Kettles Yard, Cambridge.
'The World is a Fabulous Tale', *Other Than Itself: Writing Photography*, John X. Berger and Olivier Richon, (eds), Cornerhouse Publications, Manchester, 1989.
'The World is Indeed a Fabulous Tale': Yve Lomax – a Practice around Photography, Hilary Gresty in dialogue with Yve Lomax', *The Postmodern Arts: An introductory reader*, Nigel Wheale, (ed.), Routedge, London and New York, 1995.

Extracted versions of Serious Words published as:

'Telling Times: Tales of photography and other stories', *Public Bodies/Private States: New views on Photography and gender*, Jane Brettle and Sally Rice, (eds), Manchester University Press, Manchester and New York, 1994.
'Folds in the Photograph', *Third Text*, no.32, Autumn, 1995.
'Common Notions', Symposium on Photography XVIII: Agents and Agencies, *Camera Austria*, no.62/63, 1998.